The Art of
Drawing Animals

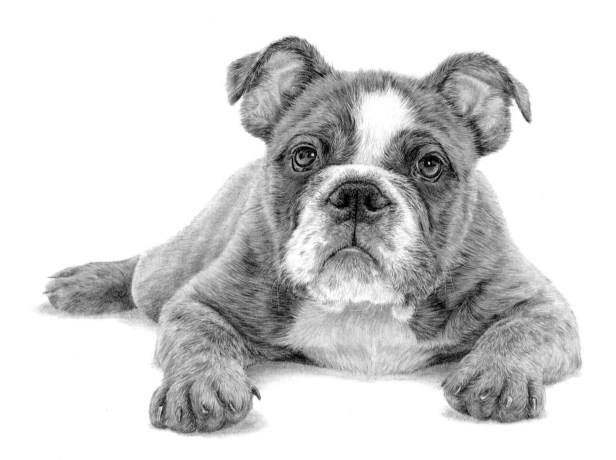

The Art of Drawing Animals

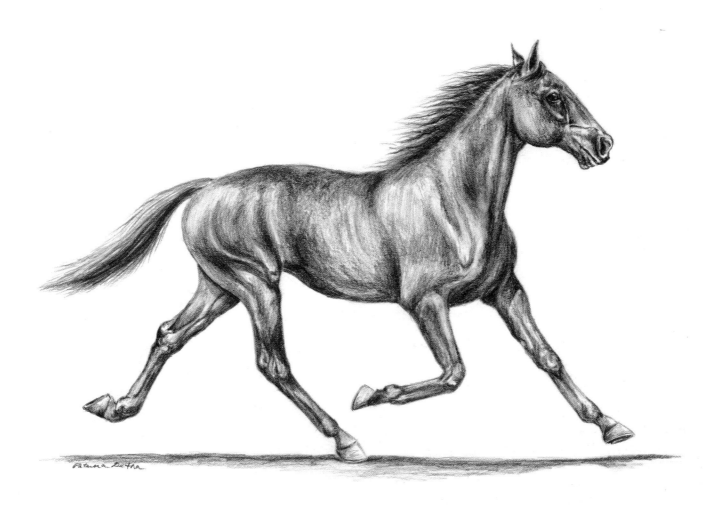

With Patricia Getha, Cindy Smith, Nolon Stacey,
Linda Weil, and Debra Kauffman Yaun
Designed by Shelley Baugh
Project Editors: Meghan O'Dell and
Elizabeth T. Gilbert
Copyeditor: Rebecca J. Razo
Index by Christy Stroud and Meghan O'Dell

WALTER FOSTER PUBLISHING, INC.

CONTENTS

INTRODUCTION TO DRAWING ANIMALS

Welcome to the exciting world of drawing animals in pencil! This compilation of projects from some of the most popular Walter Foster titles provides inspiration and instruction for creating a variety of animal drawings, including lovable cats and dogs, majestic horses and ponies, and the wondrous animals of the wild. From the fundamentals of drawing to special tips and advanced techniques, *The Art of Drawing Animals* is filled with step-by-step demonstrations to guide aspiring artists through the drawing process. There's even a section on drawing animals in colored pencil, so you can try your hand at another medium. The five artists in this collection have developed their own approach to pencil drawing, so there are countless lessons to be learned from their individual and distinct perspectives. Discover how fun and easy drawing animals can be!

TOOLS & MATERIALS

Drawing is not only fun, but it also is an important art form in itself. Even when you write or print your name, you are actually drawing! If you organize the lines, you can make shapes; and when you carry that a bit further and add dark and light shading, your drawings begin to take on a three-dimensional form and look more realistic. One of the great things about drawing is that you can do it anywhere, and the materials are very inexpensive. You do get what you pay for, though, so purchase the best you can afford at the time, and upgrade your supplies whenever possible. Although anything that will make a mark can be used for some type of drawing, you'll want to make certain your magnificent efforts last and not fade over time. Here are some materials that will get you off to a good start.

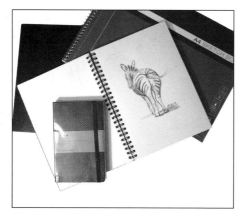

▶ **Sketch Pads** You can buy spiral-bound, stitched, or gum-bound sketchbooks in a variety of sizes. The paper in most sketchbooks is not designed for finished works—sketching is a form of visual note taking, and you should not worry about producing masterpieces with them. You may want to carry a small notebook-sized sketchbook with you so you can sketch whenever the mood strikes. It's a good idea to carry a larger sketchbook when drawing on location.

▲ **Work Station** You don't need a professional drafting table to start drawing—many brilliant drawings have been created on a kitchen table! You'll need a hard surface to use as a drawing board (or purchase a drawing board from an art supply store), and something to prop up the board with, such as a brick or a stack of books. Good lighting is essential—it's best to work in natural light, but you also can purchase a daylight bulb, which gives off a good white light and eliminates the yellow glare of standard bulbs. Make sure the lighting is direct and that there are no shadows falling across your work area. Also, you'll want to have a comfortable chair that supports your back.

▶ **Paper** Drawing paper is available in a range of surface textures: smooth grain (*plate finish* and *hot pressed)*, medium grain *(cold pressed),* and rough to very rough. Rough paper is ideal for charcoal, whereas smooth paper is best for watercolor washes. The heavier the weight of the paper, the thicker it is. Thicker papers are better for graphite drawings because they can withstand erasing far better than thinner papers can. Be sure to purchase acid-free paper, as acid causes paper to turn yellow over time.

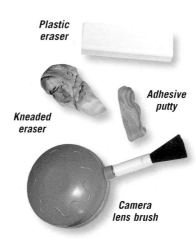

Plastic eraser

Kneaded eraser

Adhesive putty

Camera lens brush

◀ **Erasers** Mistakes are inevitable, so it's good to have a few erasers on hand. Plastic art erasers are good for removing harder pencil marks and for erasing large areas. Be careful when using this type of eraser, as rubbing too hard will damage the surface of the paper. This eraser also leaves crumbs, so be sure to softly brush them away with a makeup or camera lens brush. Kneaded erasers are very pliable; you can mold them into different shapes. Instead of rubbing the kneaded eraser across the paper, gently dab at the area to remove or lighten tone. Another great tool is adhesive putty, made for tacking posters to a wall. Like a kneaded eraser, it can be molded and won't damage the paper.

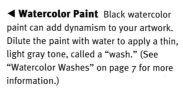

◀ **Watercolor Paint** Black watercolor paint can add dynamism to your artwork. Dilute the paint with water to apply a thin, light gray tone, called a "wash." (See "Watercolor Washes" on page 7 for more information.)

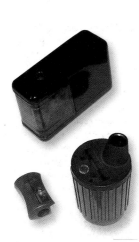

◀ **Sharpeners** Clutch pencils (see page 7) require special sharpeners, which you can find at art and craft stores. A regular handheld sharpener can be used for wood-cased and woodless pencils, but be sure to have several sharpeners on hand as these pencils can become dull. You can also purchase an electric sharpener, but it affords less control over the shape of the pencil tip.

▶ **Blending Tools** Paper stumps (also called "tortillons") are used to blend or smudge areas of graphite into a flat, even tone. Be careful when using blending tools, as they tend to push the graphite into the paper, making the area difficult to erase. Another good way to blend is to wrap a chamois cloth around your finger. Never use your finger alone for blending—your skin contains oils that could damage the paper.

PENCILS

Soft pencils (labeled "B") produce strong, black tones; hard pencils (labeled "H") create lighter marks. The higher the number that accompanies the letter, the harder or softer the lead. (For example, a 4B pencil is softer than a 2B pencil.) HB and F pencils are used for middle grades. We recommend starting with the following range of wood-cased pencils: 2H, H, HB, F, B, and 2B. As your skills develop, you can experiment with different types of pencils. Some artists like to use clutch pencils (also called "mechanical pencils"), which require special sharpeners (see page 6). You can also purchase woodless graphite pencils, which are great for covering large areas with tone or for making quick sketches. These pencils are usually very soft, and the graphite breaks easily. Charcoal pencils are also good for making very dark black marks. Keep in mind that tones vary among manufacturers—one brand's HB may look very different from another brand's, so try to stick with one brand of pencil for a consistent range of tones.

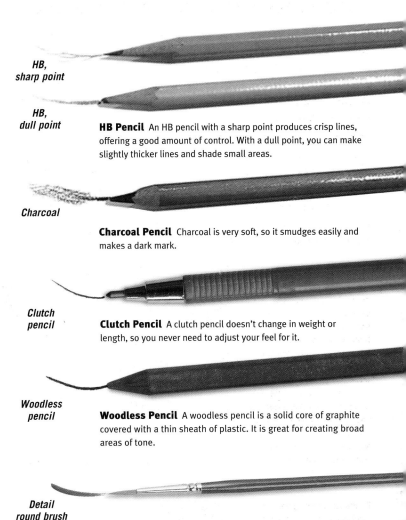

HB, sharp point

HB, dull point

HB Pencil An HB pencil with a sharp point produces crisp lines, offering a good amount of control. With a dull point, you can make slightly thicker lines and shade small areas.

Charcoal

Charcoal Pencil Charcoal is very soft, so it smudges easily and makes a dark mark.

Clutch pencil

Clutch Pencil A clutch pencil doesn't change in weight or length, so you never need to adjust your feel for it.

Woodless pencil

Woodless Pencil A woodless pencil is a solid core of graphite covered with a thin sheath of plastic. It is great for creating broad areas of tone.

Detail round brush

Small round brush

Medium round brush

Paintbrushes A few good paintbrushes make applying watercolor washes more enjoyable. Round brushes like these taper to a natural tip—purchase them in a variety of sizes, from very small for adding details to medium for filling in larger areas.

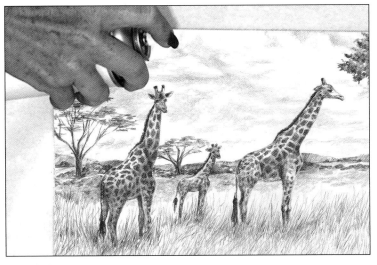

Spray Fix A fixative "sets" a drawing and protects it from smearing. Some artists avoid using fixative on pencil drawings because it tends to deepen the light shadings and eliminate some delicate values. However, fixative works well for charcoal drawings. Fixative is available in spray cans or in bottles, but you need a mouth atomizer to use bottled fixative. Spray cans are more convenient, and they give a finer spray and more even coverage.

WATERCOLOR WASHES

Incorporating washes of black watercolor paint into your drawings can give them a smooth, elegant quality that you can't achieve with graphite or charcoal. Start by gathering two jars of clean water; one for cleaning your brushes and one for adding clear water to your paint. Then find an old dish, cup, or paint palette to use for mixing the paint. Thin the paint with water, load a brush with the diluted mixture, and stroke across your paper. You don't need much paint—start with a pea-sized amount. It's a good idea to practice manipulating watercolor washes before applying them to your drawings. Try adding different amounts of water to the wash and create a range of values. Get acquainted with the techniques shown below.

◄ Drybrush Load your brush with wash and dab the bristles on a paper towel. Pull the brush lightly across the paper's surface for a texture that suggests mane and tail hair.

◄ Gradation Pull a horizontal band of wash across the paper. Add more water to your brush as you stroke away, creating a transition from dark to light that can suggest form.

◄ Wet on Dry Paint wet color onto dry paper or over a dry layer of color. This gives you a good amount of control over the paint's spread, which is great for detail.

THE ELEMENTS OF DRAWING

Drawing consists of three elements: line, shape, and form. The shape of an object can be described with simple one-dimensional line. The three-dimensional version of the shape is known as the object's "form." In pencil drawing, variations in *value* (the relative lightness or darkness of black or a color) describe form, giving an object the illusion of depth. In pencil drawing, values range from black (the darkest value) through different shades of gray to white (the lightest value). To make a two-dimensional object appear three-dimensional, you must pay attention to the values of the highlights and shadows. When shading a subject, you must always consider the light source, as this is what determines where your highlights and shadows will be.

MOVING FROM SHAPE TO FORM

The first step in creating an object is establishing a line drawing or outline to delineate the flat area that the object takes up. This is known as the "shape" of the object. The four basic shapes—the rectangle, circle, triangle, and square—can appear to be three-dimensional by adding a few carefully placed lines that suggest additional planes. By adding ellipses to the rectangle, circle, and triangle, you've given the shapes dimension and have begun to produce a form within space. Now the shapes are a cylinder, sphere, and cone. Add a second square above and to the side of the first square, connect them with parallel lines, and you have a cube.

ADDING VALUE TO CREATE FORM

A shape can be further defined by showing how light hits the object to create highlights and shadows. First note from which direction the source of light is coming. (In these examples, the light source is beaming from the upper right.) Then add the shadows accordingly, as shown in the examples below. The *core shadow* is the darkest area on the object and is opposite the light source. The *cast shadow* is what is thrown onto a nearby surface by the object. The *highlight* is the lightest area on the object, where the reflection of light is strongest. *Reflected light,* often overlooked by beginners, is surrounding light reflected into the shadowed area of an object.

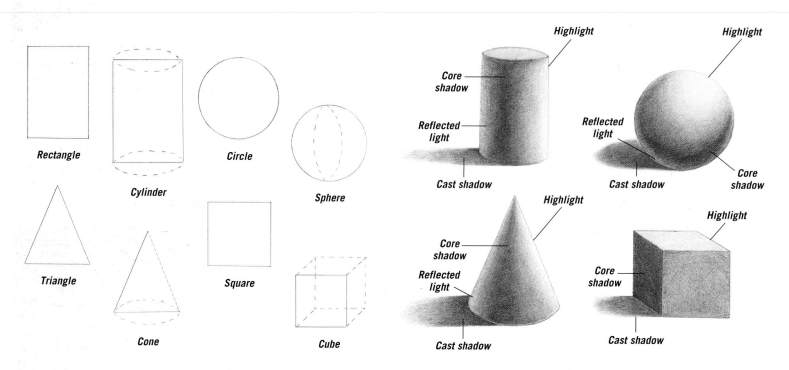

Rectangle · Cylinder · Circle · Sphere · Triangle · Cone · Square · Cube

Highlight · Core shadow · Reflected light · Cast shadow

CREATING VALUE SCALES

Just as a musician uses a musical scale to measure a range of notes, an artist uses a value scale to measure changes in value. You can refer to the value scale so you'll always know how dark to make your dark values and how light to make your highlights. The scale also serves as a guide for transitioning from lighter to darker shades. Making your own value scale will help familiarize you with the different variations in value. Work from light to dark, adding more and more tone for successively darker values (as shown at upper right). Then create a blended value scale (shown at lower right). Use a tortillon to smudge and blend each value into its neighboring value from light to dark to create a gradation.

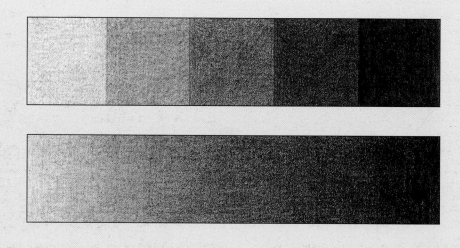

BASIC PENCIL TECHNIQUES

Ⲩou can create an incredible variety of effects with a pencil. By using various hand positions and shading techniques, you can produce a world of different lines and strokes. If you vary the way you hold the pencil, the mark the pencil makes changes. It's just as important to notice your pencil point. The point is every bit as essential as the type of lead in the pencil. Experiment with different hand positions and techniques to see what your pencil can do!

GRIPPING THE PENCIL

Many artists use two main hand positions for drawing. The writing position is good for very detailed work that requires fine hand control. The underhand position allows for a freer stroke with more arm movement—the motion is almost like painting. (See the captions below for more information on using both hand positions.)

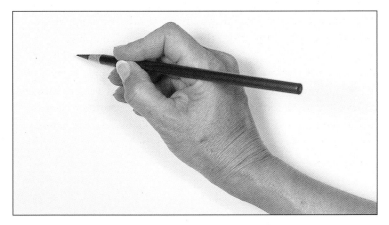

Using the Writing Position This familiar position provides the most control. The accurate, precise lines that result are perfect for rendering fine details and accents. When your hand is in this position, place a clean sheet of paper under your hand to prevent smudging.

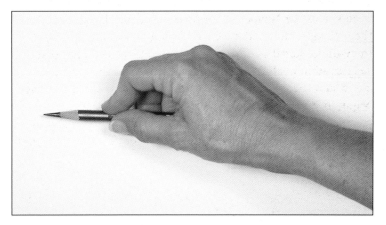

Using the Underhand Position Pick up the pencil with your hand over it, holding the pencil between the thumb and index finger; the remaining fingers can rest alongside the pencil. You can create beautiful shading effects from this position.

PRACTICING BASIC TECHNIQUES

By studying the basic pencil techniques below, you can learn to render everything from the rough, wrinkled skin of an elephant to the soft, fluffy fur of a bunny. Whatever techniques you use, though, remember to shade evenly. Shading in a mechanical, side-to-side direction, with each stroke ending below the last, can create unwanted bands of tone throughout the shaded area. Instead try shading evenly, in a back-and-forth motion over the same area, varying the spot where the pencil point changes direction.

Hatching This basic method of shading involves filling an area with a series of parallel strokes. The closer the strokes, the darker the tone will be.

Crosshatching For darker shading, place layers of parallel strokes on top of one another at varying angles. Again, make darker values by placing the strokes closer together.

Gradating To create gradated values (from dark to light), apply heavy pressure with the side of your pencil, gradually lightening the pressure as you stroke.

Shading Darkly By applying heavy pressure to the pencil, you can create dark, linear areas of shading.

Shading with Texture For a mottled texture, use the side of the pencil tip to apply small, uneven strokes.

Blending To smooth out the transitions between strokes, gently rub the lines with a tortillon or tissue.

OTHER WAYS TO SHADE

PRACTICING LINES

When drawing lines, it is not necessary to always use a sharp point. In fact, sometimes a blunt point may create a more desirable effect. When using larger lead diameters, the effect of a blunt point is even more evident. Play around with your pencils to familiarize yourself with the different types of lines they can create. Make every kind of stroke you can think of, using both a sharp point and a blunt point. Practice the strokes below to help you loosen up.

As you experiment, you will find that some of your doodles will bring to mind certain imagery or textures. For example, little Vs can be reminiscent of birds flying, whereas wavy lines can indicate water.

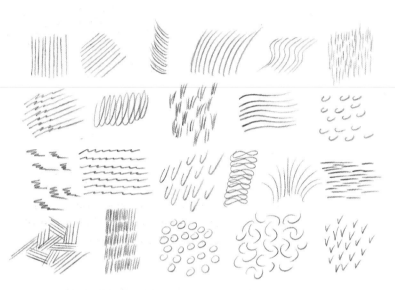

Drawing with a Sharp Point First draw a series of parallel lines. Try them vertically; then angle them. Make some of them curved, trying both short and long strokes. Then try some wavy lines at an angle and some with short, vertical strokes. Try making a spiral and then grouping short, curved lines together. Then practice varying the weight of the line as you draw. Os, Vs, and Us are some of the most common alphabet shapes used in drawing.

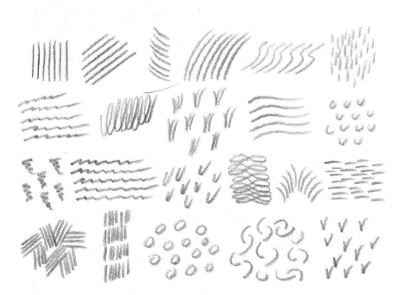

Drawing with a Blunt Point It is good to take the same exercises and try them with a blunt point. Even if you use the same hand positions and strokes, the results will be different when you switch pencils. Take a look at these examples. The same shapes were drawn with both pencils, but the blunt pencil produced different images. You can create a blunt point by rubbing the tip of the pencil on a sandpaper block or on a rough piece of paper.

"PAINTING" WITH PENCIL

When you use painterly strokes, your drawing will take on a new dimension. Think of your pencil as a brush and allow yourself to put more of your arm into the stroke. To create this effect, try using the underhand position, holding your pencil between your thumb and index finger and using the side of the pencil. (See page 9.) If you rotate the pencil in your hand every few strokes, you will not have to sharpen it as frequently. The larger the lead, the wider the stroke will be. The softer the lead, the more painterly an effect you will have. The examples below were all made on smooth paper with a 6B pencil, but you can experiment with rough papers for more broken effects.

▶ **Starting Simply**
First experiment with vertical, horizontal, and curved strokes. Keep the strokes close together and begin with heavy pressure. Then lighten the pressure with each stroke.

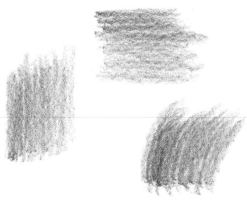

▶ **Varying the Pressure** Randomly cover the area with tone, varying the pressure at different points. Continue to keep your strokes loose.

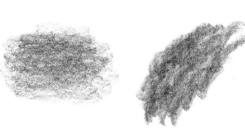

▶ **Using Smaller Strokes** Make small circles for the first example. This is reminiscent of leathery animal skin. For the second example (at far right), use short, alternating strokes of heavy and light pressure to create a pattern that is similar to stone or brick.

▶ **Loosening Up**
Use long vertical strokes, varying the pressure for each stroke until you start to see long grass (near right). Now create short spiral movements with your arm (far right, above). Then use a wavy movement, varying the pressure (far right, below).

FINDING YOUR STYLE

Many great artists of the past can now be identified by their unique experiments with line. Van Gogh's drawings were a feast of calligraphic lines; Seurat became synonymous with pointillism; and Giacometti was famous for his scribble. Find your own style!

▶ **Using Criss-Crossed Strokes** If you like a good deal of fine detail in your work, you'll find that crosshatching allows you a lot of control (see page 9). You can adjust the depth of your shading by changing the distance between your strokes.

▶ **Sketching Circular Scribbles** If you work with round, loose strokes like these, you are probably very experimental with your art. These looping lines suggest a free-form style that is more concerned with evoking a mood than with creating precise details.

▶ **Drawing Small Dots** This technique is called "stippling"—many small dots are used to create a larger picture. Make the points different sizes to create various depths and shading effects. Stippling takes a great deal of precision and practice.

▶ **Simulating Brushstrokes** You can create the illusion of brushstrokes by using short, sweeping lines. This captures the feeling of painting but allows you the same control you would get from crosshatching. These strokes are ideal for a stylistic approach.

NEGATIVE DRAWING

Negative drawing means defining an object by filling in the area around it rather than the object itself. This method is particularly useful when the object in the foreground is lighter in tone than the background, as well as for drawing hair. You can easily draw hair using lines, but how do you draw light hair? You draw the negative shadows between the hairs.

DRAWING WITH ERASERS

Graphite is very easy to manipulate with erasers. Not only can you correct mistakes, but you can use them to soften lines, create lighter shading, pull out highlights, and even draw. You can also use erasers to lighten objects, suggesting distance. The process of creating light areas or shapes on a darker graphite background is called "lifting out."

Using Negative Drawing for Hair Once the negative space is shaded (above left), you can add texture and tone to individual hairs to give them more realism and depth (above right).

Drawing Lines with an Eraser Quickly stroking the edge of a hard eraser across graphite results in a clear line that can be used to suggest highlights.

Drawing Hair To create this hair texture, apply a solid layer of shading. Then use the tip of an eraser to pull out short lines in the direction of hair growth.

SMUDGING

Smudging is an important technique for creating shading and gradients. Use a tortillon or chamois cloth to blend your strokes. It is important to not use your finger, because your hand, even if clean, has natural oils that can damage your art.

◀ **Smudging on Rough Surfaces** Use a 6B pencil on rough paper. Make your strokes with the side of the pencil and blend. In this example, the effect is very granular.

◀ **Smudging on Smooth Surfaces** Use a 4B pencil on plate-finish paper. Stroke with the side of the pencil, and then blend your strokes with a tortillon.

ANIMAL TEXTURES

There is a vast range of textures you can create for skin and hair, and each requires a slightly different technique to achieve a realistic effect. The samples below break down the process of drawing six different textures into steps. Most of these techniques are used in the "Wild Animals" chapter of this book, so you may want to refer to these pages when following the step-by-step projects.

SHORT FUR

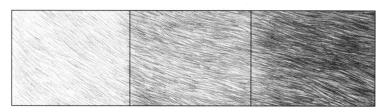

Step One Create a light undercoat with a series of swift, short pencil strokes and a very sharp 2H .5 mm mechanical pencil. (Every pencil must be very sharp to achieve this effect.) Draw the strokes in the direction of the fur growth and avoid forming obvious patterns.

Step Two Now use a sharp HB lead to create the second layer, using the same technique as in step one. Don't fill in the entire area; instead leave some of the paper showing through the lines for highlights.

Step Three Switch to a 2B pencil to work over the area again with the same short, swift strokes. This deepens the tone and creates a realistic texture. The darker 2B helps make the untouched areas look like lighter, individual hairs. This is used for the kangaroo on page 110.

SHORT, PATTERNED FUR

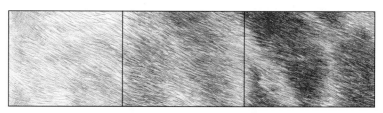

Step One Use a blunt F pencil to fill in spots with very light, solid tone. Then switch to a 2H pencil to work in a similar manner as in step one of "Short Fur," but build up dark areas by placing dark 2H strokes close together.

Step Two Now switch to an HB pencil to make short strokes that follow the direction of fur growth. In the spotted areas, keep the strokes close together; in the lighter areas, keep the strokes farther apart. Leave some paper white for highlights.

Step Three Intensify the dark spots with a sharp 2B pencil and many closely placed strokes, varying the pressure on each stroke. Build up the tone a bit more in the lighter areas with a sharp HB. This method is used for the tiger's fur on page 103.

LONG HAIR

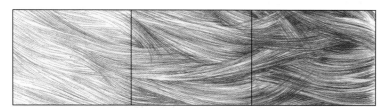

Step One Use a very sharp HB .5 mm mechanical pencil to draw a series of long, curved strokes to make a "clump" of 20 to 30 lines. Draw all the lines in a clump in the same direction and at about the same length. Each clump varies in direction and length and often overlaps another clump.

Step Two As with the short fur, use a sharp HB lead for the second layer, making your strokes more random than with the short fur. Again, leave areas of white showing through the strokes.

Step Three Switch to a 2B pencil to build up dark areas using long strokes. Create the darkest areas near the lightest lines and in areas where you want the deepest shadows. This contrast forms natural "hairs" and highlights. This method is ideal for drawing dogs with long hair.

WHITE HAIR

Step One When drawing white hair, the white of the paper does most of the work for you. You really only need to draw the shadows and the negative areas. Create the undercoat with a sharp 2H lead, but lay down strokes only in the cast shadow areas. Keep your strokes very, very light.

Step Two With a sharp HB lead, carefully create the shadows cast by the hairs, following the direction of hair growth. Don't draw too many lines, as you don't want to fill in all the white areas.

Step Three Switch to a sharp 2B to carefully create the darkest shadow areas. These contrast with the white of the paper, creating the illusion of white hair. Now use the tip of the 2H to add some light strokes to give the hair more definition. This is used in the lightest areas of the koala on page 105.

ROUGH, WRINKLED SKIN

Step One With a blunt F pencil, lay down a light, even tone. Then use a clean tortillon to blend and soften the tone, eliminating much of the "grain" of the paper. Try to keep some areas lighter and some darker so you don't create a flat tone.

Step Two Use a sharp 2H and the "scrumbling" technique (see page 103) to cover certain areas with a squiggly line that you make without lifting your pencil. This creates the illusion of a bumpy texture. Then switch to an HB to draw slightly darker horizontal lines over the squiggly lines.

Step Three Alternate between an HB and a 2B, adding more lines and scrumble lines over the first layer. This technique works well for elephant, rhinoceros, and some reptile hides. It can also be used to create leathery effects for noses and footpads if the undercoat is created with a B pencil.

REPTILE SKIN

Step One With a 2H pencil, draw a series of lines in one direction and another series of lines in the opposite direction for a diamond pattern. Use a blunt F pencil to fill in each diamond with hatchmarks. Leave a slight white outline and a highlight in the upper left corner of each diamond.

Step Two Use the 2H to stroke in the opposite direction on top of the F strokes to blend the tone. Add circular strokes with an HB in each diamond, concentrating on the lower right of each shape. Use the HB to fill in the white outline around each diamond, creating a shadow between each.

Step Three Finally, use a 2B to create the darkest shadow areas in the lower right of each diamond. Then use an HB to add circular strokes over the previous layer, evening out the tone.

DRAWING FROM PHOTOGRAPHS

Animals are always on the move, which means these captivating subjects can be challenging to draw from life. To capture a fleeting pose—as well as the lighting and mood of the moment—you may choose to work from photos. Always snap photographs from different angles and under different lighting to give yourself plenty of choices for your drawing—or use *artistic license* (the artist's prerogative to alter the photo reference) and combine several references to complete one drawing. Don't ever feel as if you have to be a slave to any given reference; artistic license allows you to alter the composition—or even the subject itself—however you please! For instance, you may use one photo as a reference for the pose, another for the texture of the fur, and your memory for the shape of the eye. It's all up to you!

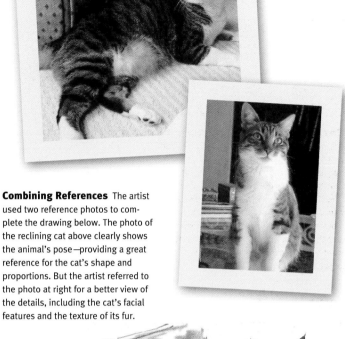

Combining References The artist used two reference photos to complete the drawing below. The photo of the reclining cat above clearly shows the animal's pose—providing a great reference for the cat's shape and proportions. But the artist referred to the photo at right for a better view of the details, including the cat's facial features and the texture of its fur.

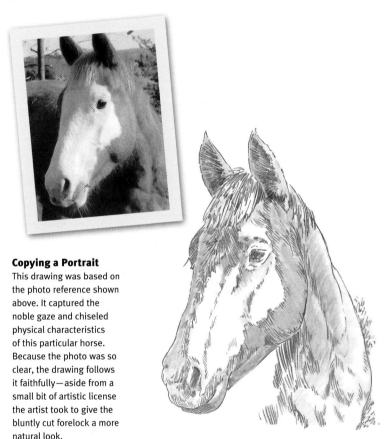

Copying a Portrait
This drawing was based on the photo reference shown above. It captured the noble gaze and chiseled physical characteristics of this particular horse. Because the photo was so clear, the drawing follows it faithfully—aside from a small bit of artistic license the artist took to give the bluntly cut forelock a more natural look.

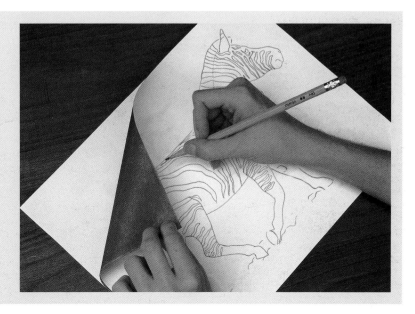

TRACING AND TRANSFERRING

Place a sheet of tracing paper on top of your photo reference and trace the major outlines of the animal. Then use *transfer paper*—thin sheets of paper that are coated on one side with an even application of graphite—to transfer the image to your drawing paper. Place the transfer paper on top of your drawing paper, graphite-side down, holding the transfer paper in place with artist's tape. Then place the tracing paper on top of the transfer paper (you may need to enlarge or reduce the image on a photocopier to fit your drawing paper) and lightly trace the lines with a pencil or a sharp object that won't leave a mark, such as a stylus or the pointed edge of the handle of a thin paintbrush. The lines will transfer to the drawing paper below.

You can purchase transfer paper at an art supply store, or you can make your own. Just cover the back of the traced image with an even layer of graphite, place the graphite side on top of the drawing paper, and lightly trace the lines of the sketch to transfer them. Check underneath the transfer paper occasionally to make sure the lines that have transferred aren't too light or too dark.

PERSPECTIVE BASICS

For a drawing to be considered realistic, it needs to give the impression that it inhabits a three-dimensional space with depth and distance. To do this, employ the rules of perspective in your drawings. The first (and most important) rule of perspective is that objects that are closest to the viewer appear larger than objects that are farther away. Here you'll find demonstrations of linear perspective (one- and two-point perspective), as well as atmospheric perspective and foreshortening. For more information, see William F. Powell's book *Perspective* (AL13) in Walter Foster's Artist's Library series.

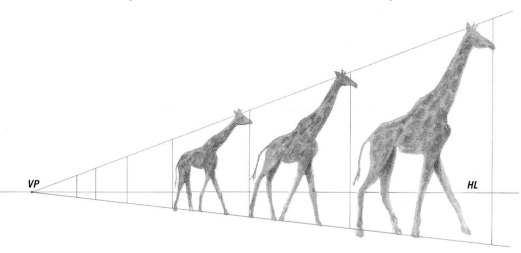

◀ **One-Point Perspective** In one-point perspective, there is only one *vanishing point* (VP), or the point at which all perspective lines converge and seem to vanish. First draw a horizontal line on your paper to represent the horizon line (HL), or eye level (meaning the height of your eyes, not where your eyes are looking). Then place a dot to the far left on the HL for the VP. Next draw a vertical line to the far right that intersects the HL at a 90-degree angle. About three-quarters of this line should be above the HL, and about one-quarter should be below it. Imagine that this vertical line is a standing giraffe. Now draw a line from the top of this giraffe to the VP, and another from the bottom of the giraffe to the VP. This V-shaped guide allows you to see exactly where the top and bottom of each successive giraffe is located.

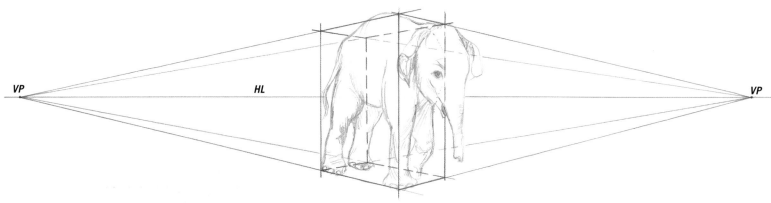

Two-Point Perspective In two-point perspective, there are two vanishing points. The best way to demonstrate this is by drawing a three-dimensional cube. First draw an HL, and place one VP on the far left and another VP on the far right. Draw a 90-degree line that bisects the HL at about the halfway point for the center "post." This line should extend above and below the HL at an equal distance. Draw lines from the top and bottom of the post that extend to each VP. Draw two more vertical lines to the left and right of the center post. These two new posts represent the corners of your cube. At the point where each corner post intersects the VP lines, draw a new line back to the opposite VP. These lines form the back edges of your cube, and the place where they intersect guides you to the position of the final back corner post, completing your cube. I sketched a baby elephant in my cube to demonstrate how animals are affected by perspective. The elephant's feet are positioned on the bottom corners of the cube, and the perspective of the VPs directly affects their positions.

▶ **Atmospheric Perspective** Another good way to create the illusion of depth and distance in your drawings is to use atmospheric perspective, which states that, due to particles in the air, objects in the distance appear less distinct and with softer edges than they would if in the foreground. So, in addition to appearing proportionately smaller than objects closer to the viewer, an object in the distance should also appear lighter in value. In this example, the artist formed adhesive putty (see page 6) into a ball and rolled it evenly over the entire dog (left) to lighten it.

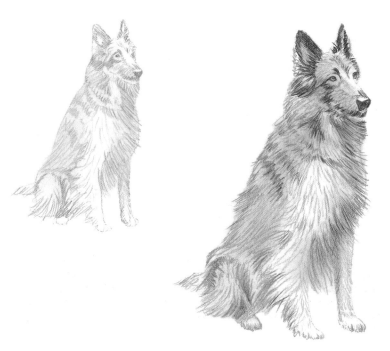

FORESHORTENING

As you learned with linear perspective, things appear smaller the farther away they become; the same is true with parts on objects. Foreshortening causes the closest part of an object to appear larger than parts that are farther away. Foreshortening pertains only to objects that are not parallel to the picture plane. Because of your viewing angle, you must shorten the lines on the sides of the nearest object to show that it recedes in the distance. For example, if you look at someone holding his arm straight down against the side of his body, the arm is perfectly vertical (and parallel to the picture plane), so it appears to be in proportion with the rest of his body. But if he raises his arm and points it directly at you, the arm is now angled (and no longer parallel to the picture plane), so it appears disproportionate to the rest of the body. (The hand looks bigger and the arm looks shorter.) So you would draw a large hand and an arm with shortened sides. That's foreshortening—now just apply those rules to the animals you draw, when necessary.

▶ **Visual Example** To see foreshortening in action, hold a dinner plate straight out in front of you. It appears as a circle. Now tilt the plate slowly away from you. The plate now appears much shorter; this shape is called an "ellipse."

▼ **Recognizing Foreshortening** This sketch of an iguana is a good example of foreshortening. Notice the difference in the size of the iguana's right foot compared to its left foot. The left foot was drawn much larger because it's closer to the viewer.

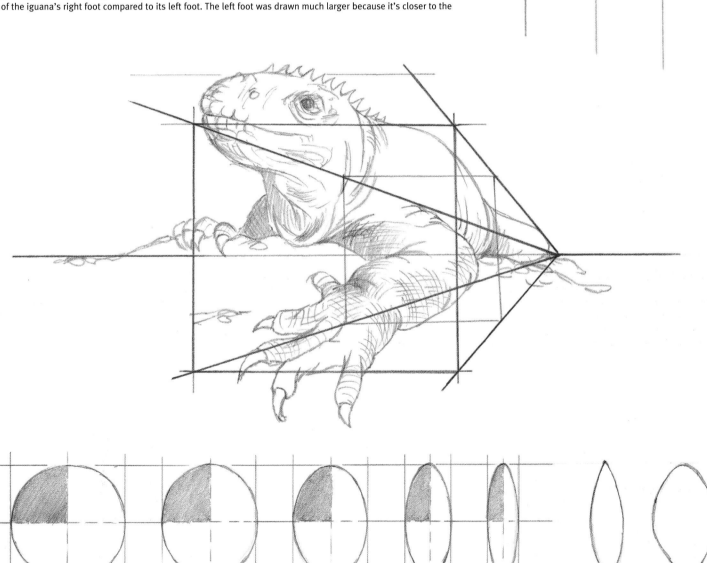

Incorrect

Drawing Ellipses An ellipse is merely a circle that has been foreshortened, as discussed above. It's important for artists to be able to correctly draw an ellipse, as it is one of the most basic shapes used in drawing. Try drawing a series of ellipses, as shown here. Start by drawing a perfect square; then bisect it with a horizontal line and a vertical line. Extend the horizontal lines created by the top and bottom of the square; also extend the center horizontal line to the far right. Create a series of rectangles that reduce in width along the horizontal line. Go back to the square and draw a curve from point to point in one of the quarters, as shown here. Repeat this same curve in the remaining quarters (turn the paper as you draw if it helps), and you will have created a perfect circle within the square. Repeat this process in each of the narrowing rectangles to produce a range of ellipses. Use this exercise whenever you have difficulty drawing a symmetrical ellipse or circle.

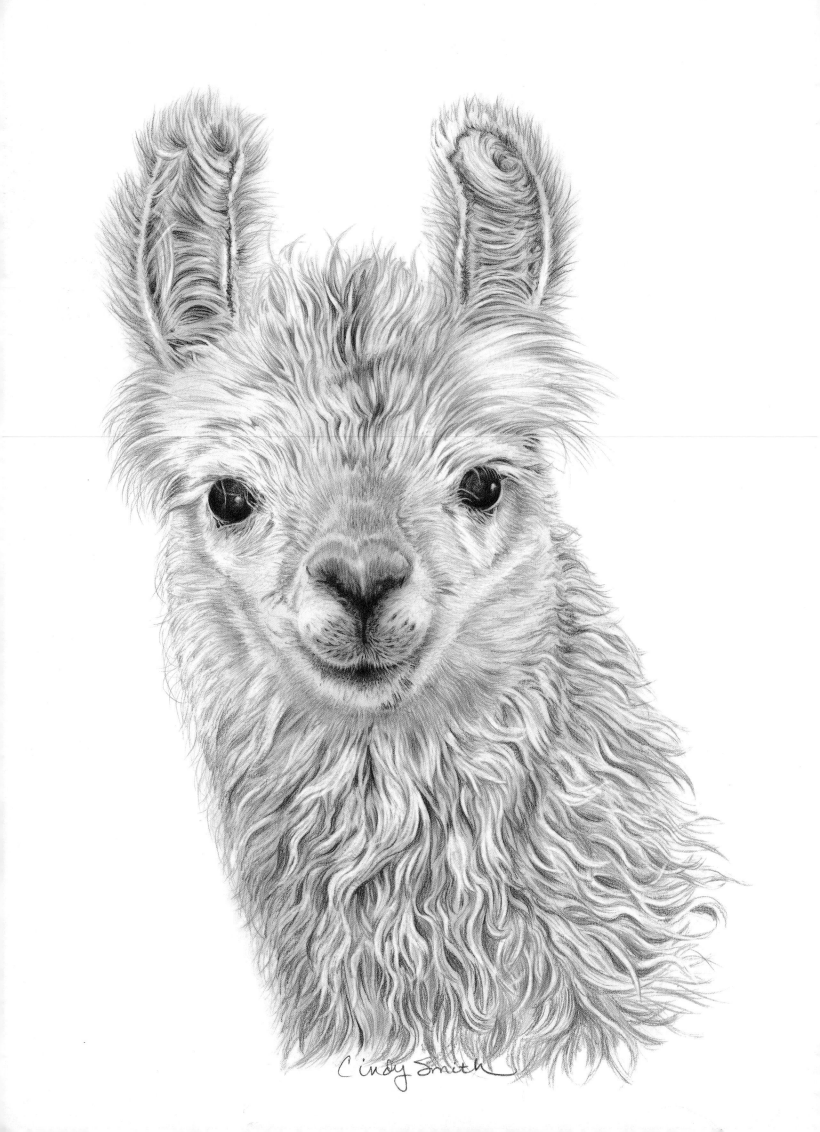

Cindy Smith

BABY ANIMALS
WITH CINDY SMITH

A native of Boise, Idaho, Cindy Smith has been producing artwork since early childhood. Although wildlife is her favorite subject, Cindy enjoys the challenge of creating remarkably realistic pencil drawings of anything—from people and buildings to flowers and automobiles. She also employs a variety of other media, such as oil, acrylic, and watercolor pencil; her collection of works even includes digital art and videos. Passionate about the great outdoors, she spends many weekends camping, fishing, and taking photo references for her art in the mountains and deserts of Idaho with her family. Some of Cindy's other hobbies are basket weaving, crocheting, cross stitching, and carving rhea eggs.

Bunny

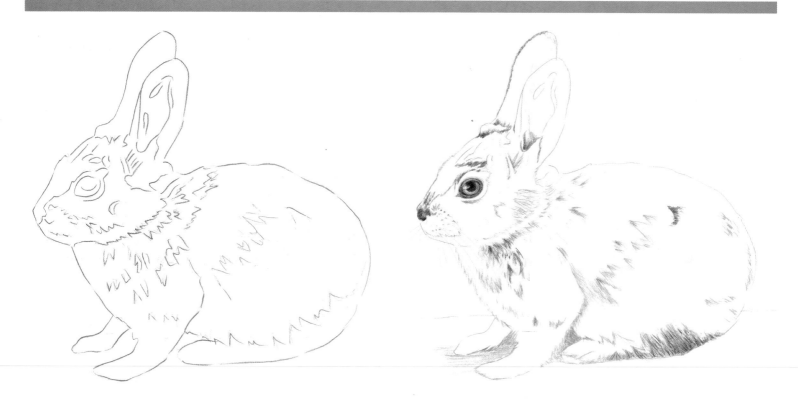

Step One I begin by using an HB pencil to sketch the bunny freehand. The basic round-ness of the bunny's head and body makes this an easy task. Then I indicate (or "map out") the areas of darkest fur.

Step Two Now I switch to a 2B pencil and start defining the eye (see "Shading the Eye" on page 19), nose, and ears. Then I use an H pencil to place the whisker markings and whiskers. I use the same pencil to begin laying down short strokes in the darkest areas of fur, as well as add the cast shadow under the bunny.

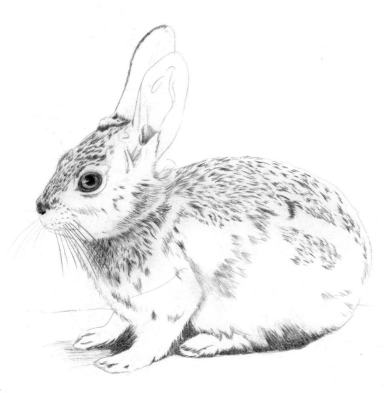

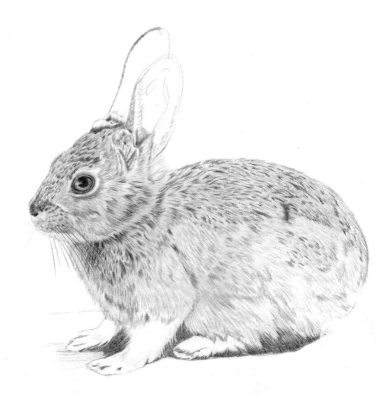

Step Three With a 4B pencil, I fill in the darkest areas of fur. I use quick, short, tapering strokes, careful to leave openings for the lighter and midtone areas of fur. I concentrate on drawing in the direction of fur growth, and I apply longer strokes for the hair around the belly. Using a large bristle brush (sometimes called a "gesso brush"), I blend the soft 4B strokes to create a soft midtone. Then I darken the whiskers, using a 2H pencil for the lighter whiskers and an H for the darker ones.

Step Four Next I fill in the midtone areas of fur on the head and body using 2B and H pencils, occasionally blending the strokes with the bristle brush. For the darker area around the nose, I use an H pencil. Then I create various V shapes throughout the fur to achieve a "clumpy" look, and I begin adding some fur to the edges of the bunny's left ear.

▶ **Step Five** I continue applying the dark and midtone fur on the feet and ears, and I use a tortillon to blend the soft, fleshy area inside the ears. I return to the pencil and go over the entire bunny, defining shadows and shapes. Then I form my kneaded eraser into a point to "draw" the lightest hairs. I also use the kneaded eraser to lift out lighter shapes in the fur on the belly, chest, and around the eyes.

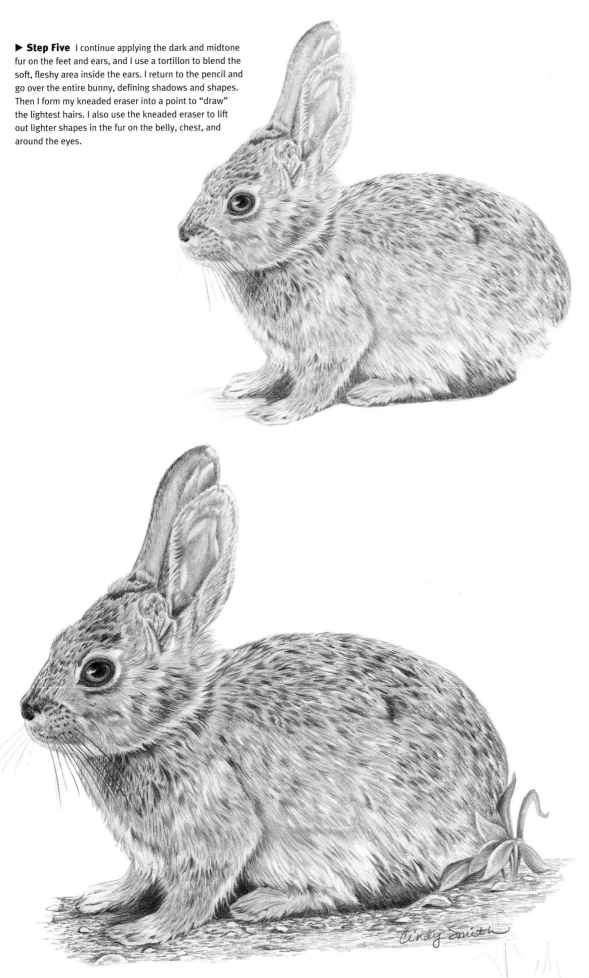

Step Six To create greater contrast, I accent all the dark and light areas in the fur. Then I add some plants and pebbles to "ground" the bunny. I build up the pebbles and sand with a 4B pencil and then use a tortillon to blend the tone. I shape a kneaded eraser into a point and use it to dab at the rocks to create highlights.

SHADING THE EYE

Step One First I use a 2B to darken the outlines of the eye and pupil. I am careful to avoid the highlight, which overlaps the iris for a more natural appearance.

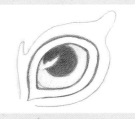

Step Two I use a 2B to fill in the iris and blend it with a tortillon; I use a 4B to fill in the pupil. I also define the rim around the eye with a 2B and blend the tone with a tortillon.

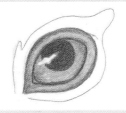

Step Three I use a 4B to soften the edges of the rim, leaving a lighter strip in the middle to give the rim a rounded look. I add a touch of light shading to each corner of the eye with a 4B. Then I add a layer of H to slightly darken the iris. I am careful to darken the iris more at the upper lid to set it back into the eyelid. Then I use my kneaded eraser to lighten the highlight. Finally, I use a 4B to make the pupil as dark as possible.

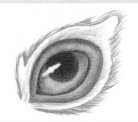

Step Four For the white areas around the rim, I use a 2B to add radiating lines; then I use the tortillon to blend them outward from the rim of the eye.

KITTEN

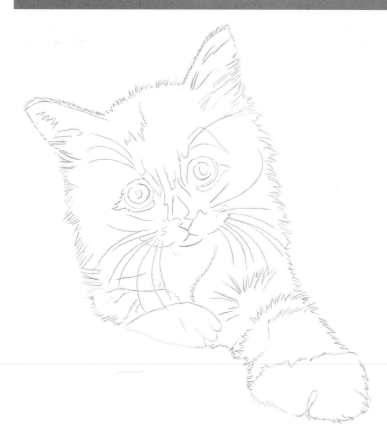

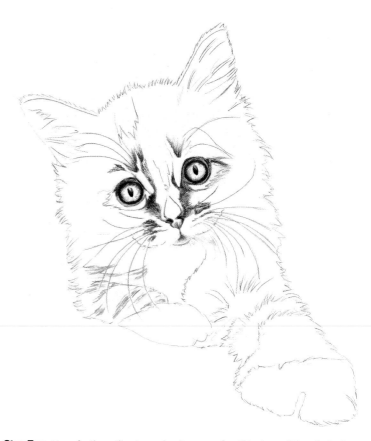

Step One I place a sheet of tracing paper on top of my reference photo and lightly trace the outline and facial features of the kitten, being careful to keep the outline light. I also outline the fur, following the direction of the hair growth. Once the outline has been established, I freehand the whiskers and the stripes in the fur.

Step Two I transfer the outline to my drawing paper (see "Tracing and Transferring" on page 13) and then begin defining the facial features, paying particular attention to the eyes, as they will be the focal point of this drawing. I reinforce the darkest areas of the face using a 2B pencil, but I am careful to leave a highlight in each eye. I want these highlights to be the lightest areas of the drawing, with the pupils being the darkest.

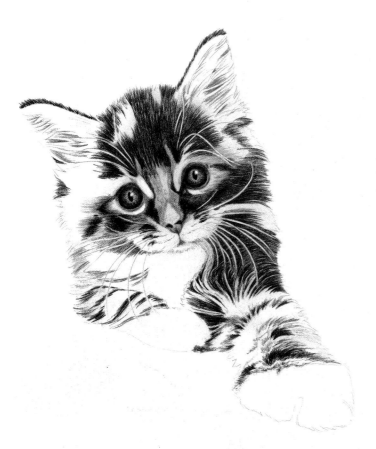

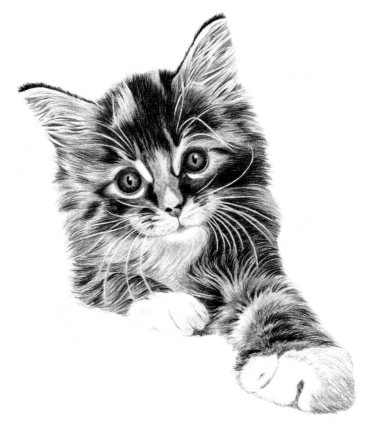

Step Three I continue shading the kitten, using a 2B pencil to emphasize the darkest areas of the fur with quick, short, tapering strokes that are lifted at the end. I create the whiskers by drawing around them (see "Negative Drawing" on page 11). Next I add tone to the eyes with an H pencil, leaving highlights in each. Then I use a tortillon to soften the irises.

Step Four I lay in the midtone areas of the fur with an H pencil and use a 2H pencil for the slightly lighter fur. Next I blend the dark areas and midtones together with the bristle brush, using a sweeping back-and-forth motion.

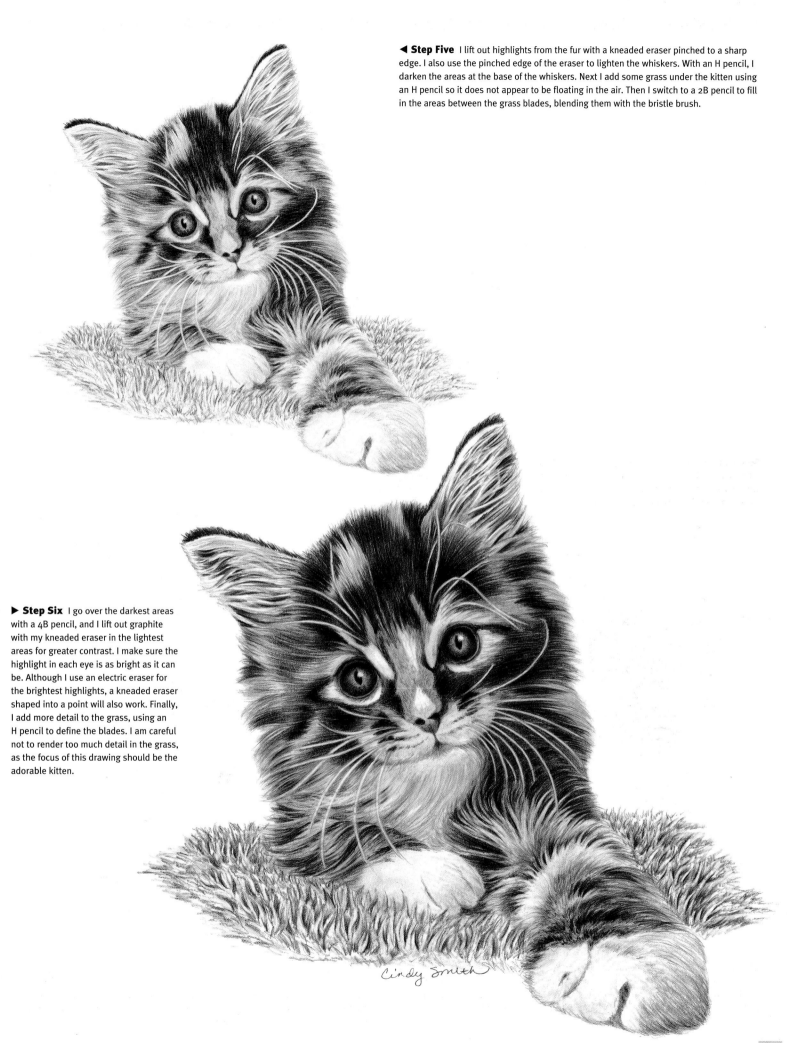

◄ Step Five I lift out highlights from the fur with a kneaded eraser pinched to a sharp edge. I also use the pinched edge of the eraser to lighten the whiskers. With an H pencil, I darken the areas at the base of the whiskers. Next I add some grass under the kitten using an H pencil so it does not appear to be floating in the air. Then I switch to a 2B pencil to fill in the areas between the grass blades, blending them with the bristle brush.

► Step Six I go over the darkest areas with a 4B pencil, and I lift out graphite with my kneaded eraser in the lightest areas for greater contrast. I make sure the highlight in each eye is as bright as it can be. Although I use an electric eraser for the brightest highlights, a kneaded eraser shaped into a point will also work. Finally, I add more detail to the grass, using an H pencil to define the blades. I am careful not to render too much detail in the grass, as the focus of this drawing should be the adorable kitten.

Cindy Smith

GOSLING

▶ **Step One** I start by placing a sheet of tracing paper over my reference photo and tracing the gosling. Then I freehand the water ripples and the rock. I am careful not to make a solid outline for the gosling. Instead, I use short, quick strokes to indicate its soft feathers. Next I transfer the outlines to a piece of drawing paper.

▶ **Step Two** With a 4B pencil, I outline the eye and fill in the pupil. Then I use a 2B to fill in the iris and blend the tone with a tortillon. I use a 2B to establish the shadow areas on the gosling, following the direction of the feathers. Next I darken the area where the gosling's body meets the water. Then I begin refining the gosling's fluff with an extremely sharp 2B pencil. I use a 2B for the darkest areas and an H for the midtones. I apply the lighter areas last with a 2H. I use sharp, quick, tapering strokes overlapping each toned area, starting with the darkest areas. I sharpen my pencil every few strokes.

▶ **Step Three** I continue rendering the fluff on the gosling's head, working in the same fashion as on the body. I use an H pencil for the subtle shadows around the eyes and on the bill. Then I go over the entire gosling, emphasizing shadows and lifting out highlights with a kneaded eraser. Using a 4B, I begin placing the darkest darks in the water and blend these with a tortillon. I also indicate the darkest areas of the rock with the 4B. Then I lift out some soft feathers along the outline of the gosling with a kneaded eraser.

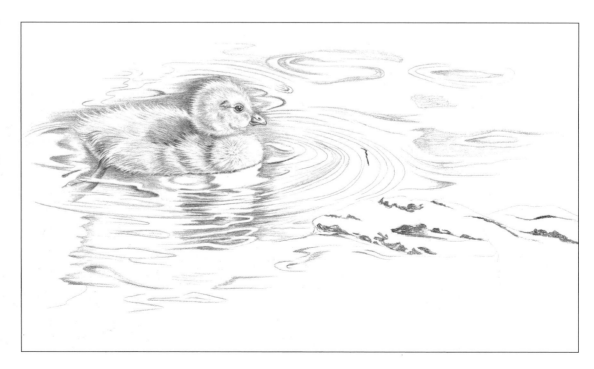

▶ **Step Four** Next I dip a tortillon in graphite powder (shavings I collect from sharpening all my pencils) and softly spread the powder (which is a combination of different grades of pencil) in the midtone areas of the water. I lift out highlights in the water using a kneaded eraser pinched to a sharp edge. Then I use a 4B to strengthen the darkest areas of the water and rock.

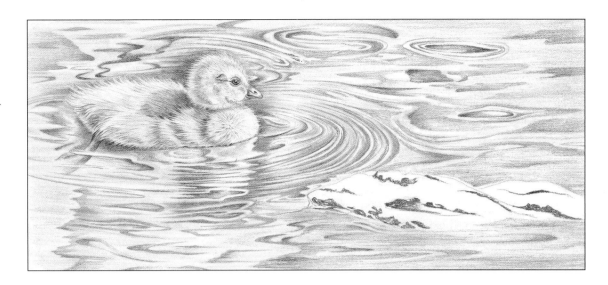

▶ **Step Five** I create the rock with the same techniques I used for the water: I use a 4B for the darkest areas, dip a tortillon in graphite powder for the midtones, and pull out highlights with a kneaded eraser.

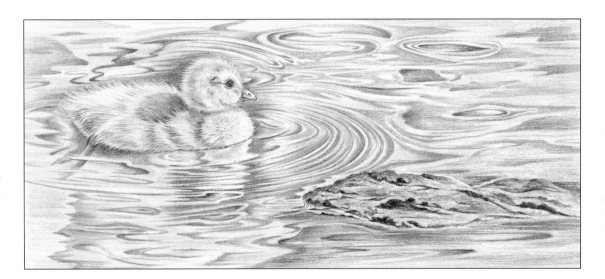

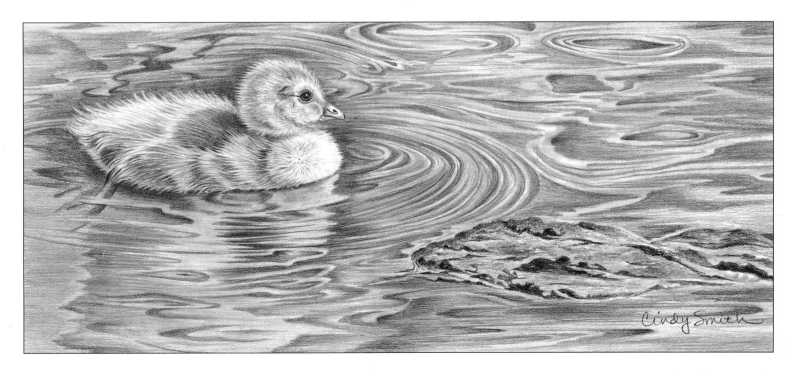

Step Six After leaving the drawing alone for a few days, I come back to it with fresh eyes. I notice that the gosling blends in with the water, so I use an H pencil to darken lighter areas of the water and a 2B pencil for deeper areas. Then I lift out some tone from the gosling's chest to create greater contrast with the water. Now I can see the gosling more clearly. It is often beneficial to come back to a piece after a few days and make any necessary adjustments.

FOAL

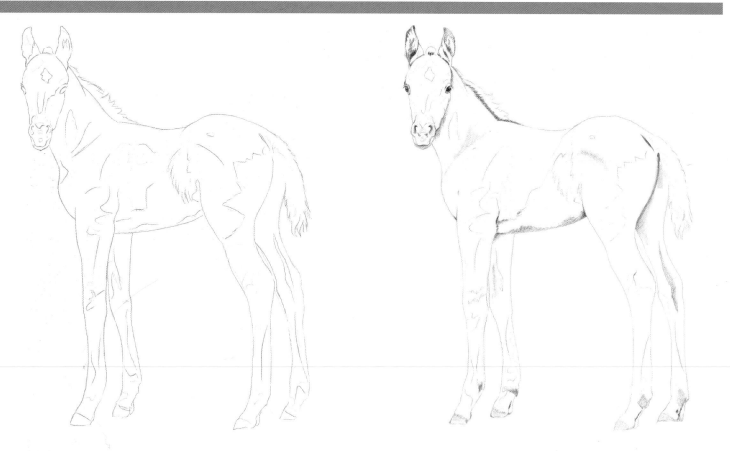

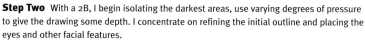

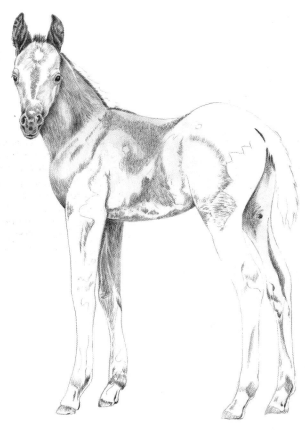

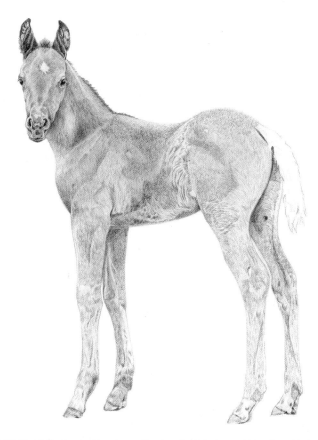

Step One Using tracing paper, I outline the foal and its facial features, and then I free-hand the identifying markings on the rest of its body. This helps me map out the light and dark values of the body. Next I transfer the outline to drawing paper.

Step Two With a 2B, I begin isolating the darkest areas, use varying degrees of pressure to give the drawing some depth. I concentrate on refining the initial outline and placing the eyes and other facial features.

Step Three Next I darken the eyes, nostrils, and ears with a 4B. I use a 2B for the muzzle and start the head and neck with the same pencil. I blend the muzzle with a tortillon to make it appear smooth. On the neck, I use short, quick, tapering strokes and blend with the bristle brush. I fill in the darker areas of the body and legs with a 4B. Using the "map" from step one as a guide, I follow the direction of hair growth. I vary my strokes for the different types of hair; some strokes are short and tapered, whereas some are more of a scribble.

Step Four I finish the head with a sharp 2B, using short strokes and blending with the bristle brush. Then I apply the midtone areas of the body and legs using a 2B. I continue varying the types and directions of my strokes, blocking in the patterns and hair types. Then I blend the tone with a tortillon.

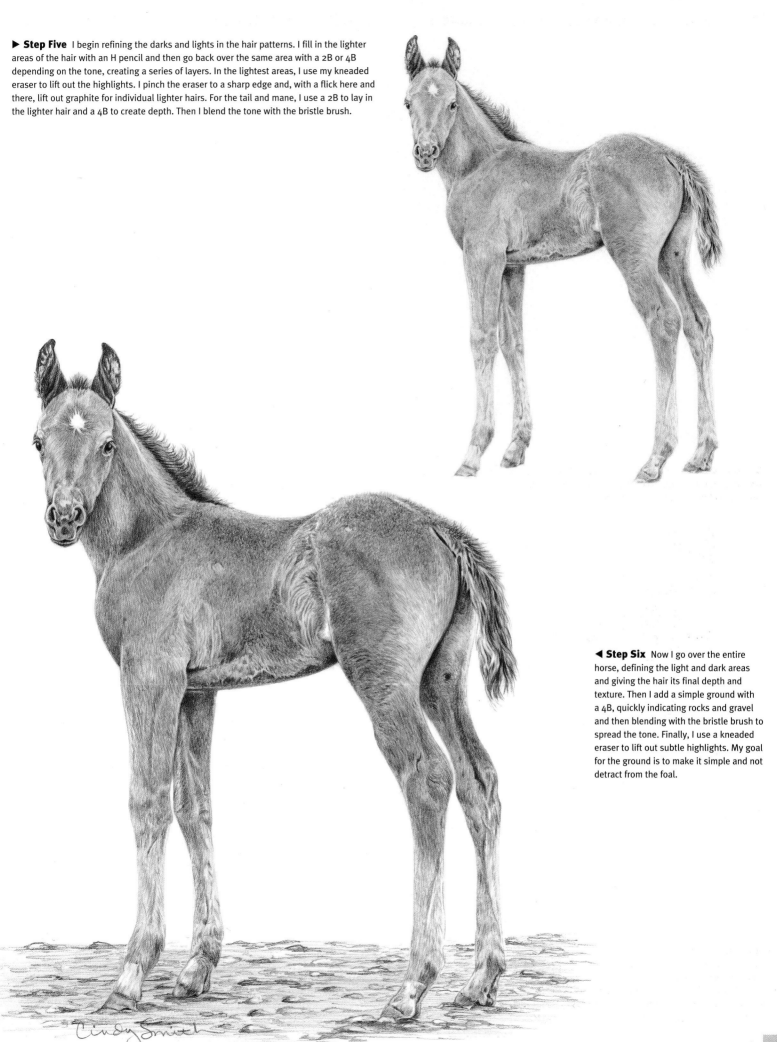

▶ **Step Five** I begin refining the darks and lights in the hair patterns. I fill in the lighter areas of the hair with an H pencil and then go back over the same area with a 2B or 4B depending on the tone, creating a series of layers. In the lightest areas, I use my kneaded eraser to lift out the highlights. I pinch the eraser to a sharp edge and, with a flick here and there, lift out graphite for individual lighter hairs. For the tail and mane, I use a 2B to lay in the lighter hair and a 4B to create depth. Then I blend the tone with the bristle brush.

◀ **Step Six** Now I go over the entire horse, defining the light and dark areas and giving the hair its final depth and texture. Then I add a simple ground with a 4B, quickly indicating rocks and gravel and then blending with the bristle brush to spread the tone. Finally, I use a kneaded eraser to lift out subtle highlights. My goal for the ground is to make it simple and not detract from the foal.

DOBERMAN PUPPY

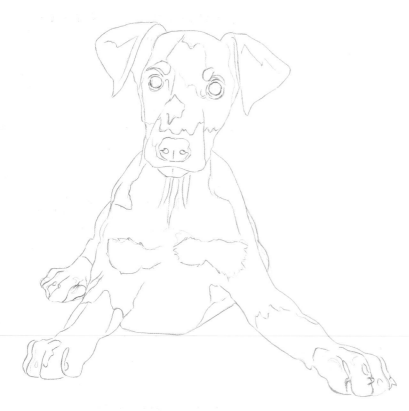

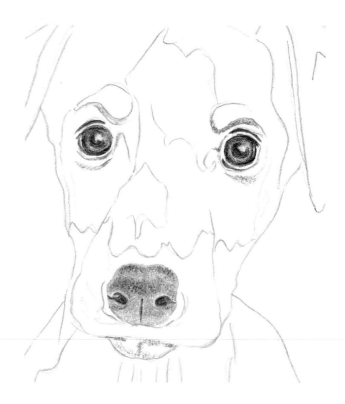

Step One To begin this drawing, I place a sheet of tracing paper on top of my reference photo and lightly trace the outline and facial features of the puppy. I also map out the major value areas, such as the patches of light fur on the chest and paws, as well as the light eyebrows. Then I transfer the outline to drawing paper.

Step Two Starting with the eyes, I outline and darken the pupils with a 4B. Then I fill in the iris with a 2B, smoothing the tone with a tortillon to achieve a glossy look. I use the same 2B to begin creating the bumpy texture on the nose, being careful to leave the top and front of the nose lighter to help create the form. Then I use a 4B to darken the nostrils. (See "Drawing the Nose and Muzzle" on page 27 for more information.)

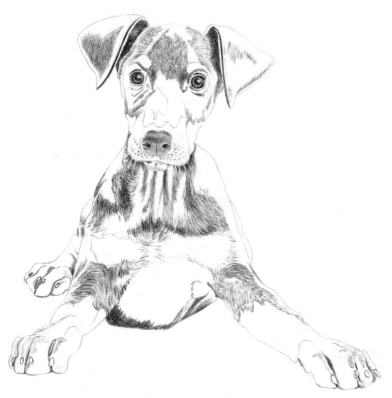

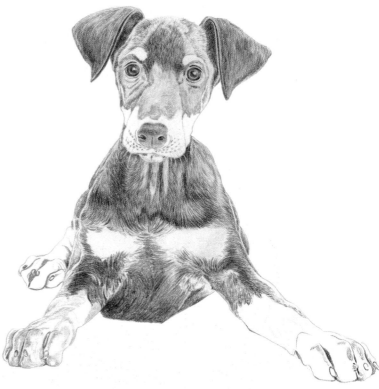

Step Three Using a 4B pencil, I add long, linear strokes to the darkest areas of the ears, face, paws, and body. As I draw, I make sure my lines follow the direction of the hair growth, noting where the hair swirls and changes direction (mostly on the chest and upper areas of the front legs). With a 2B pencil, I re-outline the claws, and I add small dots on the muzzle to indicate the whisker markings. To create the whiskers that hang down from the muzzle, I simply draw around these areas when shading the upper chest.

Step Four I continue to build up the darkest areas on the chest, shoulders, and face with the 4B pencil, placing more pressure on the pencil for darker areas and using less pressure for lighter areas. I avoid adding tone to the light areas I established in my initial sketch.

▶ Step Five Next I use a rounded 2B pencil and create the lighter tones in the areas I had previously avoided: the legs, paws, chest, muzzle, and eyebrows. I use the same pencil to further shade the upper part of the face, adding two or three layers of graphite for a darker tone. For areas in shadow, I blend the tone with a tortillon.

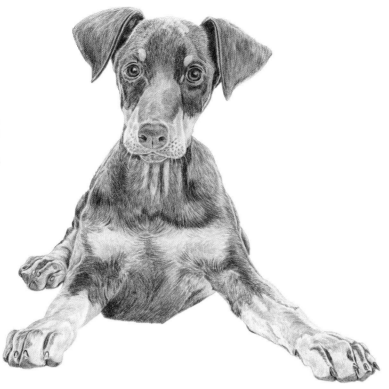

DRAWING THE NOSE AND MUZZLE

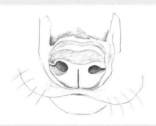

Step One I start by sketching the shape of the nose and muzzle, including the whiskers and the vertical crease through the middle of the nose. Then I use a 2B pencil to indicate the main areas of shadow.

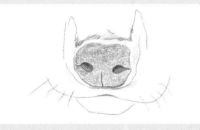

Step Two I use a dull 2B to cover the nose with small circular strokes. Note that I shorten the vertical crease a bit at this stage.

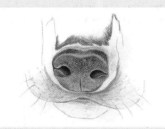

Step Three I add another layer of circular strokes in the midtone areas. Then I switch to a 4B and add more circular strokes to the upper part of the nose, being careful not to create any solid areas of graphite. These harsh separations between light and dark give the nose a wet appearance. To add tone to the muzzle area, I use an H pencil and a light touch. Then I add small dots to indicate the whisker markings.

Step Four Now I make the dark areas even darker with the 4B pencil. I darken the upper area in the nostrils, leaving the outer edges lighter. Then I use small, tight circular strokes on the front of the nose and larger circular strokes on the dark strip above the nose. I lift out tone in areas with a kneaded eraser for highlights. I add more tone to the muzzle with the H pencil, and I further define the whiskers and whisker markings. Then I feather short strokes from the top of the nose up onto the bridge.

◀ Step Six Now I use a 4B to further darken the body, upper part of the face, ears, and upper part of the front legs. Where needed, such as along the edges of the front legs and shoulders, I lift out tone with a kneaded eraser to create highlights. Returning to the eyes, I make the pupils as dark as possible, lifting out a highlight in each when finished. I also add more tone to the top of the nose and nostrils. As a final touch, I use a 2H to shade lightly under the pup's chest and front legs, and I blend the tone with a tortillon.

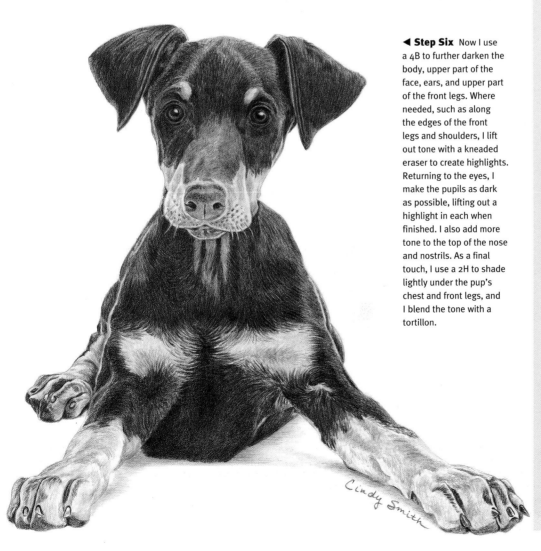

Cindy Smith

BEAR CUB

▶ **Step One** I outline the basic shape and facial features of the cub using tracing paper. Then I free-hand sketch the tree and the identifying marks of the cub. Now I transfer the outlines to a piece of drawing paper.

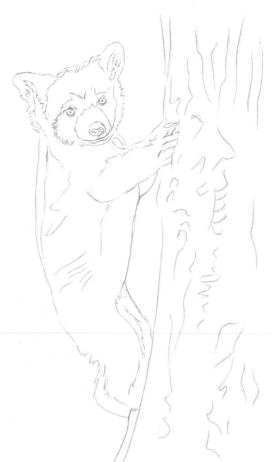

▶ **Step Two** I begin the eyes by outlining them with a 4B. I use a 2B for the iris, being careful to leave highlights, and then I blend with a tortillon. I use an H pencil to identify the area around the eyes and a 4B pencil for the nostrils. Using circular strokes, I fill in the rest of the nose with a 2B. I use my 4B with short, tapering strokes on the ears, and I add the darkest areas on the paws, back leg, and parts of the tree. Then I use the bristle brush to blend the graphite.

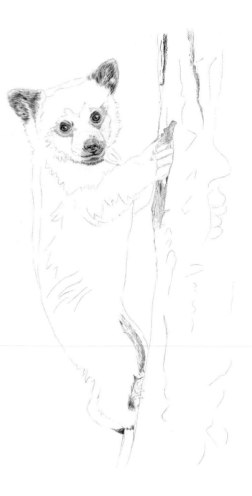

▶ **Step Three** I continue working on the head with a 2B, using short, tapering strokes that follow the direction of hair growth. Then I take my 4B and go back over the head, adding darker strokes for depth. Next I blend the tones together with the bristle brush. I use a 2B and an H for the muzzle and lighter areas of the face. Then I use a 2B to start identifying the darker areas of the fur, such as under the arms, under the chin, on the back leg, and between the toes. For the longer, darker fur I use a 4B with tapering strokes; for the fuzzier fur (such as under the chin), I use a dull 4B and a scribbling motion.

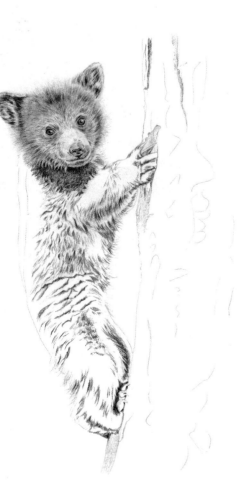

▶ **Step Four** Now I use a very sharp 2B to lay in some midtones on the cub's body with short, tapering strokes. I spread the tone often with the bristle brush. Then I use a kneaded eraser to pull out tone for the lightest areas of fur.

▶ **Step Five** Next I go back and reinforce my previous work with a 2B pencil, adding more strokes for depth in the midtone areas. Then I use a 4B to define the darkest darks. I am careful to vary my strokes, as some areas of the cub's fur are wavy or matted rather than straight.

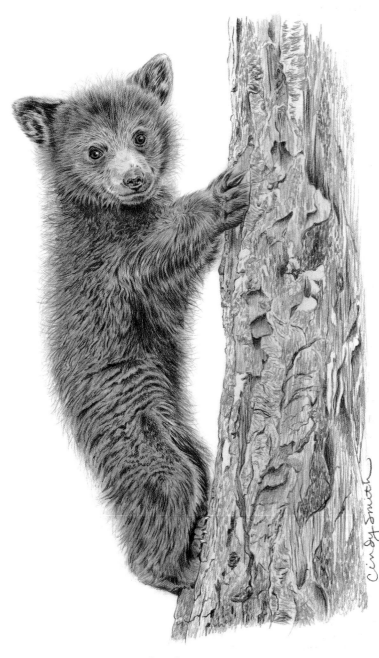

▶ **Step Six** I continue adding depth to the cub by filling in the darker areas with a 4B and using a 2B to fill in more of the midtone areas. I build up several layers to make the fur appear more dense. Now I start developing the tree by identifying the dark crevices with a 4B. I use my tortillon to spread and blend the tone. Using H, 2B, and 4B pencils and a sequence of light and dark scribbles, I create the textures of the bark.

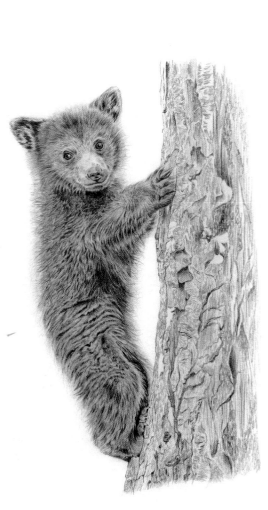

▲ **Step Seven** To finish, I emphasize all the darks with a 4B and lift out highlights where needed. I take a step back and view the drawing from a distance—when I'm pleased with the dark values and light patches of fur, I sign my drawing.

Kitten & Butterfly

▶ **Step One** I start by tracing the outline of the kitten, including the facial features. This kitten is looking up at a butterfly, which I'll add in step 6. I freehand the markings on the kitten's body, and then I transfer the outlines to drawing paper.

▶ **Step Two** I outline the kitten's eyes with a 4B and fill in the pupils, leaving a highlight in each. Then I use a 2B for the iris and blend the tone with a tortillon to achieve a smooth, glassy look. I fill in the nose with a 2B and circular strokes, and I darken the nostril with a 4B. Then I use the 2B to start defining the dark stripes on the head.

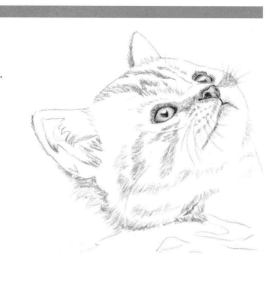

▶ **Step Three** With a 4B, I fill in the dark shadows in the ears. I use my kneaded eraser pinched to a sharp edge for the long hair inside the ears. I don't need to draw every hair, as the viewer's eye will fill in what is missing. Next I use a 2H to draw the light hair on the face, avoiding the whiskers. I also darken the stripes on the head. To emphasize the whiskers, I lighten them with my kneaded eraser. Then I begin the stripes on the kitten's body by stroking with a 2B.

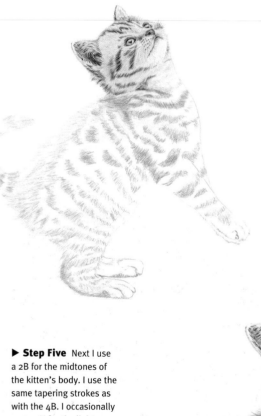

▶ **Step Four** Now I darken and refine the dark stripes. I use a sharp 4B with tapering strokes in the direction of hair growth, being careful to leave spaces for individual white hairs. Then I use a 2B for the midtones in the neck area, also leaving spaces for lighter hairs.

▶ **Step Five** Next I use a 2B for the midtones of the kitten's body. I use the same tapering strokes as with the 4B. I occasionally use an H for the lighter hair, such as in the chest area, and a 2B for the longer hair on top of the back. I continue to leave spaces for the lightest hairs. Once all the fur has been laid in, I go back with a 4B and blend the darks with longer, smoother strokes.

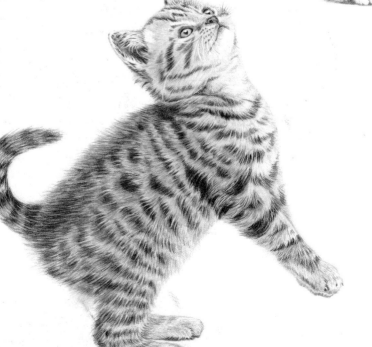

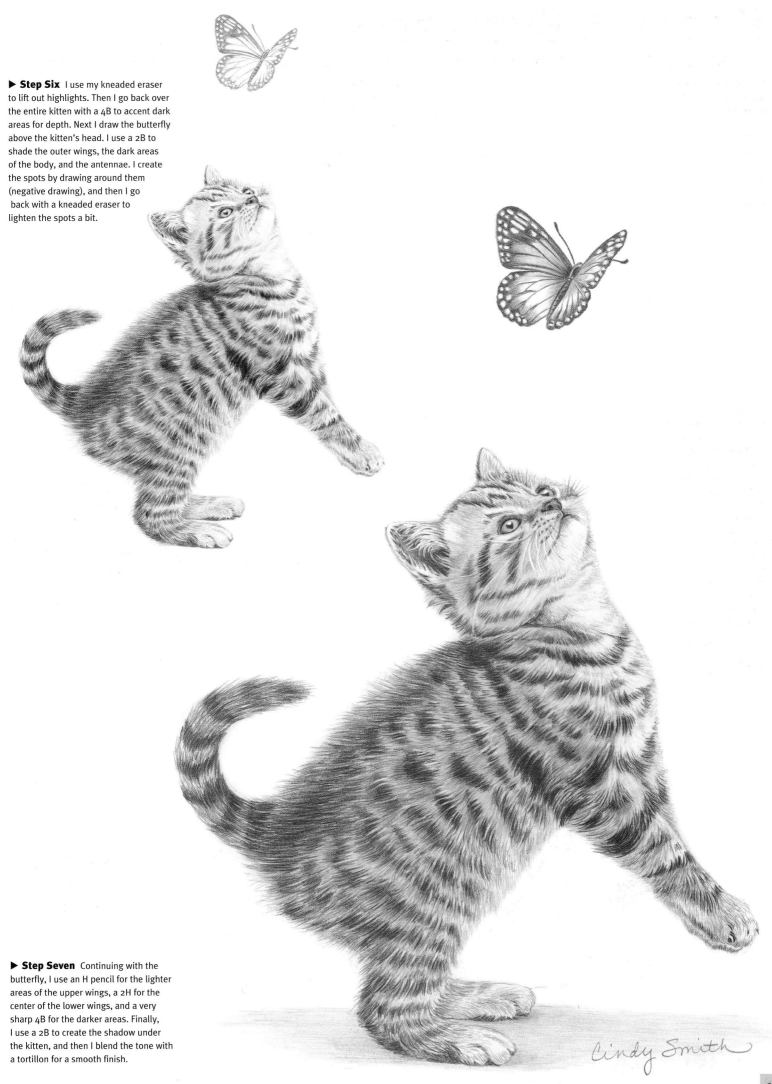

▶ **Step Six** I use my kneaded eraser to lift out highlights. Then I go back over the entire kitten with a 4B to accent dark areas for depth. Next I draw the butterfly above the kitten's head. I use a 2B to shade the outer wings, the dark areas of the body, and the antennae. I create the spots by drawing around them (negative drawing), and then I go back with a kneaded eraser to lighten the spots a bit.

▶ **Step Seven** Continuing with the butterfly, I use an H pencil for the lighter areas of the upper wings, a 2H for the center of the lower wings, and a very sharp 4B for the darker areas. Finally, I use a 2B to create the shadow under the kitten, and then I blend the tone with a tortillon for a smooth finish.

Cindy Smith

Fawn

Step One I begin by using tracing paper to create the basic outline of the fawn, including the facial features. After I freehand the identifying markings and map out the values, I transfer the outline to drawing paper.

Step Two I fill in the pupils with a 4B and use a 2B for the outline around the eye, which I blend with a tortillon. Then I fill in the nostrils with a 4B and shade the top of the nose with a 2B, using circular strokes for texture. Next I use my 2B to start defining darker areas on the rest of the fawn.

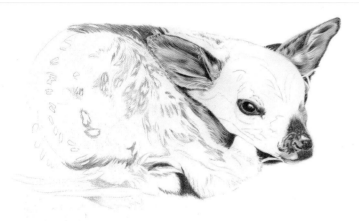

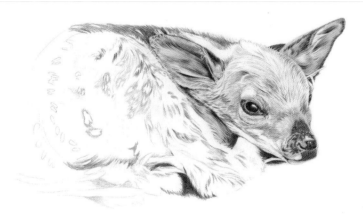

Step Three I continue to emphasize darker areas of the fawn with a 2B and a fairly light touch, so I can go back later and make any necessary corrections. I work on the ears, using an H pencil and tapering strokes for lighter areas, a 2B for the midtones, and a 4B for the darkest areas. Then I blend the tone with the bristle brush.

Step Four Now I turn my attention to the fawn's head. First I lay in the darker, deeper hairs with a 2B pencil. I use long, tapering strokes and am careful to follow the direction of fur growth.

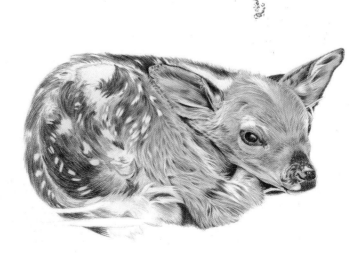

Step Five For the lighter midtones on the head, I use a 2H pencil and the same long, tapering strokes that I used for the darker tones. Then I work on the foreleg and lighter areas of the body using the same techniques that I did with the head, adding depth with a 4B pencil.

Step Six I begin developing the dark areas on the fawn's back with a 4B, using long, tapering strokes. I leave some areas light for now, as I'll come back to them later. At this point, I concentrate more on following the direction of hair growth than perfecting these dark areas.

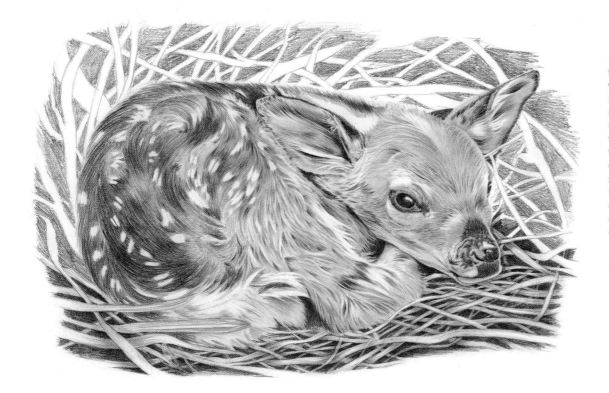

◄ Step Seven Now I use a 2B pencil to fill in some of the areas on the back that were previously left white. Then I use an H pencil to start creating the background reeds. I fill in the spaces between the reeds with a 4B pencil, spreading the tone with the bristle brush. (You can see the basic outlines for the reeds at the top of this drawing.) Next I use a 2B to add shadows to the reeds that are overlapped by other reeds. I lift out highlights in the overlapping reeds and create the curved edges of the "frame" with my kneaded eraser.

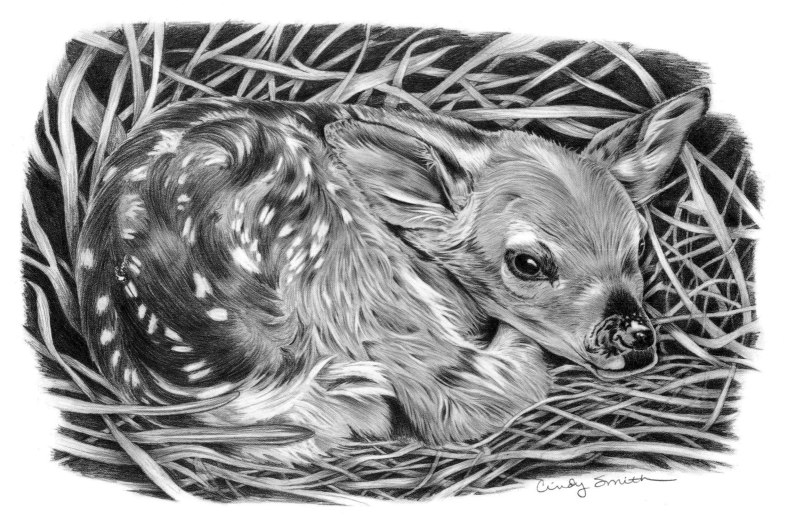

Step Eight I continue shading the reeds and the spaces between the reeds—I want the background to be subtle so it doesn't detract from the fawn, yet I still want it to seem like a natural camouflage for its coat. Finally, I use a 4B to darken all the darks, and I pull out highlights with a kneaded eraser to create more contrast.

Lion Cub

◄ Step One I trace the outline of the lion cub, as well as the facial features and the darkest markings of the fur. Then I transfer the drawing to another piece of paper.

► Step Two Starting with the eyes, I use a 4B to fill in the pupils and outline the eyes. I shade the darker parts of the iris with a 2B and blend the tone into the lighter areas of the iris with a tortillon. Next I use a 4B for the mouth and nostrils; I use a 2B and circular strokes for the tip of the nose. Then I work from the area below the eyes up to the forehead, establishing the dark, medium, and light tones for the rest of the cub's fur. I lay down the darks first with short, quick, tapering strokes. For the midtones, I use a 2B and longer strokes, occasionally blending with the bristle brush.

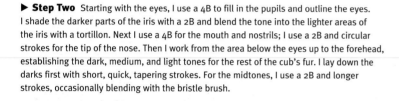

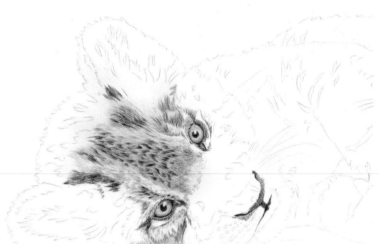

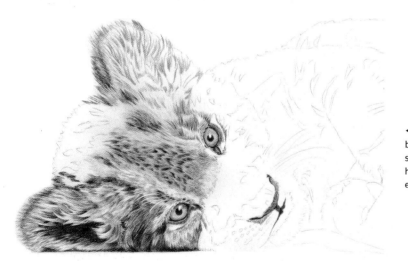

◄ Step Three I use a 4B to fill in the dark inner ear, and then I switch to a 2B pencil to begin the midtone tufts of hair on the head. I periodically use the bristle brush to blend and spread the tone. I use my kneaded eraser pinched to a sharp edge and "draw" the lighter hairs, which lifts out the tone I applied with the bristle brush. By looking at the cub's left ear, you can see how I lay in the patterns of the fur before adding the darker areas.

► Step Four I work down the bridge of the nose with a dull 4B, laying in the darker areas with short strokes. I also use the 4B for the dark areas at the base of the whiskers and below the mouth. I lay in the midtones with a 2B, establishing the various tones of the fur on either side of the nose.

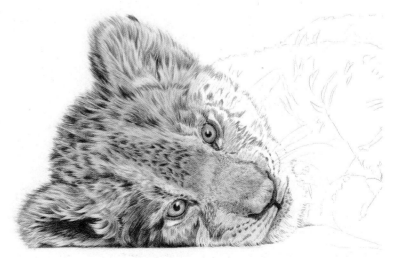

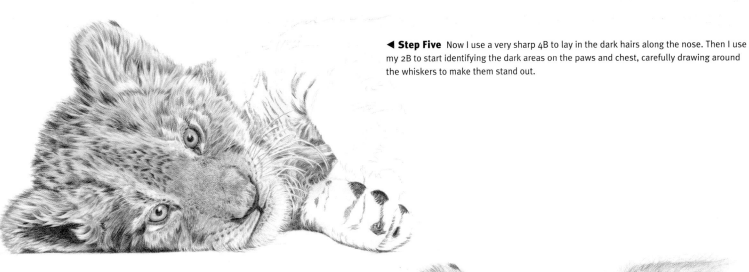

◄ **Step Five** Now I use a very sharp 4B to lay in the dark hairs along the nose. Then I use my 2B to start identifying the dark areas on the paws and chest, carefully drawing around the whiskers to make them stand out.

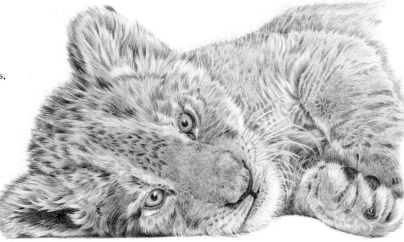

▶ **Step Six** Now I work on the rest of the cub's body. I use a dull 2B for the midtones, following the direction of fur growth. For the shorter hair on the leg, I use a scribbling motion and then blend with a tortillon. I use a 4B for the darkest darks. Then I lift out highlights and the small hairs on the paws with a kneaded eraser.

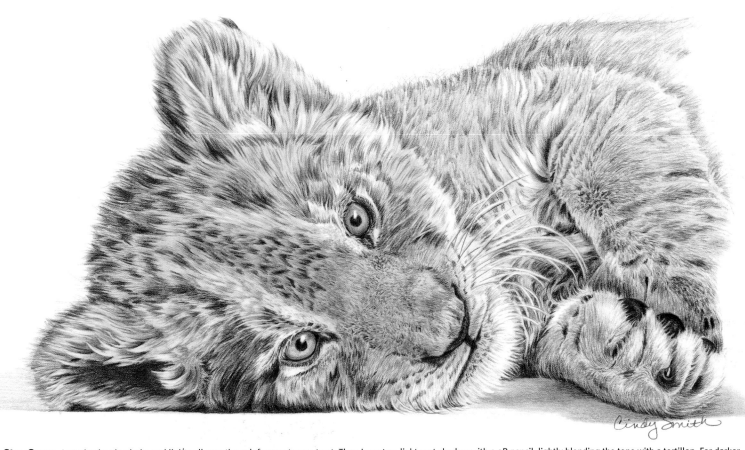

Step Seven I emphasize the darks and lights all over the cub for greater contrast. Then I create a light cast shadow with a 2B pencil, lightly blending the tone with a tortillon. For darker shadows, I add another layer of tone in the same manner. Now my drawing is complete!

YORKIE PUPPY

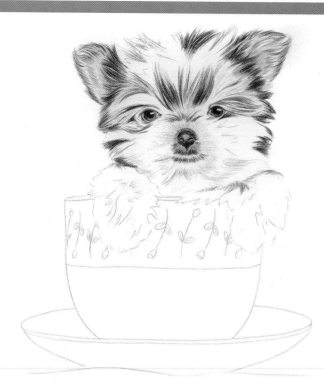

Step One I trace the major outlines of this adorable Yorkie puppy and the teacup using tracing paper. Then I freehand the whiskers and fur markings of the dog and transfer the drawing to another piece of paper.

Step Two I begin shading by outlining the eyes and lightly filling in the irises with a 4B pencil, blending the tone in the irises with a tortillon. I also fill in the pupils, using heavier pressure and leaving a highlight in each. I shade the nose with circular strokes and a 4B pencil, and I create the dark area under the nose with a 2B. I start establishing the darker areas of the head with a 4B, creating some midtones by blending the tone with the bristle brush. Then I use a 2B and long, tapering strokes for the midtones of the ears; I blend the tone inside the ears with a tortillon to make it look like skin.

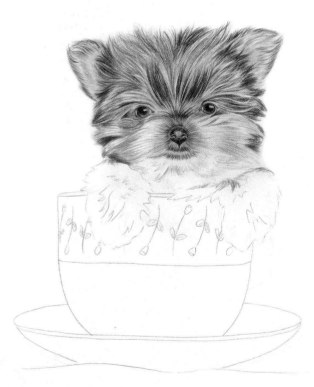

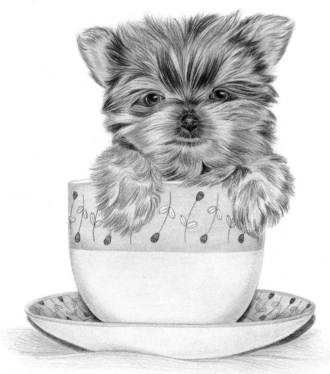

Step Three I continue working on the head, alternating between an H and a 2B for the lighter and midtone areas, respectively. I use long, tapering strokes, being careful to follow the direction of the hair. I periodically "draw" lighter hairs by lifting out tone with my kneaded eraser pinched to a sharp edge, and I use a 4B to add a few darker hairs throughout for depth. I also draw darker individual hairs over the lighter hairs in various directions for a more natural appearance. Then I start on the whiskers at the sides of the nose with an H pencil.

Step Four Next I use a 4B to darken the darks, bringing out the highlighted hair. I continue lifting out lighter hairs with my pinched eraser, and I periodically blend and spread the tone with the bristle brush. I start laying in the darker areas of the paws with a 2B, leaving white areas for the lighter hairs. I switch to working on the teacup before finishing the paws so I can make the paws overlap the teacup. I use an H pencil to cover the entire cup with long, even strokes that are close together. I add another layer of H pencil for the darker areas of the cup and saucer. I continue defining the darks of the teacup and saucer with a sharp 2B pencil. I use a 4B for the outline and stems of the flowers and a 2B for the darkest flowers. Then I use a 2B to add dark shading to the outer edges of the cup and saucer, achieving a rounded look. Next I create the darks of the paws with a 4B pencil.

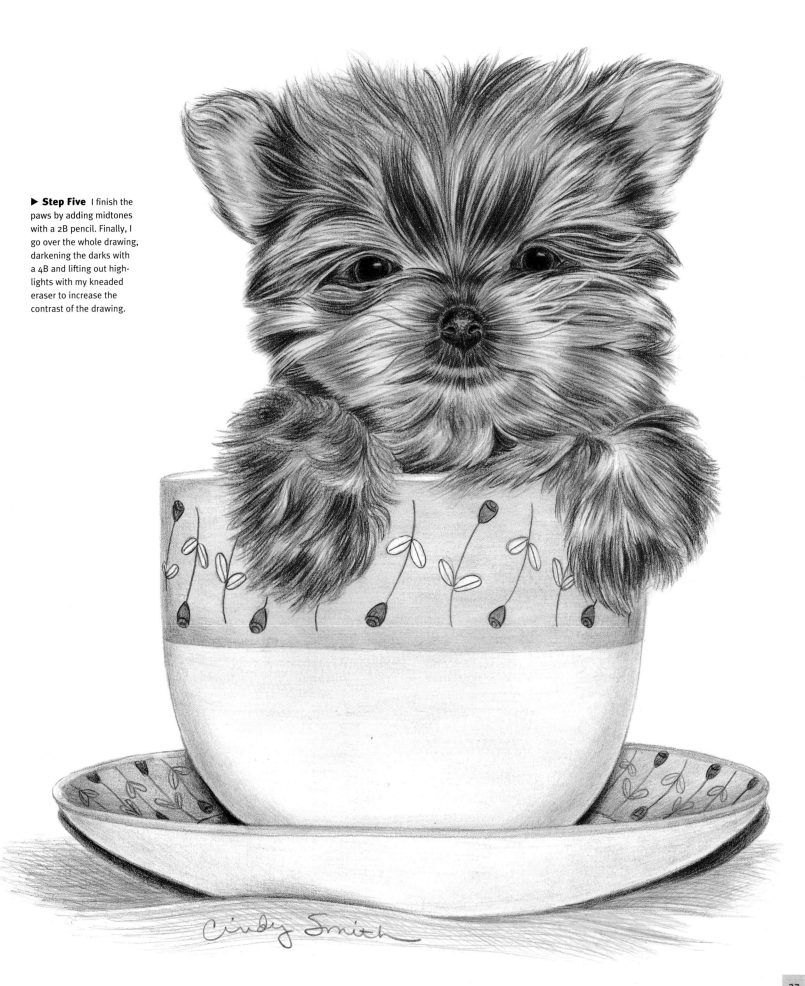

▶ **Step Five** I finish the paws by adding midtones with a 2B pencil. Finally, I go over the whole drawing, darkening the darks with a 4B and lifting out highlights with my kneaded eraser to increase the contrast of the drawing.

LAMB

▶ Step One I begin by using tracing paper to create the outline of the lamb's body and facial features. Then I freehand the light and dark areas of the wool, using loose, bumpy lines rather than hard, straight lines. I also freehand the blades of grass. Now I transfer the outlines to drawing paper.

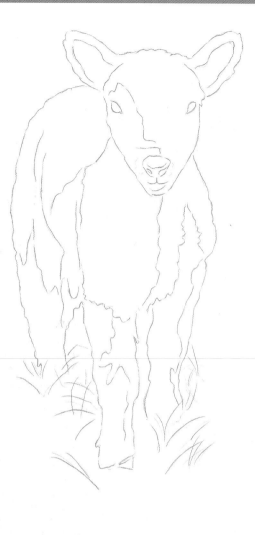

▶ Step Two I use a 4B to create the darkest areas of the eyes, nose, and mouth. Then I blend the eyes with a tortillon. I create small, circular strokes to create texture on the nose, using a 4B for the darker areas and a 2H for the lighter areas.

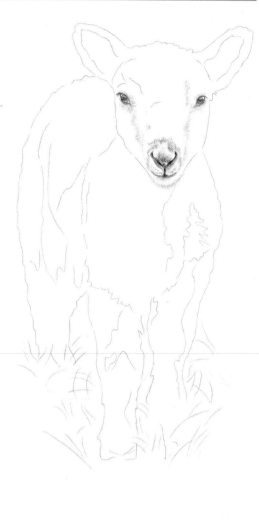

▶ Step Three I use a dull 4B with soft, loose, circular strokes to begin establishing the darks and shadowed areas of the wool. I use closer, tighter, circular strokes for the darker areas of wool and loose, light strokes for the lighter areas. Then I blend and soften my strokes with a tortillon.

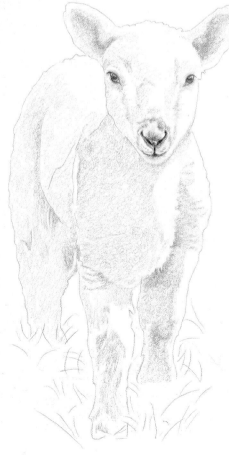

▶ Step Four I continue working on the wool with 2B and 4B pencils. I blend the tone over the forms of the body (such as the belly and chest) with a tortillon, and then I use the bristle brush to spread light tone all over the wool. Then I create deeper areas in the wool with a 2B.

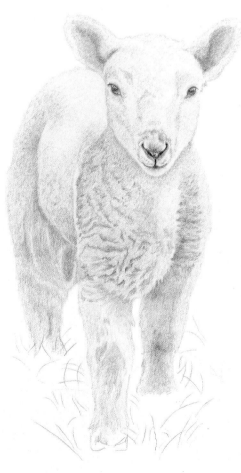

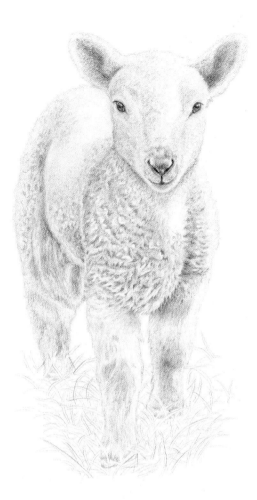

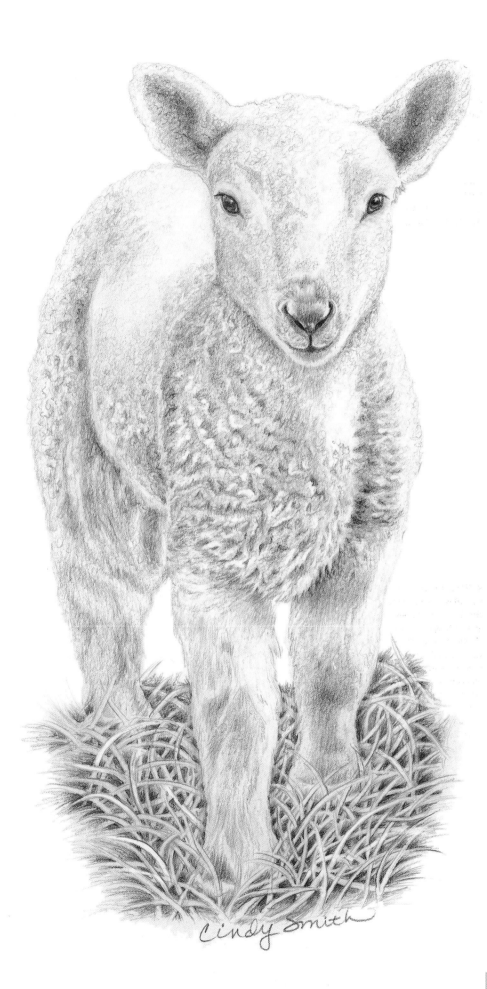

▲ Step Five I use my kneaded eraser to lift out highlights in the wool. Then I go back with my 4B pencil to reinforce the dark areas of the eyes, nose, and mouth. I use a 2B to emphasize the dark areas of the wool. Then I begin the grass by sketching the blades with a 2H pencil.

▶ Step Six I use a 2B to fill in the spaces between the blades of grass; then I add tone to the blades with the bristle brush and reinforce the shadows with a 2B pencil. As a final touch, I lift out highlights on some of the blades using a kneaded eraser.

Cindy Smith

Giraffe Calf

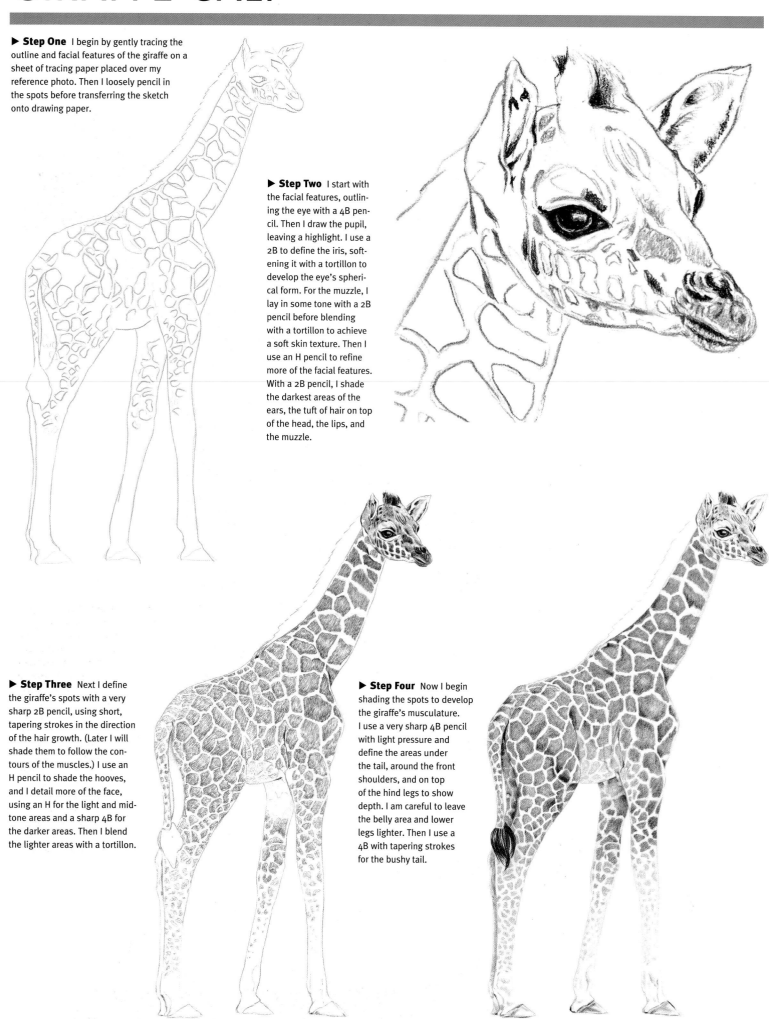

▶ **Step One** I begin by gently tracing the outline and facial features of the giraffe on a sheet of tracing paper placed over my reference photo. Then I loosely pencil in the spots before transferring the sketch onto drawing paper.

▶ **Step Two** I start with the facial features, outlining the eye with a 4B pencil. Then I draw the pupil, leaving a highlight. I use a 2B to define the iris, softening it with a tortillon to develop the eye's spherical form. For the muzzle, I lay in some tone with a 2B pencil before blending with a tortillon to achieve a soft skin texture. Then I use an H pencil to refine more of the facial features. With a 2B pencil, I shade the darkest areas of the ears, the tuft of hair on top of the head, the lips, and the muzzle.

▶ **Step Three** Next I define the giraffe's spots with a very sharp 2B pencil, using short, tapering strokes in the direction of the hair growth. (Later I will shade them to follow the contours of the muscles.) I use an H pencil to shade the hooves, and I detail more of the face, using an H for the light and midtone areas and a sharp 4B for the darker areas. Then I blend the lighter areas with a tortillon.

▶ **Step Four** Now I begin shading the spots to develop the giraffe's musculature. I use a very sharp 4B pencil with light pressure and define the areas under the tail, around the front shoulders, and on top of the hind legs to show depth. I am careful to leave the belly area and lower legs lighter. Then I use a 4B with tapering strokes for the bushy tail.

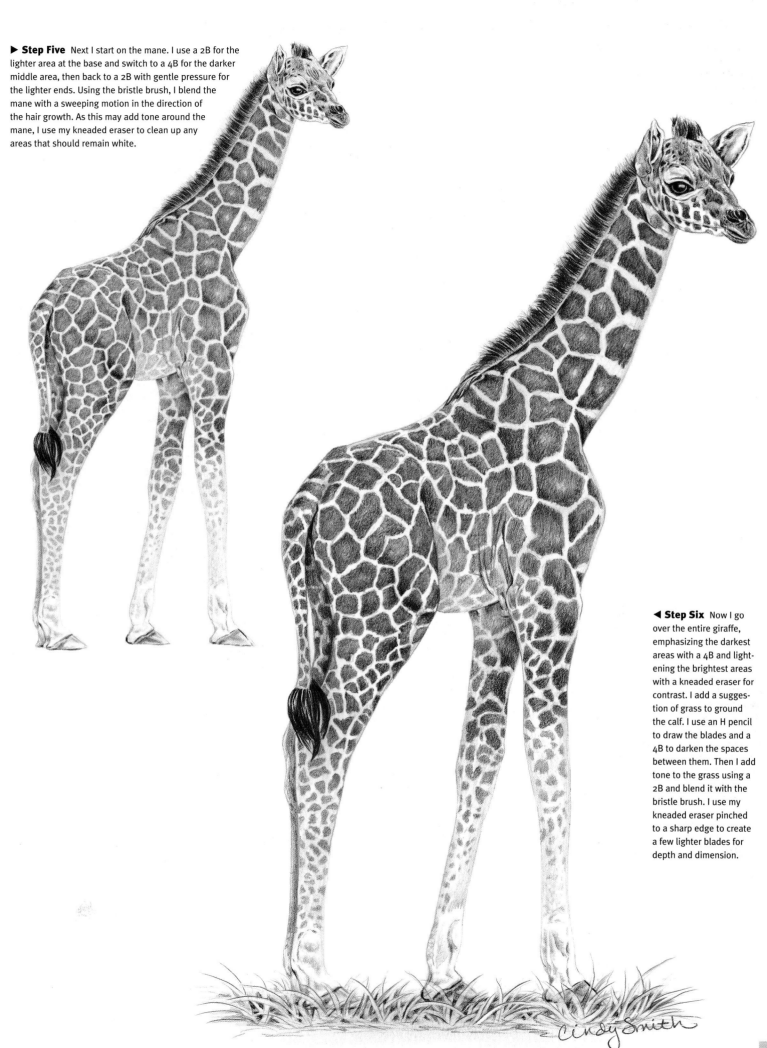

▶ **Step Five** Next I start on the mane. I use a 2B for the lighter area at the base and switch to a 4B for the darker middle area, then back to a 2B with gentle pressure for the lighter ends. Using the bristle brush, I blend the mane with a sweeping motion in the direction of the hair growth. As this may add tone around the mane, I use my kneaded eraser to clean up any areas that should remain white.

◀ **Step Six** Now I go over the entire giraffe, emphasizing the darkest areas with a 4B and lightening the brightest areas with a kneaded eraser for contrast. I add a suggestion of grass to ground the calf. I use an H pencil to draw the blades and a 4B to darken the spaces between them. Then I add tone to the grass using a 2B and blend it with the bristle brush. I use my kneaded eraser pinched to a sharp edge to create a few lighter blades for depth and dimension.

Cindy Smith

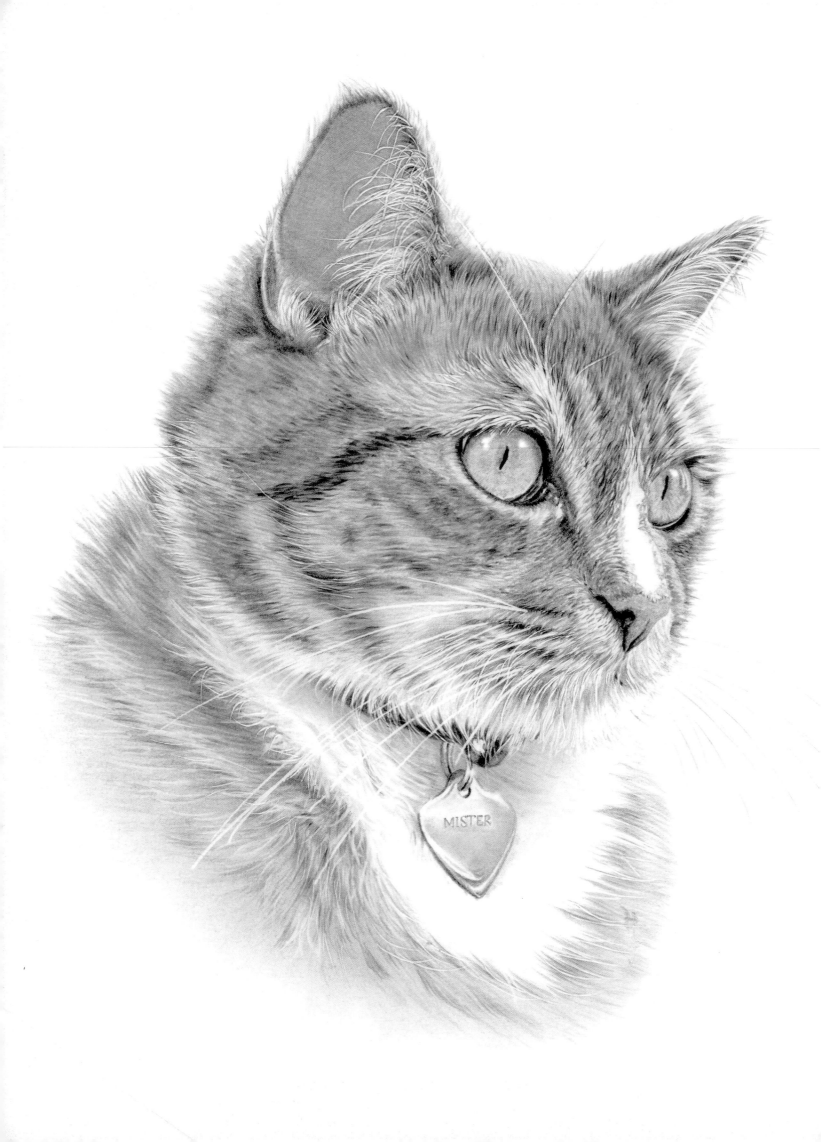

DOGS & CATS
WITH NOLON STACEY

Nolon Stacey is a self-taught graphite artist who specializes in realistic portraits of animals, people, and rural scenery. As a child in South Yorkshire, England, Nolon cultivated his interest in drawing throughout school. He eventually earned a degree in mathematics from Warwick University, but he soon returned to his artistic passion. He currently lives in North Yorkshire, England, and under takes a variety of commissioned work, ranging from portraits of people and pets to buildings and street scenes. Nolon also publishes through Kadinsky Art and sells his work through Presence Gallery in North Yorkshire, England.

CATS IN A BAG

Step One With so much of the cats' bodies obscured by the bag, this is a relatively simple drawing. I don't have to worry much about the accuracy of their bodies, so I create the outline freehand. I begin by drawing the bag, and then I place the facial features and indicate the main areas of fur. I include plenty of detail in the outline, which saves me from having to assess the placement of elements as I progress. I even indicate the serrated edge of the bag.

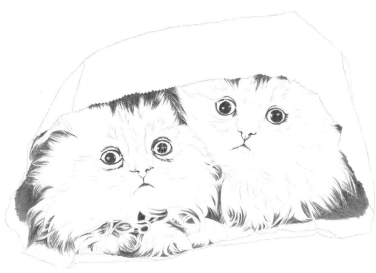

Step Two I indent the cat's whiskers before shading to preserve the white of the paper. (See "Incising" on page 102.) Then I begin picking out all the black areas of the drawing, blocking them in with a 2B pencil. This involves some negative drawing, which simply means that I shade around the clumps of hair. The fact that I sketched these hairs as part of the line drawing makes this process much simpler.

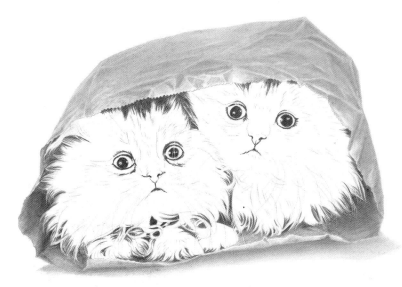

Step Three I now block in the main shading of the bag using a blunt HB pencil. As I apply tone to the bag, I leave the outer edge white to help create the illusion of contrast between the cats and the bag. To model the folds and crinkles on the bag, I lift out the raised areas with an eraser and darken areas of shadow across the surface. I also add a cast shadow under the bag using the HB pencil.

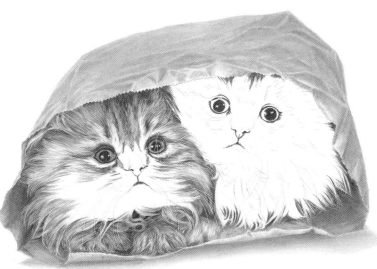

Step Four Now I address the hair on the cat at left. Beginning with the markings on the forehead, I use 2B and HB pencils to create the darker and lighter hairs, respectively. Stroking in the direction of hair growth, I move upward in the middle of the head and curve outward as I move toward the sides. Using fairly random lines, I flick some hairs off course for realism. As I get closer to the bag where the hair is in shadow, I am conscious to darken my strokes. Using this same shading method, I move across the rest of the cat's face and down onto its paws. I've already negatively drawn the darks around the paws, so I simply block in this lower area using an HB pencil. I then go over it again with a 2B pencil to add texture and create clumps of hair. I also block in the iris using an HB pencil.

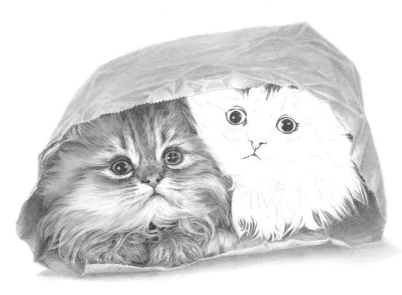

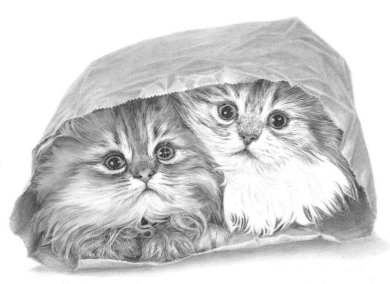

Step Five I finish the first cat by using an H pencil to draw fairly light lines within the fur, adding texture to the white area of the face. I also darken the area where the top lip overlaps the bottom, and I apply small circles over the nose for texture. I apply more pressure to the pencil at the sides of the nose and toward the bottom to create form. I also add the dark whisker markings on the cheeks.

Step Six I use the exact same process to shade the next cat. I want the cat at right to be slightly lighter than the cat at left, so I leave more white paper showing through my pencil lines as I progress. I constantly turn to my reference image so I can accurately re-create the markings in my drawing, changing from the HB to the 2B pencil for the darker markings.

▶ **Step Seven** I use *block shading* (applying an even layer of graphite over an area) on the bottom half of the second cat using an HB pencil and begin to create gaps between clumps of hair using a 2B pencil. These are lines that I apply fairly randomly to change the direction of hair growth. Finally, I stroke over these clumps of hair using a sharp eraser to lighten them slightly. I also define the hairs of the cat's chin using the same eraser. To complete the drawing, I use an electric eraser to further define some of the whiskers.

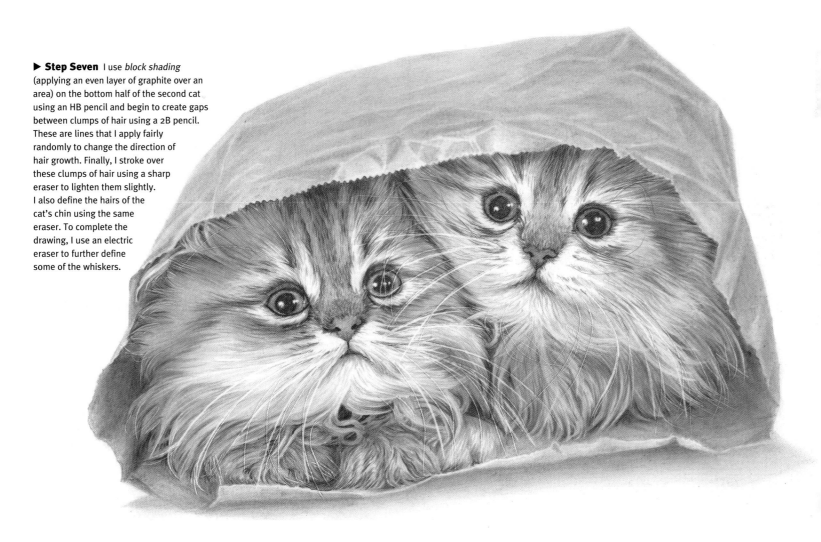

Bulldog

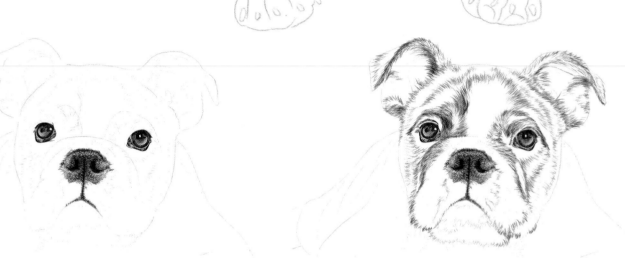

▶ **Step One** I sketch the outline of the head using an HB pencil, placing it slightly to the right and above the middle of my drawing area. I add the arch indicating the muzzle, the shape of the jowls, and the eyes, adjusting until I achieve accurate proportions. Very little of the body is showing, so it is quite simple to sketch the shoulders, front paws, and what little of the rear body is visible. I now refine this sketch so I have definite areas to begin shading, delineating them with strokes that follow the direction of hair growth.

Step Two I lighten my initial sketch with a putty eraser (also called "adhesive putty") and then use a 2B pencil to block in the darkest areas, which include the eyes, nostrils, and slightly open mouth. Then I apply a layer of HB graphite to each eye, lightening the tone as I move toward the bottom edges to give them a spherical look. I leave the highlight free of tone. I finish by darkening the skin around the eyes and then complete the right eye in the same manner. I also create texture on the nose by drawing random cracks over a layer of tone using a 2B pencil. Notice how the cracks in the middle of the nose all point away from the nostrils and middle crease, giving the illusion of curvature in this area.

Step Three Now I move on to the hair. Bulldogs have a fairly short, coarse coat, so I will be using short pencil strokes throughout the body. I begin with the darkest areas of the head, which are the skin folds and shadows within the ears. Using a 2B pencil, I apply short strokes in the direction of growth. The hair always grows away from the eyes in a slight spiral shape, moving up over the head and out toward the ears, and also down the side of the muzzle and out toward the side of the face. Remembering this pattern makes the early stages easier. These short lines not only provide me with the darkest areas, but they also create smaller, more manageable areas on the face that I can address one at a time.

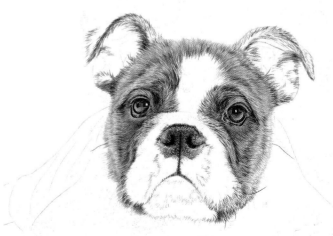

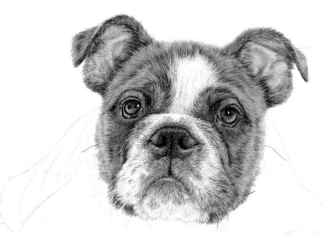

Step Four Switching to an HB pencil, I use the same short strokes to add the hair spiraling away from the eye. I intentionally leave areas of paper showing through my lines, which I then go over with a 2H pencil to create the lightest hairs. I continue this process over the rest of the head. The darker 2B lines that I applied earlier are now showing through the lighter HB lines, giving the impression of folds and ridges of fur. For the white patch on the forehead, I merely stroke a few short lines with an H pencil to indicate light hair.

Step Five The muzzle is slightly trickier—this area features very short white hairs and black skin beneath. I create this look using very short pencil strokes, leaving white between the hairs. The area directly below the nose and the lower lip is almost free of hair, so I indent a few stray hairs and then shade it using a 2B pencil. Then I apply a few strokes of HB for more white hair on the muzzle and along the tops of the ears.

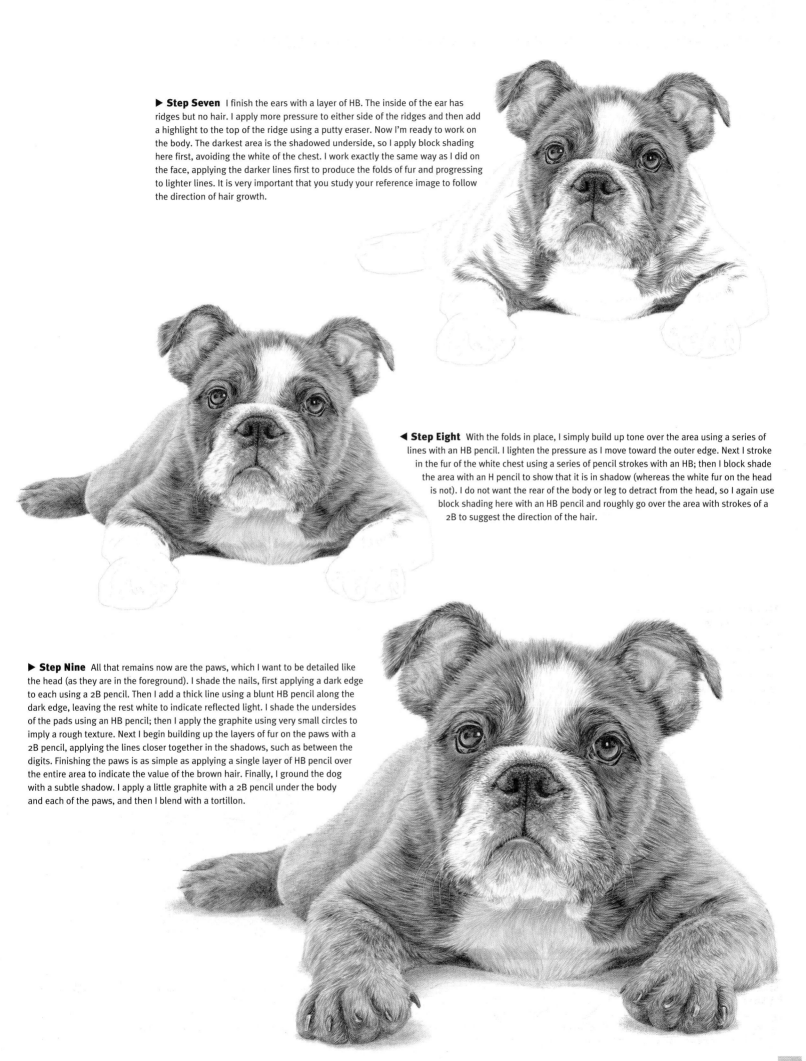

▶ **Step Seven** I finish the ears with a layer of HB. The inside of the ear has ridges but no hair. I apply more pressure to either side of the ridges and then add a highlight to the top of the ridge using a putty eraser. Now I'm ready to work on the body. The darkest area is the shadowed underside, so I apply block shading here first, avoiding the white of the chest. I work exactly the same way as I did on the face, applying the darker lines first to produce the folds of fur and progressing to lighter lines. It is very important that you study your reference image to follow the direction of hair growth.

◀ **Step Eight** With the folds in place, I simply build up tone over the area using a series of lines with an HB pencil. I lighten the pressure as I move toward the outer edge. Next I stroke in the fur of the white chest using a series of pencil strokes with an HB; then I block shade the area with an H pencil to show that it is in shadow (whereas the white fur on the head is not). I do not want the rear of the body or leg to detract from the head, so I again use block shading here with an HB pencil and roughly go over the area with strokes of a 2B to suggest the direction of the hair.

▶ **Step Nine** All that remains now are the paws, which I want to be detailed like the head (as they are in the foreground). I shade the nails, first applying a dark edge to each using a 2B pencil. Then I add a thick line using a blunt HB pencil along the dark edge, leaving the rest white to indicate reflected light. I shade the undersides of the pads using an HB pencil; then I apply the graphite using very small circles to imply a rough texture. Next I begin building up the layers of fur on the paws with a 2B pencil, applying the lines closer together in the shadows, such as between the digits. Finishing the paws is as simple as applying a single layer of HB pencil over the entire area to indicate the value of the brown hair. Finally, I ground the dog with a subtle shadow. I apply a little graphite with a 2B pencil under the body and each of the paws, and then I blend with a tortillon.

Dachshunds

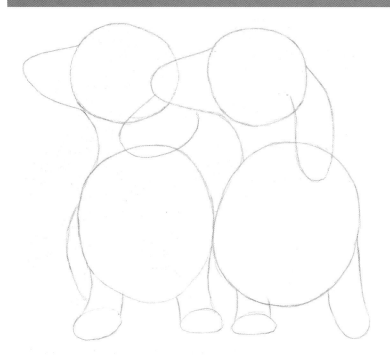

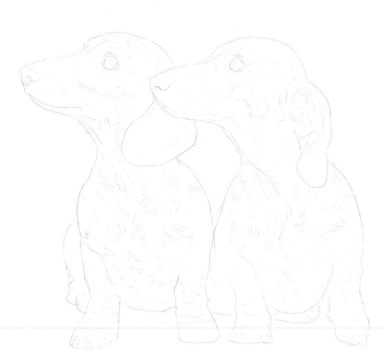

Step One When drawing two similar dogs, like these two Dachshunds, it is important to identify and translate the differences between them. You don't want to end up with a drawing of two dogs that look identical. With this in mind, I work on both dogs simultaneously. I begin by marking out the general shape of the dogs using circles to represent the bodies and heads. Then I add rough shapes for the muzzles, ears, and legs. I want the two dogs to be looking at the same thing, but again I don't want them to look like the same image duplicated, so I slightly lower the muzzle of the dog on the right. Different positioning of the ears also helps distinguish the two.

Step Two I now fine-tune my outline to provide a better idea of the dogs' structures. First I erase all the internal lines that aren't required, leaving just the outline of the dogs. Then I add the facial features and identify the main markings of the coats. I don't want any harsh lines that may show through later, so I use a putty eraser to lighten my line drawing until I can hardly see it. I then use it as my basis for creating a much more detailed line drawing. I mark out the main areas of hair using lines in the direction of growth. The chest is quite complex in terms of how the direction of hair growth changes, so I carefully refer to my photo reference for guidance.

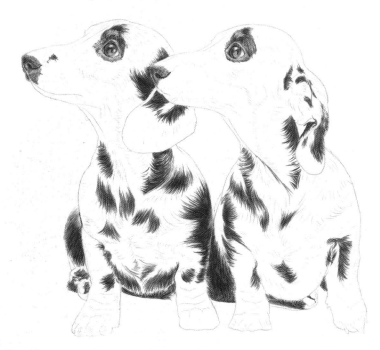

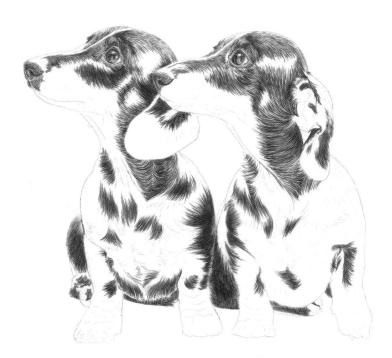

Step Three Now I block in the darkest areas of the dogs using a 2B pencil. I begin with the blacks of the nostrils and the eyes, leaving the highlights free of tone. Then I section off the areas of dark hair by simply indicating the edges with strokes that follow the direction of hair growth. I then fill in these areas with a 2B pencil, still stroking in the direction of hair growth and tapering each stroke as it moves toward the edge of the section. In this stage, I ignore any areas that do not appear black.

Step Four Now I begin blocking in some of the larger areas of fur. I accomplish this in two stages (steps four and five). Using a 2B pencil, I apply fairly short and very dark lines over the tops of the heads, across the muzzles, and down the necks. I place the lines closer together in darker areas, such as the below the eyes, and farther apart in lighter areas, such as the tops of the heads. At this point, the white of the paper still shows between the lines, so it looks too harsh.

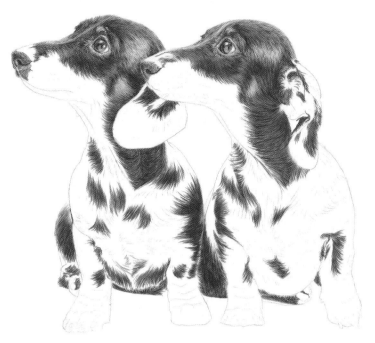 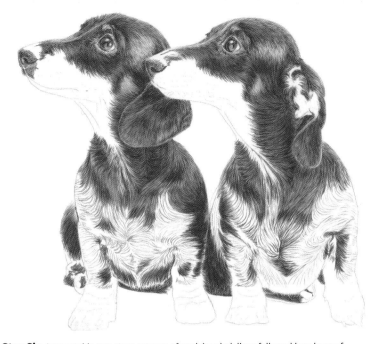

Step Five The second stage involves applying a fairly dark layer of graphite over the lines to soften the look of the coats. As this is black hair, I stick with the 2B pencil to achieve a dark layer, but I am careful not to apply too much pressure—I still want the lines from steps three and four to show through. As I apply these layers, I avoid the two "brown" spots on the sides of the faces and the lighter hair behind the eyes. Then I switch to an HB and apply a lighter layer of graphite over these areas.

Step Six I repeat this two-stage process of applying dark lines followed by a layer of shading across the necks and shoulders. Then I address the chests using a 2B pencil, applying sparse guidelines in the direction of hair growth. With this hair growing in all different directions, it would be very easy to end up with a section of hair that looks very unnatural, so it's important to roughly map out the flow of the hair. There are essentially three crowns on the chest from which the hairs spread: one in the middle of the chest and two above the legs. The hair spirals from these crowns up to the neck and down to the stomach.

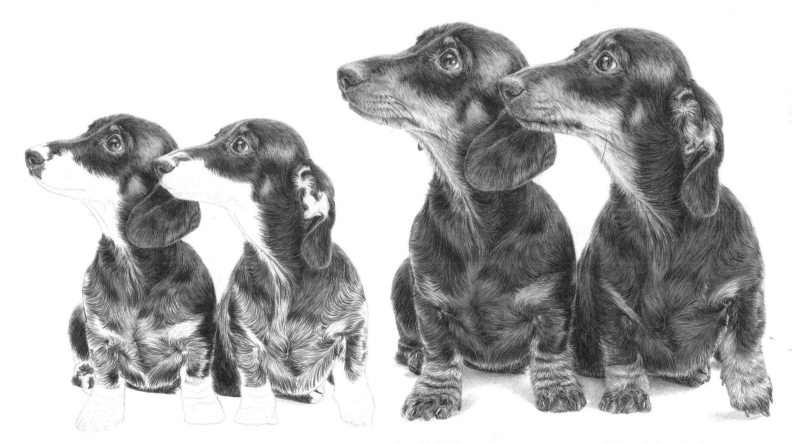

Step Seven With these hair-growth guidelines in place, I am now confident that I can accurately add the dark lines of the chests. I do this using a 2B pencil and tapered strokes. The lines all originate from the crowns of the hair and blend into the existing strokes. You can see that this has provided the shape and structure of the chests—even without shading.

Step Eight The lower legs and paws are covered with brown hair—not black—so I layer these lighter areas with an HB pencil. I use the same pencil to apply strokes over the "brown" muzzles and jaw areas of the dogs. I start near the tops of the muzzles and lighten the pressure as I move down over the cheeks, as the light hits these areas more directly. I draw the dark whisker markings, darken the shadows between the lips, and add a crease where the skin stretches to the side just below the mouth. I add whiskers with long, curved strokes using an HB pencil. Finally, I use a 2B pencil to ground the two floating Dachshunds with simple cast shadows beneath them.

Kittens

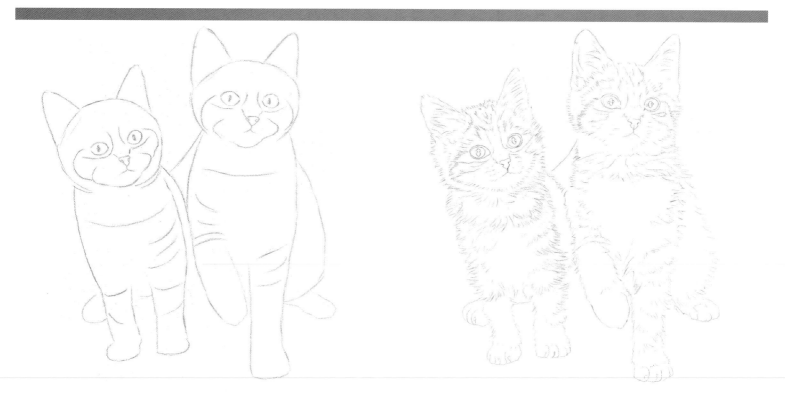

Step One Because my drawing will be relatively small (approximately 8 1/2 x 10 inches) and my reference is not a close-up photo of the kittens, I use a "sketch" method of drawing. I begin with a rough line drawing to ensure that I have my proportions correct, erasing and adjusting the lines as necessary. I include the general shape of the kittens, the features, the ears, and some rough guidelines for the main fur markings.

Step Two Once I have positioned the features accurately, I lighten my line drawing with a putty eraser to the point where I can barely see it. I use this as a guide for creating a much more detailed line drawing. (If I were to try to draw these two cats in detail without this initial guide, I would most likely lose touch of the proportions.) In this drawing, I detail the features, show the main markings on the coats, and indicate the direction of fur growth. This early sketch allows me to concentrate solely on tone and texture later.

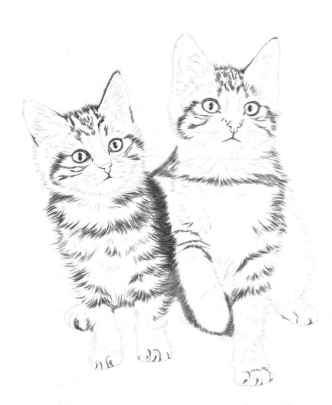

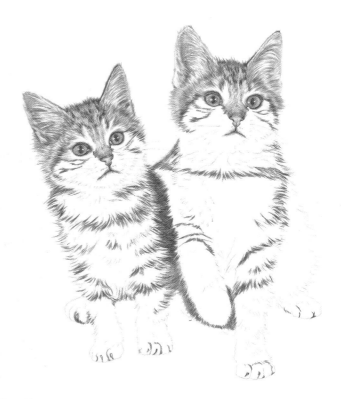

Step Three With my final sketch in place, I indent the whiskers before adding any tone to the face. Then, to simplify the drawing at an early stage and visually break up the white paper, I begin shading by filling in the darkest areas of the kittens using a 2B pencil. After filling in the pupils and skin around the eyes, I quickly add the dark markings of the heads, the shadow between the kittens, and the areas of the body where the hair separates. To create these dark strands of hair, I loosely draw my lines using a back-and-forth motion. I ignore any hair that doesn't appear completely black in the reference.

Step Four Before continuing work on the fur, I address the features. I simply block in the eyes using a blunt HB pencil, avoiding the highlights; then I add radial lines around the pupils using a sharp HB pencil. I shade the nose using an H pencil and small circles. Now I return to the fur, starting with the cats' foreheads. I have already applied the darkest markings, so I simply go over the areas using an HB pencil, stroking in the direction of hair growth. I draw medium-length lines leading up the heads and out toward the ears. At this stage, I make sure to leave the white of the paper showing through between the lines.

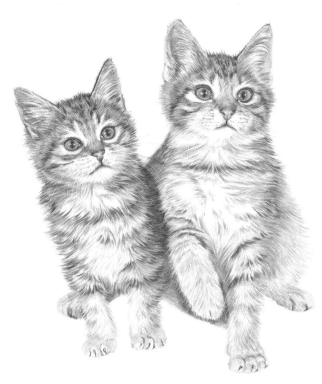

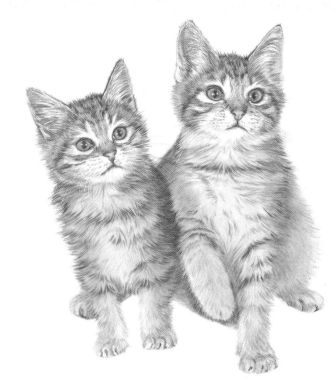

Step Five I create the whisker markings using a 2B and then shade around them using an HB pencil to suggest the subtle parting of fur. Now I work fairly quickly and spontaneously on the fur. Using strokes in the direction of fur growth, I work across the areas under the heads using an HB pencil. As I work away from the heads, I lighten my strokes slightly. Switching to an H pencil, I layer lighter strokes into the cheek areas. I continue this process across the body of both kittens, working from dark to light. I apply more pressure and place my lines closer together as I move toward the outer edge of each kitten, flicking the pencil outward to create the fluffy edge of fur. I also very roughly add some texture to the legs and paws; I will refine this in the next step.

Step Six Now I use a tissue to lightly blend the fur of each cat. I avoid only the areas surrounding the eyes and nose, as I want these to remain pure white. This blending not only softens the slight harshness of my lines, but it also creates the midtone fur across each cat's entire body.

▶ **Step Seven** Now I use a sharply cut eraser to lift out some of the white fur that I lost by blending, focusing on the chests and the fronts of the legs. To add the white whiskers, I use the eraser as I would a pencil. Where the whiskers extend beyond the fur, I apply fine lines of an H pencil. Finally, I create a cast shadow using a blunt 2B and blending with a tissue.

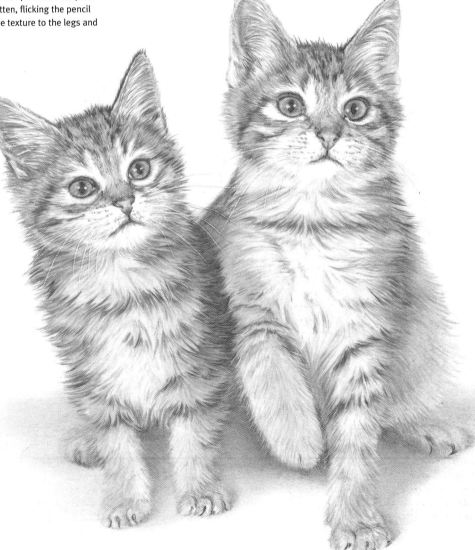

CAT PORTRAIT

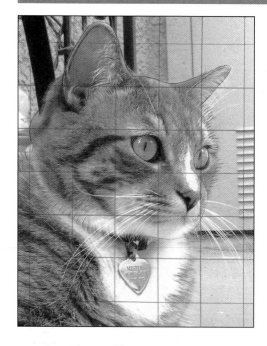

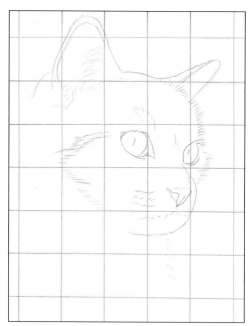

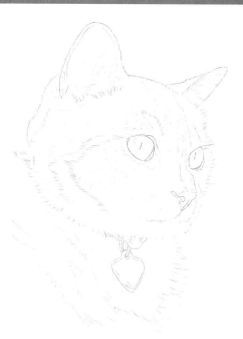

Step One I want this portrait to be very detailed and accurate, so I use the grid method to create my initial outline drawing. I begin by drawing a one-centimeter grid on a printout of my reference image (I don't want to damage the original photo).

Step Two Then I lightly draw a three-centimeter grid on my drawing paper using a 2B pencil (harder pencils can indent the paper and show through on the finished piece). This will enlarge the reference photo to three times the original size. Once I have my grid in place, I simply work through each square, transferring as much detail as I can from the reference to my paper.

Step Three Now I completely erase any traces of my grid and redraw any parts of my line drawing that have been erased in the process. Some people prefer to erase their grid as they progress, but I prefer to start with a line drawing that is as clean as possible. I do not want to be distracted by squares during the shading process.

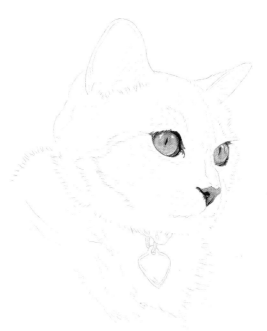

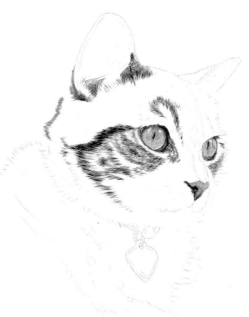

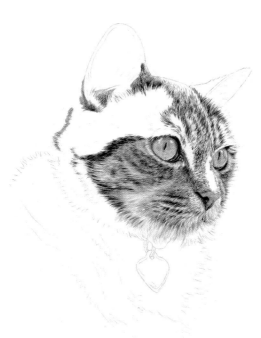

Step Four As I often do, I begin by picking out the darkest areas (the nostrils and eyes) using a 2B. Notice that the pupils aren't the usual "cat" shape; because the cat's head is turned from the viewer, they appear almost as lines. To complete the iris, I use an HB pencil to fill in the eyeball with a midtone, leaving the highlights white. I then create radial lines emanating from the pupil. For the nose, I simply fill in the shape using an HB pencil, darkening slightly as I move toward the bottom.

Step Five With the eyes and nose complete, I look at the expanse of white paper in front of me and feel quite intimidated. To break up the drawing into more manageable sections, I create some solid breaks within the fur on the head, beginning with the dark "C" shape across the cheek. For this I use a 2B pencil, first pressing quite hard to create some very dark gaps in the hair and then lightening the pressure for slightly lighter fur. I also add shading above the cat's right eye, at the base of the ear, and at the back of the head. Switching to an HB pencil, I use short lines to add the fur under the eye and up to the "C."

Step Six I apply a layer of HB graphite over the cheek area to blend the strokes, softening the darks and eliminating the white of the paper showing through. I work my way down with the H pencil to indicate the line of the mouth, stroking in the direction of hair growth. I use a 2B pencil for the darker hairs of the mouth as well as the whisker markings. Then I layer short strokes of an HB pencil over the mouth. (I don't concern myself with whiskers yet—I will erase them at the end.) Using my 2B pencil, I create tiny "V" shapes over the forehead; the white showing through gives the impression of tapering hairs.

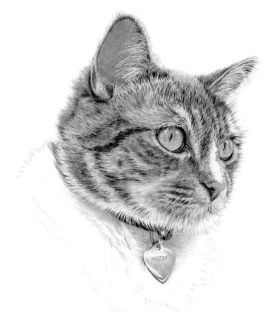

e same method as I used on
areas mixed in with lighter
il, I don't concern myself with
iewer back to the face of the
ears; this will save me from

Step Eight I fill in the inside of each ear using an HB pencil. The impressed hairs remain free of tone. Now I get the collar in place before moving on to the chest. Whenever a collar is present in a reference photo, I like to include it. I find that it adds interest and can personalize a drawing. I shade what little of the collar is showing using a 2B pencil, drawing up into the hair laying over it. I draw the dark shadows of the metal tag using a 2B pencil and shade the smooth, shiny surface with a 2H pencil, blending it with tissue. I simply write the cat's name, Mister, with a sharp H pencil, leaving white edges to give it an engraved appearance. Then, using the H pencil, I lay down a light shadow pattern on the white hair of the cat's chest.

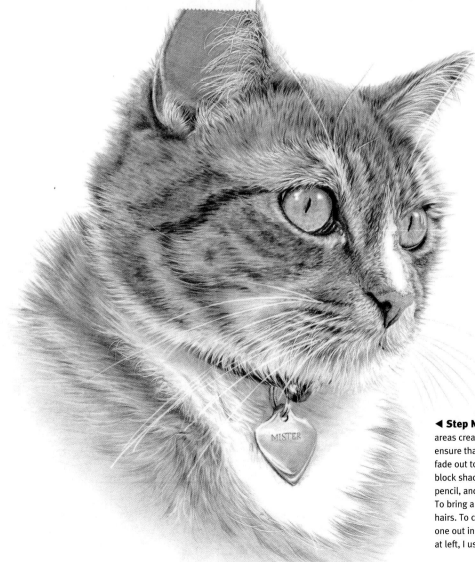

◄ **Step Nine** I finish the rest of the chest in two stages. First I lay down the darker areas created by partings in the hair. Then I indent some stray hairs to save time and ensure that all the white won't become covered with graphite. I want the drawing to fade out toward the bottom, so I don't include much detail along the edges; I simply block shade with an H pencil. Finally, I block shade the entire chest using a blunt HB pencil, and I blend the graphite using tissue to fade out the tone along the bottom. To bring a little detail to the area, I use a sharp vinyl eraser to cut in some lighter hairs. To complete the drawing, I add whiskers using an electric eraser, curving each one out in a single stroke from the whisker markings on the cheek. For the whiskers at left, I use curving strokes and an H pencil.

SPRINGER SPANIEL PUPPY

▶ **Step One** I begin by transferring the basic outline of the pup using an HB pencil and transfer paper. I trace only the most basic outlines to ensure that the proportions are accurate and every feature is positioned as it is in the reference photo. Then I refine the outlines to suggest the pup's hair, erasing the transferred lines as necessary. Using short, tapering strokes, I indicate the direction of hair growth across the figure. I also refine the outlines of the eyes and nose.

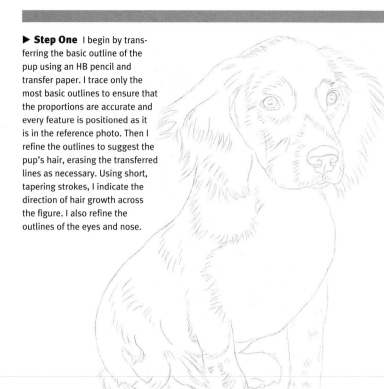

▶ **Step Two** I use a 2B pencil to block in the pup's pupils, working around the highlight. I also add the thin lines of dark skin around the eyes. Then I use the same pencil to begin developing the darkest areas of hair around the eye socket, around the face, within the ears, and down the back, always stroking in the direction of hair growth. I vary the length of each stroke to keep the hair from looking too uniform, and I taper them to build the groundwork for seamless transitions between values.

▶ **Step Three** After I've addressed the darkest areas with tone, I increase the value by stroking over them with a 4B pencil. I pay close attention to the curving and swirling patterns within the hair. Returning to the 2B pencil, I stroke within the ears to define strands of hair, focusing on the shadows. The new strokes follow the direction of the previous strokes and blend easily to create the illusion of wavy hair. I also apply a layer of tone to the nose using light, circular strokes.

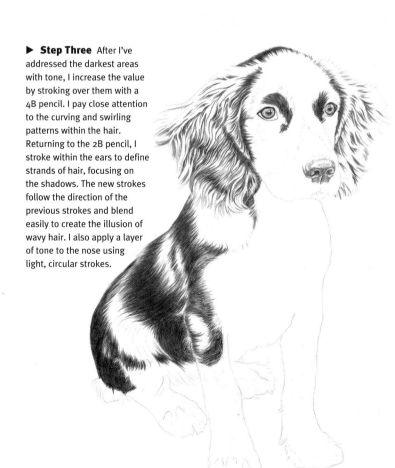

▶ **Step Four** Now I use an HB pencil to apply the lightest tones to the dog's ears. I stroke alongside the previous layers of graphite, creating a soft, silky look. I also develop the eyes and nose, adding midtones and pulling out highlights where needed. I use the 2B pencil to pull tone over the light areas of the body, connecting the sections of hair. I also begin developing the hair over the dog's face, scooping under and over the eyes to follow the direction of hair growth.

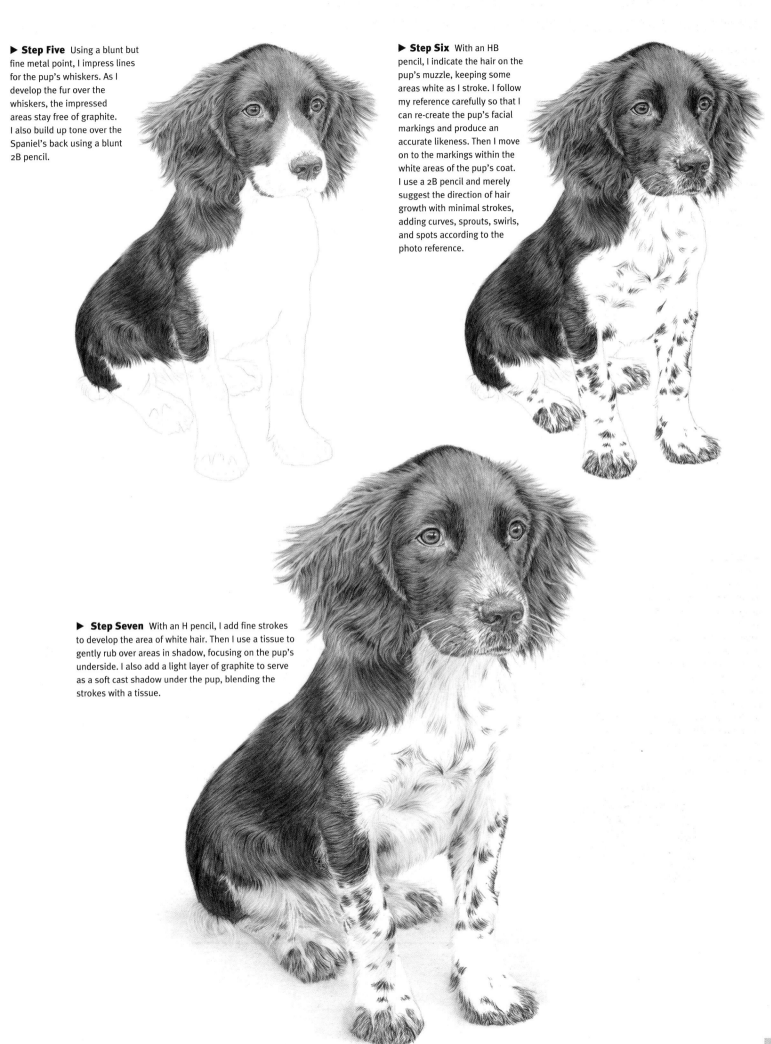

▶ **Step Five** Using a blunt but fine metal point, I impress lines for the pup's whiskers. As I develop the fur over the whiskers, the impressed areas stay free of graphite. I also build up tone over the Spaniel's back using a blunt 2B pencil.

▶ **Step Six** With an HB pencil, I indicate the hair on the pup's muzzle, keeping some areas white as I stroke. I follow my reference carefully so that I can re-create the pup's facial markings and produce an accurate likeness. Then I move on to the markings within the white areas of the pup's coat. I use a 2B pencil and merely suggest the direction of hair growth with minimal strokes, adding curves, sprouts, swirls, and spots according to the photo reference.

▶ **Step Seven** With an H pencil, I add fine strokes to develop the area of white hair. Then I use a tissue to gently rub over areas in shadow, focusing on the pup's underside. I also add a light layer of graphite to serve as a soft cast shadow under the pup, blending the strokes with a tissue.

Husky

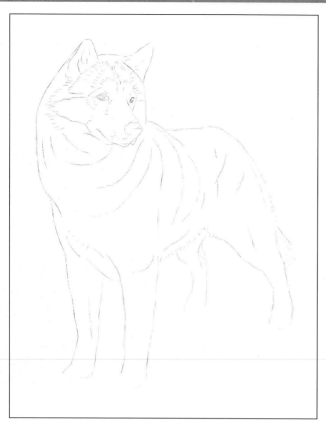

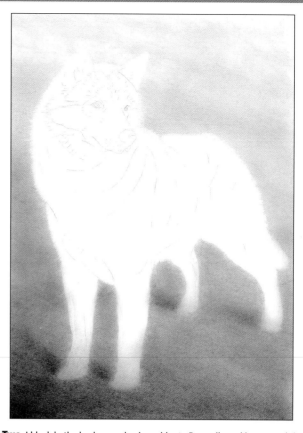

Step One This Husky is in a striking stance, so I aim to capture its powerful look in my drawing. I decide to include a dark background so the light, fluffy coat of the Husky stands out on the paper. (Remember that lighter dogs run the risk of getting lost in the white of the paper.) I begin by sketching a rough outline of the Husky. I don't refine the sketch because I'll put in the background first—I can fine tune the outlines later. However, I make sure to position the features accurately. I also mark the folds of skin that help indicate the twist in the upper body.

Step Two I block in the background using a blunt 5B pencil, working around the shape of the dog. I apply more pressure as I move toward the bottom. I don't want a detailed background that will take away from the dog, so I keep it abstract. In my reference, the dog's upper body is darker than the lower body and legs; I counter this by using a background that gradates from dark moving up to light. To add interest, I use a putty eraser to stroke rough lines at the top of the drawing, giving the impression of a sky. I also add subtle shadows near the dog's legs. I use a pencil eraser to flick out around the edge of the dog, suggesting fluffy fur.

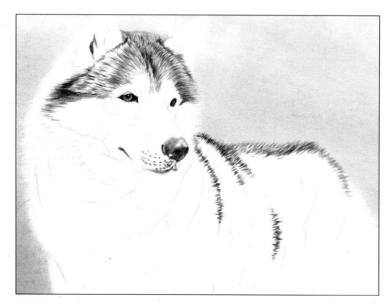

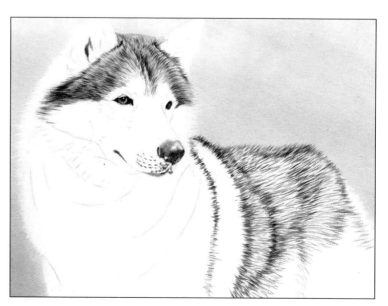

Step Three Now I start working on the dog. First I pick out the darkest areas and shade them with a sharp 2B pencil. These include the eyes and nose which, at this distance, don't require much detail. Then I move on to the dark fur of the head and back, simply using random, zigzagging lines. Returning to the head, I use a sharp 2B pencil and fairly short lines to develop the hair up and over the forehead and out toward the ears. The Husky has light areas around the eyes, so I leave these white for now.

Step Four I now switch to an HB pencil and go over the dark fur of the head with more short lines, following the same direction as used in step three. I then block shade over the areas of dark hair using a blunt 2H pencil to add tone and eliminate the white of the paper. This method of applying 2B, then HB, and finally 2H pencils gives the fur a sense of great depth. I repeat this technique over the back of the dog, applying my lines closer together where my guidelines indicate creases in the coat.

► **Step Five** Moving to the dog's back, I repeat my technique of adding HB and 2H lines over the 2B strokes. I extend the layer of 2H pencil down over the thigh, creating a lighter tone of fur. I also erase some lines of hair on the underside of the dog and where the stomach meets the hind leg. I block in the fur of the hind legs using an HB pencil, making sure that the tones differ from those of the surrounding background. I erase the back edge of each leg to suggest reflected light.

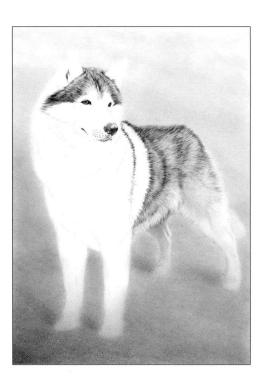

► **Step Six** I now focus on the front of the dog. The coat here is much lighter than across the body, so I use the same technique as in previous steps. However, instead of starting with the lines of a 2B pencil, I start with the lines of an H pencil. Then I move to the 2H and layer over the top with the blunt side of a 2H pencil. I leave the white of the paper showing though where the light is hitting the back of the legs and the dog's front right shoulder.

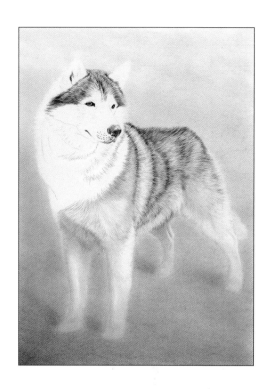

► **Step Seven** As I continue across the neck, I minimize detail in this area so the Husky's face stands out. I simply use an HB pencil and begin filling in the area with strokes in the direction of hair growth, applying the lines closer together to create creases in the coat. I switch to a 2B pencil for the neck area at left, where the coat is in shadow. My lines are slightly longer here, as the fur lengthens around the neck.

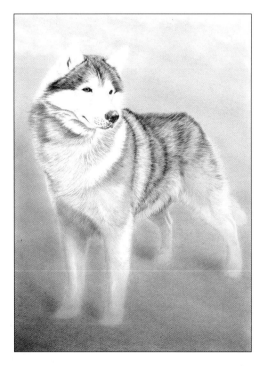

► **Step Eight** I now go over the neck with a blunt 2H pencil to blend the area, and then I pick out the highlights using a pencil eraser. The main highlights are just to the left of the muzzle, where clumps of fur are catching the light. I also blend along the left edge of the neck where it is almost completely in shadow. Then I use an HB pencil to shade the remaining parts of the face and ears. The shadows of the face include the inner corner of the eye, under the eye, along the base of the muzzle, and down the dog's cheek. I roughly shade these areas using very little detail. I then darken the back sides of the ears, which are also in shadow, using a 2B pencil. To finish, I erase the top of the muzzle to create more contrast within the face.

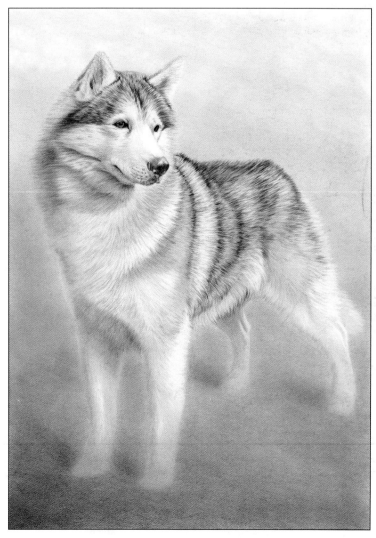

Silver Tabby

Step One I begin by roughly sketching the general shape of the cat using an HB mechanical pencil. This cat's pose makes for quite a simple outline, as we have no legs to worry about—just the mound of the cat's back, the neck, and the head. I include the ears and features of the face to ensure that I have everything correctly positioned. I use the ears as a guide to align the eyes and line of the mouth.

Step Two When I am happy with the layout and proportions of my rough sketch, I can fine-tune the sketch. I erase my rough outline until I can barely see it, and I use it as a guide for building details, such as the features, outline, and fur markings. I prefer that my outlines follow the direction of hair growth so they won't show through in the final drawing.

Step Three I am now ready to begin shading the cat's fur. I approach this drawing a little differently than usual. As the cat's back is mostly black with patches of gray and lighter fly-away hairs, I first indent the fly-away hairs using an empty mechanical pencil so that they will remain white through my later shading. I then use a similar method of indenting with a hard pencil. Using a sharp 5H pencil, I draw all the light hairs of the cat's back that appear in the darkest areas. I apply quite a lot of pressure, which slightly indents the paper while creating the light line. This method allows me to simply shade over these areas; the indented lines and 5H lines will show through.

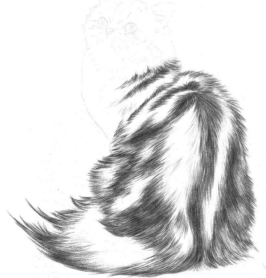

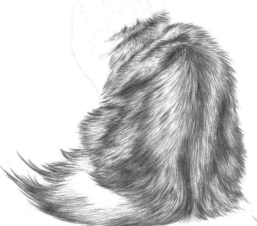

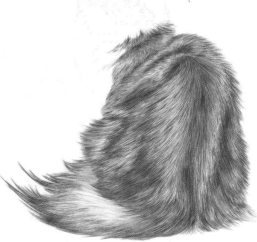

Step Four As you can see, I have shaded over all but the lightest areas of the back using strokes with a sharp 2B pencil. My earlier indenting has now resulted in the cat having three tones of hair: the black, the light 5H, and the indented hairs that are left as the white of the paper. I flick my pencil outwards at the end of every stroke so as to avoid any harsh edges to my shading. This will make blending the dark areas into the light areas much easier later.

Step Five I now switch to an HB pencil and fill in the remaining areas of the back. These areas are the lighter parts of the back so I keep my strokes quite far apart, allowing the white of the paper to show through in between. I vary the angle of my lines only slightly while following the direction of hair growth. This slight variation creates clumps of diverging and parting hair.

Step Six As the cat is black and silver, I want to soften the white of the paper that is still showing through by covering the entire area with a layer of H graphite. The only hairs that now appear white are the fly-away hairs that we indented at the start. Applying this layer at this stage, rather than earlier, also has the benefit of blending the graphite that is already there, softening some of the harsh lines.

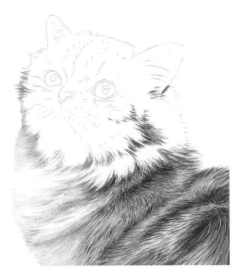 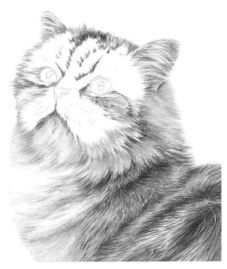 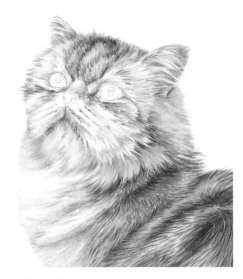

Step Seven I continue up the neck to begin defining the area around the face. The hair of the neck is gray in color, so I use a blunt H pencil and block shade the left side of the neck. I leave a few white areas where the light is catching the fur. I switch back to the 2B pencil to darken the area that defines the cheek and use zigzag lines to create the appearance of fur.

Step Eight I use the same mix of H and 2B pencil strokes over the rest of the face, creating the markings with zig-zagging strokes of a 2B and blocking in the lighter hair with a blunt H pencil. The insides of the cat's ears are slightly darker but have light hairs growing over them. I block shade this area using an HB pencil and then erase the lighter hairs with the sharp edge of an eraser. Then I define the mouth with a dark shadow, gradually lightening toward the bottom of the chin.

Step Nine I fill in the rest of the cat's face using an HB pencil and a series of short lines. I simply apply more pressure with the HB to create the darker areas and lighten my pressure for the light areas. Note how the hair grows out from the eyes toward the sides of the face and up toward the ears.

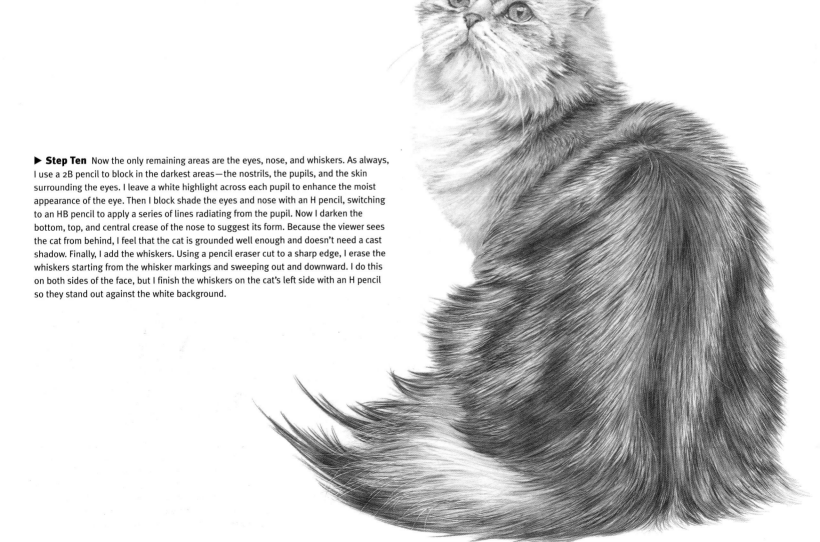

▶ **Step Ten** Now the only remaining areas are the eyes, nose, and whiskers. As always, I use a 2B pencil to block in the darkest areas—the nostrils, the pupils, and the skin surrounding the eyes. I leave a white highlight across each pupil to enhance the moist appearance of the eye. Then I block shade the eyes and nose with an H pencil, switching to an HB pencil to apply a series of lines radiating from the pupil. Now I darken the bottom, top, and central crease of the nose to suggest its form. Because the viewer sees the cat from behind, I feel that the cat is grounded well enough and doesn't need a cast shadow. Finally, I add the whiskers. Using a pencil eraser cut to a sharp edge, I erase the whiskers starting from the whisker markings and sweeping out and downward. I do this on both sides of the face, but I finish the whiskers on the cat's left side with an H pencil so they stand out against the white background.

DALMATIAN

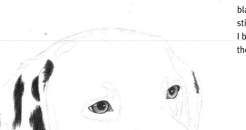

▶ Step One I begin by sketching the general shape of the Dalmatian's head using an HB pencil. As this is a relatively simple head shot, I can sketch the outline without needing to block in shapes or use a grid. I make sure to capture the tilt of the head, which gives this dog great character. I ensure that the tops of the ears, eyes, and line of the mouth are all parallel and follow this tilt. I also roughly mark in some of the spots.

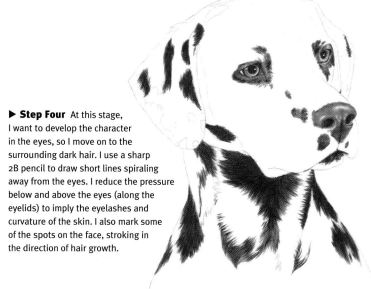

▶ Step Two Once I am happy with my outline, I begin blocking in the darkest areas using a 2B pencil. Although there are many black spots on this dog, I do not want to block in each black patch entirely, as areas of the coat still reflect light. In addition to the spots, I block in the pupil, the dark outline of the eyes, and the nostrils.

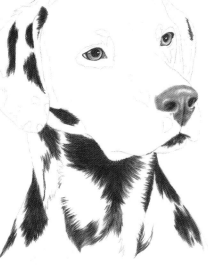

▶ Step Three I now move on to the nose and eyes. I shade the eyes using an HB pencil and radial lines around the pupil. I apply less pressure to the outer edge of the iris to give the eyes a three-dimensional quality. Then I use a blunt 2B pencil to shade the nose area, avoiding the highlights around the nostrils and on the tip. I also darken the ridge in the middle of the nose and the area beneath the nostrils.

▶ Step Four At this stage, I want to develop the character in the eyes, so I move on to the surrounding dark hair. I use a sharp 2B pencil to draw short lines spiraling away from the eyes. I reduce the pressure below and above the eyes (along the eyelids) to imply the eyelashes and curvature of the skin. I also mark some of the spots on the face, stroking in the direction of hair growth.

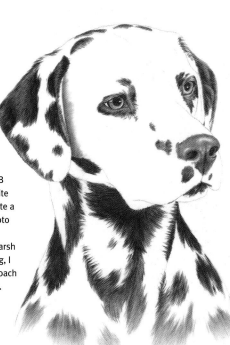

▶ Step Five Now I complete the black spots by adding the areas in reflected light. Again using a sharp 2B pencil, I draw short lines with the white of the paper showing through to create a lighter tone. I study my reference photo and ensure that my lines follow the direction of hair growth. To avoid a harsh line around the bottom of the drawing, I greatly lighten my pressure as I approach the bottom edge, fading out the tone.

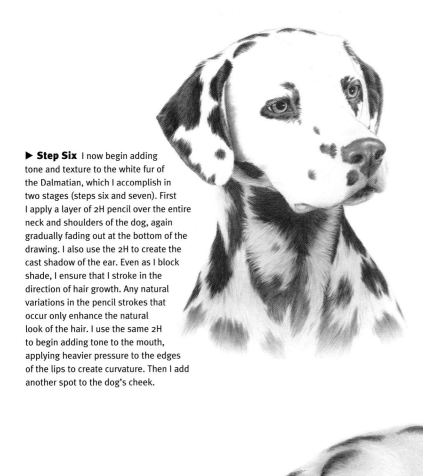

▶ **Step Six** I now begin adding tone and texture to the white fur of the Dalmatian, which I accomplish in two stages (steps six and seven). First I apply a layer of 2H pencil over the entire neck and shoulders of the dog, again gradually fading out at the bottom of the drawing. I also use the 2H to create the cast shadow of the ear. Even as I block shade, I ensure that I stroke in the direction of hair growth. Any natural variations in the pencil strokes that occur only enhance the natural look of the hair. I use the same 2H to begin adding tone to the mouth, applying heavier pressure to the edges of the lips to create curvature. Then I add another spot to the dog's cheek.

▶ **Step Seven** I go back over the areas I have just shaded with a sharp pencil eraser. I apply strokes in the direction of the hair growth to bring out the lightest hairs. Slightly varying the shape, curvature, and direction of the strokes in areas will create a sense of depth and give a more natural look to the hair. I repeat this process on the ears and begin shading the cheeks.

▶ **Step Eight** Now I work on the white fur of the face. Because the fur is white, I don't need to worry too much about detail—only rough shading is required, as any detail would be lost in this light tone. Using the blunt side of a 2H pencil, I follow the direction of hair growth and shade below the eye and down the side of the muzzle. I also add the subtle ridge on the forehead and shade along the back of the head, where less light is hitting the coat. Then I lightly shade the area above the nose and around the mouth. The whisker markings are quite subtle, so I suggest them simply using dots and an H pencil. Finally, I return with the 2H to shade between the markings, implying separation of hair in this area.

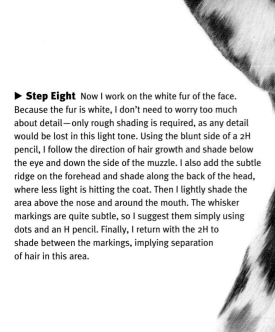

Maine Coon

Step One I begin sketching the general shape of the cat. This cat has an interesting pose; we are viewing it from the side, but its head is turned, looking behind and slightly upward. With this in mind, I shift the position of the cat to the left side of the paper. This creates a more dynamic composition and encourages the viewer to wonder what the cat is looking at.

Step Two As always, I fine tune the outlines until I have a detailed line drawing to work with. This fine tuning includes defining the features and the markings of the cat's coat. I also indicate the pupils, guiding the cat's gaze so that it appears to look directly into the vacant space behind it. I am not too concerned with the markings on the body—I will address these during the shading stage.

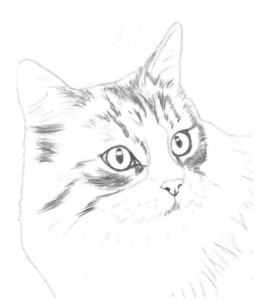

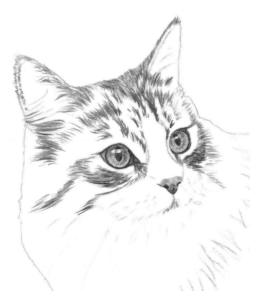

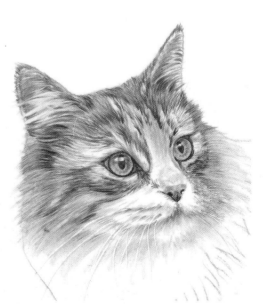

Step Three I begin shading the head first, as this will be the more taxing area of this drawing. I block in the black areas of the eyes and nose, as well as the darkest markings of the cat's head. I simply create short and dark lines with a 2B pencil, making sure to follow the direction of hair growth.

Step Four Switching to a slightly lighter HB pencil, I further develop the markings of the head. The cat's eyes are relatively dark, so I use the HB pencil and light pressure to block shade the eyes; then I apply more pressure as I add radial lines. I also create the eyelid's cast shadow along the top of each eye. Then I block in the nose, darkening it slightly toward the bottom and sides to suggest its form.

Step Five To finish the head, I first indent the whiskers with a blunt but fine metal point; then I apply a light layer of graphite over the entire area using an H pencil and avoiding only the white of the muzzle and the white fur surrounding the eyes. I then apply texture within the fur by overlaying short strokes using an HB pencil. The coat should lighten around the neck, so I change to a blunt H pencil as I move down. To finish the head, I first indent the whiskers with a blunt but fine metal point; then I apply a light layer of graphite over the entire area.

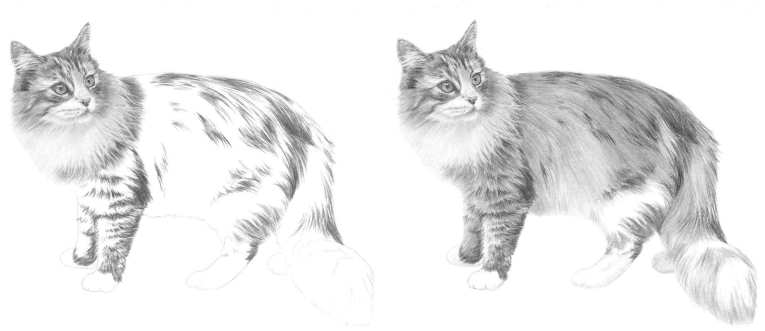

Step Six After finishing the fur on the neck, I tackle the darks of the rest of the cat in one go. I begin by picking out the darkest areas of fur using a 2B pencil and a series of lines in the direction of hair growth. To create the area where the lighter neck fur lays over the dark fur, I first block in the area and then erase the overlaying hairs. As the light source is in front of the cat, most of the darkest fur is on the backs of the legs, body, and tail. Note that the fur on the legs is shorter in length than on the body—with this in mind, I keep my pencil strokes shorter in these areas.

Step Seven I now block shade the entire body using a blunt HB pencil, avoiding only the fronts of the legs, the light fur at the top of the hind leg, and the end of the tail that is catching the light. Although I am only block shading at this stage, I still follow the direction of hair growth. This ensures that if any of my shading pencil strokes show through at the end, they will only enhance the appearance of fur.

▶ **Step Eight** To further develop the coat, I go back over the entire body with a sharp 2B pencil, applying lines in the direction of hair growth. I randomly create areas where my lines are closer together and areas where they are farther apart to give the appearance of natural partings and clumps within the coat. I work dark lines into the lighter areas for texture; then I use an eraser to create random light hairs and define the light patch on the hind leg.

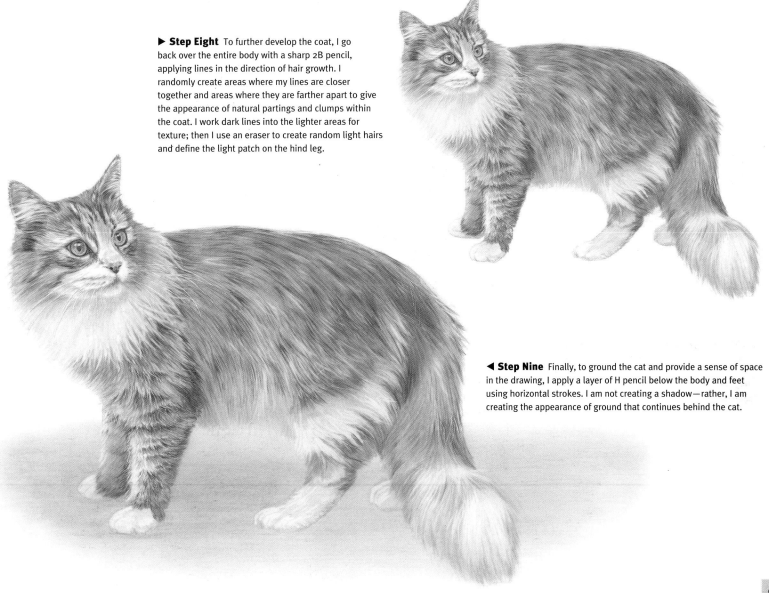

◀ **Step Nine** Finally, to ground the cat and provide a sense of space in the drawing, I apply a layer of H pencil below the body and feet using horizontal strokes. I am not creating a shadow—rather, I am creating the appearance of ground that continues behind the cat.

OCICAT

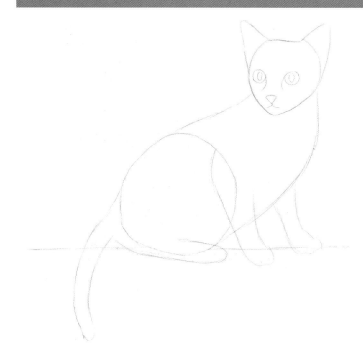

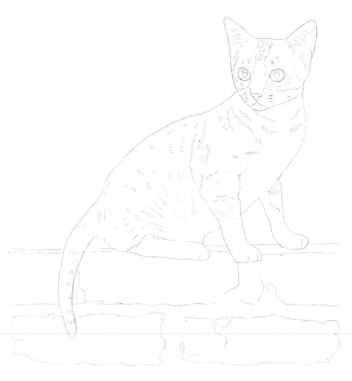

Step One I begin by sketching the rough position of the cat. I plan to place the cat on a wall with its tail hanging down, so I mark this wall by placing a horizontal line a third of the way up the paper. I draw a large circle on the line for the cat's rear and a smaller circle for the cat's head. I join the two circles with sweeping lines to indicate the chest and back. I also add the ears, which helps show the direction of the cat's head. I expand on my outline drawing by adding the front and rear legs, the tail, and the facial features, adjusting the shapes to match my reference.

Step Two Now that I have a rough idea of position and proportion, I erase my rough drawing almost completely and create a detailed line drawing on top. I fine-tune the features and delineate the main markings of the cat's coat. I also sketch the wall beneath the cat. Notice that the bricks are not simply rectangles—they are irregular and cracked.

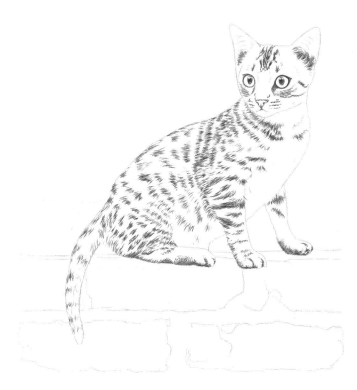

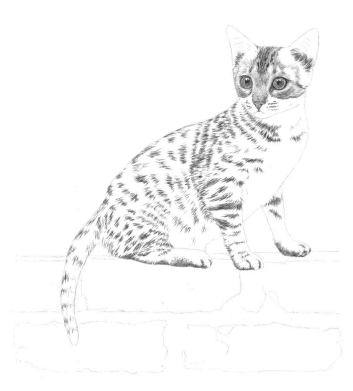

Step Three To begin shading, I pick out all the black areas of the cat. These include the pupils, nostrils, and black markings all over the body. I simply block in some areas, such as the pupils, using a 2B pencil—but the black areas on the coat need to have more form. I indicate these areas using very short lines in the direction of hair growth. Note how these markings are farther apart across the back where the coat is stretched but closer together around the hind leg where the fur collects.

Step Four I now start filling in the features and the face. I apply a layer of graphite using an H pencil over the eyes and nose, leaving highlights in the eyes. I then draw radial lines out from the pupil to create the textured look of a cat's eye. The fur of the face is very short, so I use a sharp HB pencil to draw short lines up from the nose, out around the eyes, and over the top of the head. Layered over the black areas of the fur, these lines create the midtone. I leave the white of the paper showing through to indicate the lighter fur above and below the eyes.

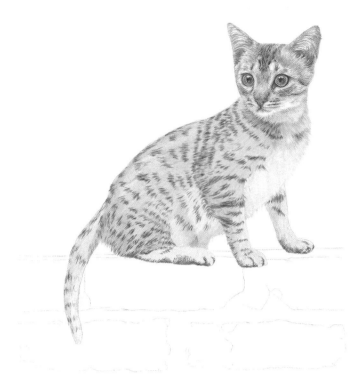

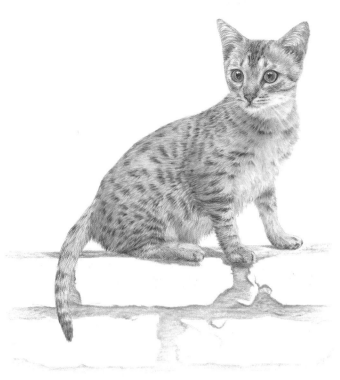

Step Five I now block shade the entire cat. Using an H pencil, I cover the cat with a single layer of graphite, avoiding only the white chin and the area around the nose. I then apply a second layer over the cat, this time avoiding the lighter chest and fronts of the legs. I slightly darken the insides of the ears; then I erase the stray white hairs that grow over the ears.

Step Six With roughly the right tones in place, I create the texture of the body. Using a sharp HB pencil, I apply short lines over the body following the direction of hair growth. I use more pressure in the shadow areas, such as under the haunches and around the shoulder. To add texture to the paws, I greatly shorten my strokes. I also apply texture to the lighter chest and underside using an H pencil. I finish the cat by erasing the whiskers using an electric eraser. Then I move to the wall, filling in the cement using small, circular strokes and an HB. I lighten my pressure as I move down the wall, fading to create a soft edge.

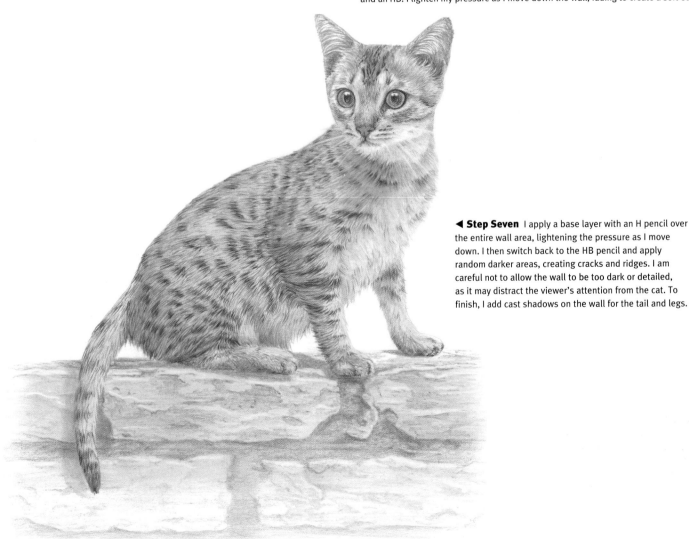

◀ **Step Seven** I apply a base layer with an H pencil over the entire wall area, lightening the pressure as I move down. I then switch back to the HB pencil and apply random darker areas, creating cracks and ridges. I am careful not to allow the wall to be too dark or detailed, as it may distract the viewer's attention from the cat. To finish, I add cast shadows on the wall for the tail and legs.

LABRADOR RETRIEVER

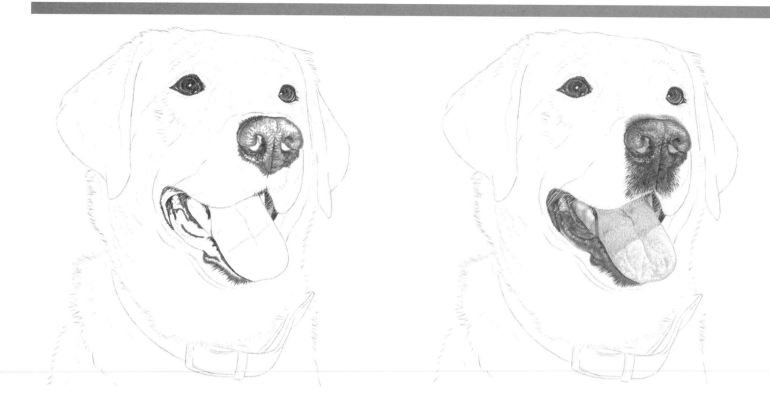

Step One As I want this drawing to be a very detailed and lifelike portrait, I use the grid method to create my line drawing. (See steps one, two, and three on page 52.) Once I have my detailed outline in place, I immediately dive into detailed shading. Using a 2B pencil, I apply tone in the darkest areas: the pupils, the skin surrounding the eyes, the edges of nostrils, and the mouth area. I move on to the nose using an HB pencil, drawing very small circles and varying the size and pressure to suggest the form. I am careful to leave the tops and sides of the nose white where the light is reflecting. In this case, the insides of the nostrils aren't black—the light is reflecting within.

Step Two To complete the nose, I use an HB pencil to apply a layer of slightly larger circles over the entire nose, toning down the highlights and adding texture. I also apply dark shading below the nose with a 2B pencil. As I move outward, I draw short lines that converge to a point, suggesting gaps between the light hairs. Before addressing the mouth's interior, I indent whiskers and hairs along the upper lip. Then I use the 2B pencil to add tone to the gums, giving them a smooth and moist look by leaving small specks of white. Now I shade the tongue with an HB pencil. I use this shadow to suggest its form, curving the shadow over the tongue's surface.

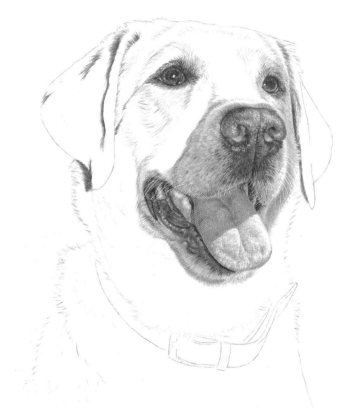

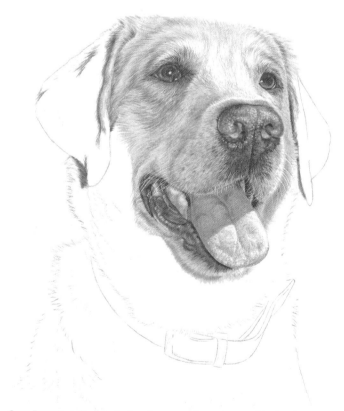

Step Three I now begin to work on the fur. A Labrador has a short, yellow coat, so I will render it almost exclusively using a sharp HB pencil and short strokes that follow the direction of hair growth. I leave quite a lot of white paper showing through my lines to keep the fur light. To change the tone, I simply apply the lines closer together or farther apart to create darker or lighter areas. To make the rest of the head a little less daunting, I look for darker areas of fur, such as around the ears, and shade these first. This breaks up the space and creates smaller areas to work on.

Step Four From the muzzle, I continue up and over the top of the head with the HB, taking the hair back and out toward the ears. I leave the bridge of the muzzle and the area above the eyes almost completely white, as this is where the light is hitting the dog's head directly. I apply very few light lines with a 2H pencil to indicate some hair here.

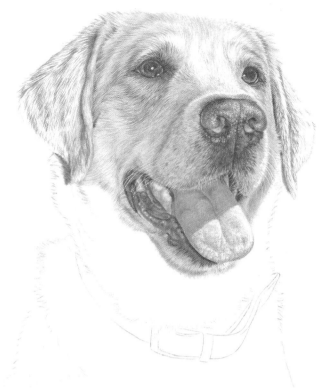

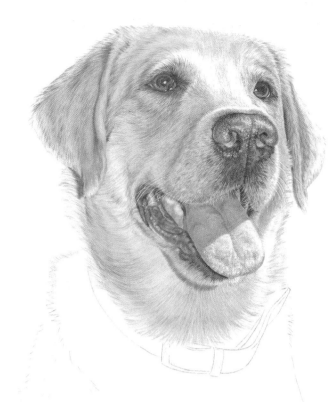

Step Five I work on the ears in two stages. In stage one, I create the texture of the ears using an HB pencil. I make a ridge at the inner edge of the ear where it folds slightly. I curve my lines around the edges of the ear, giving the impression that the coat continues on the other side. The light on the left ear is strong, so I leave it almost completely white.

Step Six In stage two, I simply apply an even layer of HB pencil over the ears, making sure that I don't apply too much pressure—I don't want this layer to be as dark as the lines I laid in the first stage. A Labrador's ears are generally darker than its body, so I also blend the area with a tissue until I reach the desired shade. I use the same two-stage method (laying in lines with an HB pencil, then shading over the top) for the area directly below the mouth.

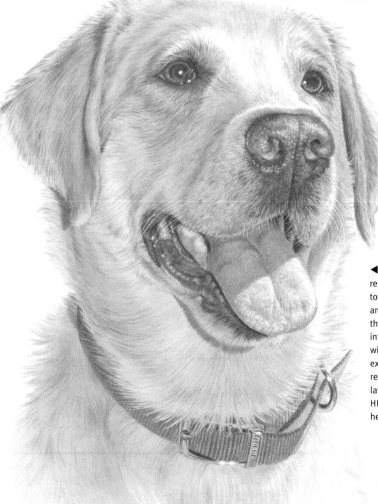

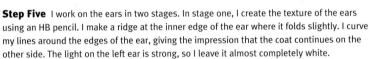

◄ **Step Seven** Now I work on the collar. There are just two textures here to re-create—the fabric band and the buckle. First I indent strands of hair over the band to protect them from tone. Then I lay down ridges along the band using parallel lines and a 2B pencil. To give the ridges form, I lightly shade to the left of each line. I finish the band by applying a layer of HB pencil over it. The metal buckle is slightly more intricate. I add the sharp edges with a 2B pencil and shade over the entire area with an H pencil. I lift out highlights with a kneaded eraser. You can see that I have extended the highlight slightly beyond the actual buckle—this makes it appear to really shine. Once I finish the buckle, I create the coat below the neck. First I add a layer of H pencil, blending the strokes with a tissue. Then I go over the area with an HB pencil, stroking in the directions of hair growth. To keep the viewer's focus on the head, I fade out gradually along the bottom for a soft, subtle edge.

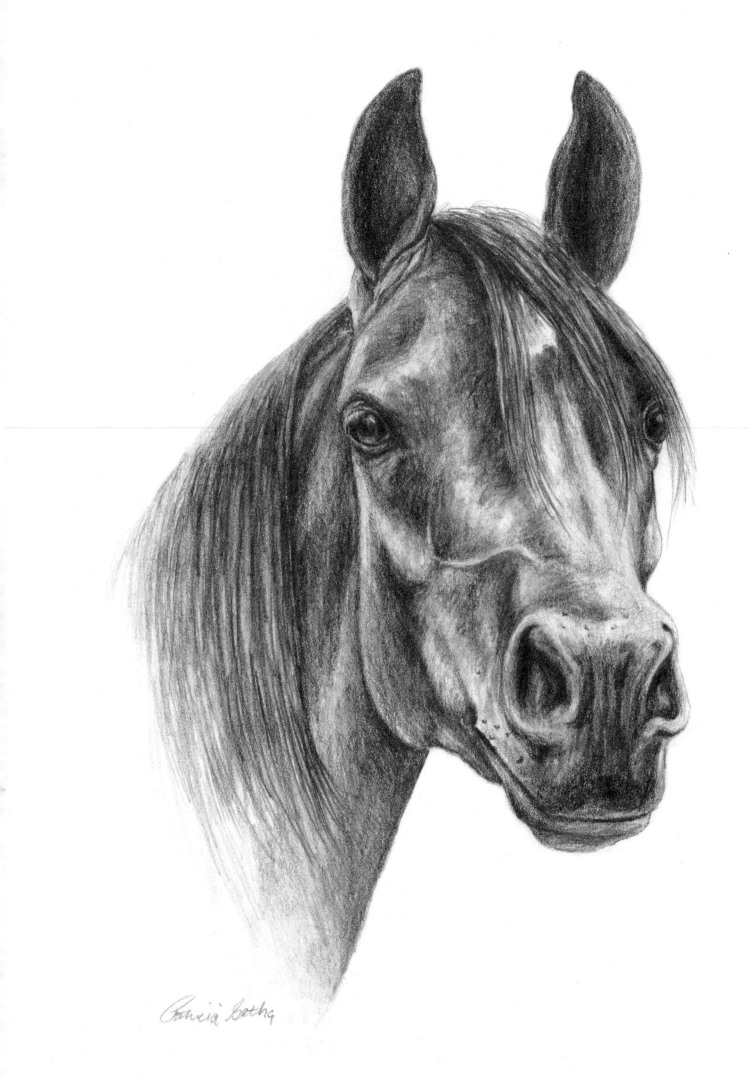

Patricia Botha

HORSES & PONIES
WITH PATRICIA GETHA

A graduate of the University of Cincinnati, Patricia Getha worked in the graphic arts industry as a pre-press professional for more than 20 years before pursuing a lifelong desire to paint and draw one of her favorite animals, the horse. As a young girl, she spent many summers looking after and showing horses. Drawing played a large role in Pat's life, but it was a love of horses that enabled her to master the subject.

Pat is proficient in a variety of media, including watercolor, graphite, oil, and colored pencil. She exhibits both her art and photography in juried competitions and has won national awards for her exquisite work in both venues. Pat currently resides in Ohio and works primarily as a commission artist.

ANATOMY & PROPORTION

Some knowledge of the horse's anatomy and proportion is important for correctly blocking in the basic shape of the subject at the beginning of each drawing.

Proportion refers to the proper relation of one part to another or to the whole, particularly in terms of size or shape. Proportion is a key factor in achieving a likeness of a subject. For drawing animals and people, artists often use head size as a measuring unit for determining the length of other body parts. For example, the body of the horse is about four times the length of its head. Utilizing this kind of approximation will help you draw the horse in correct proportion.

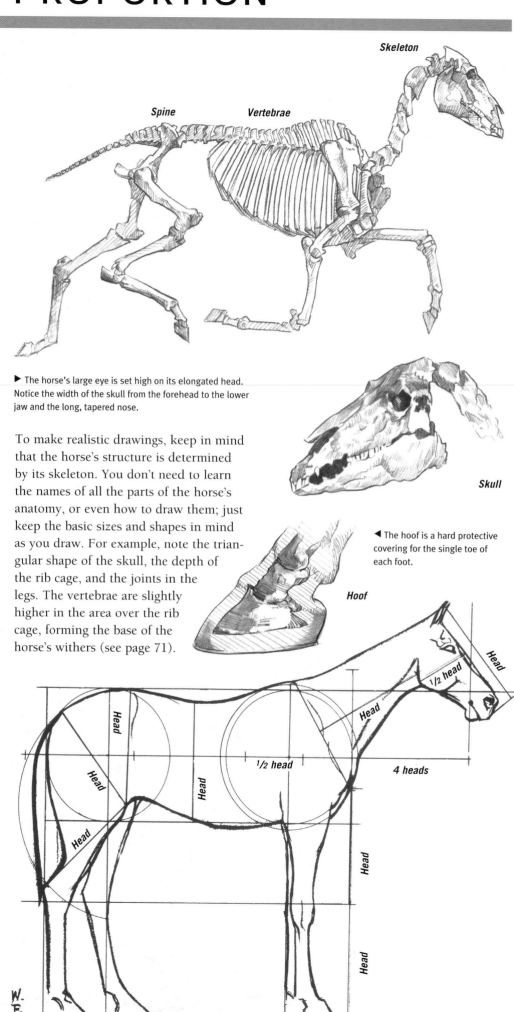

Skeleton

Spine **Vertebrae**

▶ The horse's large eye is set high on its elongated head. Notice the width of the skull from the forehead to the lower jaw and the long, tapered nose.

To make realistic drawings, keep in mind that the horse's structure is determined by its skeleton. You don't need to learn the names of all the parts of the horse's anatomy, or even how to draw them; just keep the basic sizes and shapes in mind as you draw. For example, note the triangular shape of the skull, the depth of the rib cage, and the joints in the legs. The vertebrae are slightly higher in the area over the rib cage, forming the base of the horse's withers (see page 71).

Skull

◀ The hoof is a hard protective covering for the single toe of each foot.

Hoof

Scapula

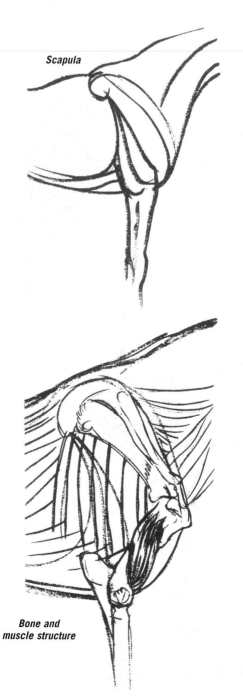

Bone and muscle structure

Familiarity with the horse's anatomy and musculature will help you make your drawings look realistic. Generally, areas with large, smooth muscles will be shaded lightly, whereas the areas of smaller overlapping muscles will require more complex shading. Study the illustrations to see how the muscles and tendons wrap around the horse's skeletal structure.

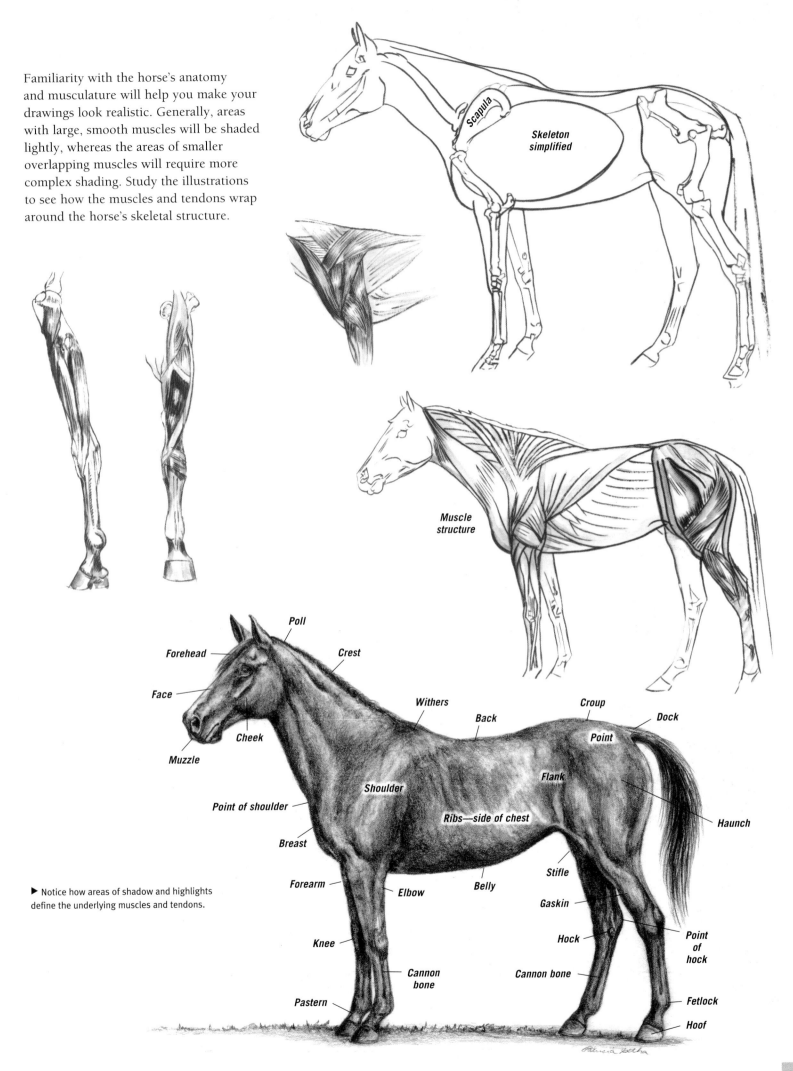

Skeleton simplified

Scapula

Muscle structure

▶ Notice how areas of shadow and highlights define the underlying muscles and tendons.

Poll

Forehead

Crest

Face

Cheek

Muzzle

Withers

Back

Croup

Dock

Point

Shoulder

Flank

Haunch

Point of shoulder

Ribs—side of chest

Breast

Forearm

Elbow

Belly

Stifle

Gaskin

Knee

Hock

Point of hock

Cannon bone

Cannon bone

Pastern

Fetlock

Hoof

Basic Profile Study

Step One I use an HB pencil and light pressure to block in the basic shape of the horse's head. Following the angles of the example, I use quick, diagonal strokes to indicate the muzzle, ear, and back of the head. Then I divide the head vertically at the midpoint, as shown. This will provide a reference for adding the jawline.

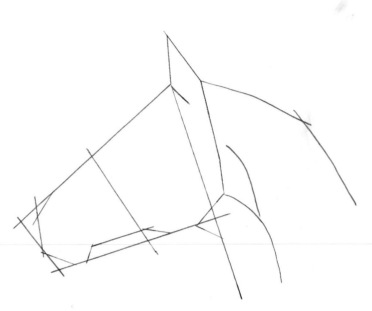

Step Two I continue using straight lines to block in the shape of the muzzle, paying particular attention to where these guidelines intersect. Now I roughly indicate the curve of the jaw with a series of lines that extend up to the base of the ears. Then I add a few curves to suggest the form of the neck.

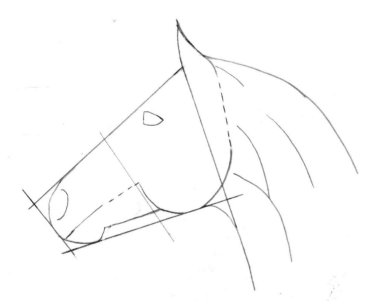

Step Three Working within the guidelines, I begin refining the neck, muzzle, and jaw. I carefully place the eye and nostril; then I indicate the line of the mouth. I use the dotted lines to check the accuracy of my proportions and angles.

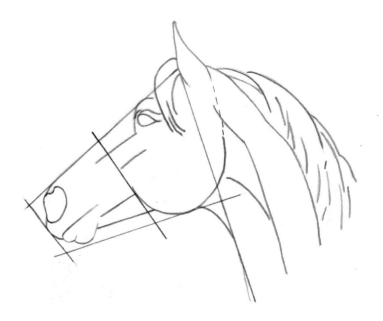

Step Four I develop the facial features and further refine the outlines, following the subtle curves of flesh around the mouth. Then I block in the mane and forelock with strokes that follow the direction of hair growth. I keep my strokes as light as I can in these initial stages.

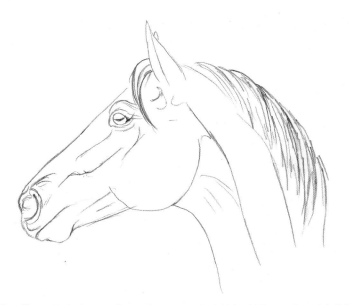

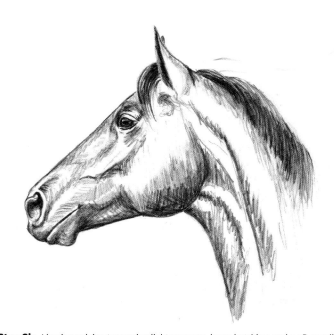

Step Five With the basic outline in place, I erase the initial guidelines. I also subtly lighten the outlines so they don't show through the final drawing. To do this, I softly dab at the lines with my eraser. Alternatively, I can trace my outline onto a clean sheet of paper before moving on to the next steps. (See "Tracing and Transferring" on page 13.)

Step Six I begin applying tone using light pressure, loose hatching, and a 3B pencil. I start with the darkest areas, such as beneath the jawline, in the nostril and eye, and within the mane and forelock. This establishes the general value pattern, which will guide the development of tone and texture of the horse's coat in the next step.

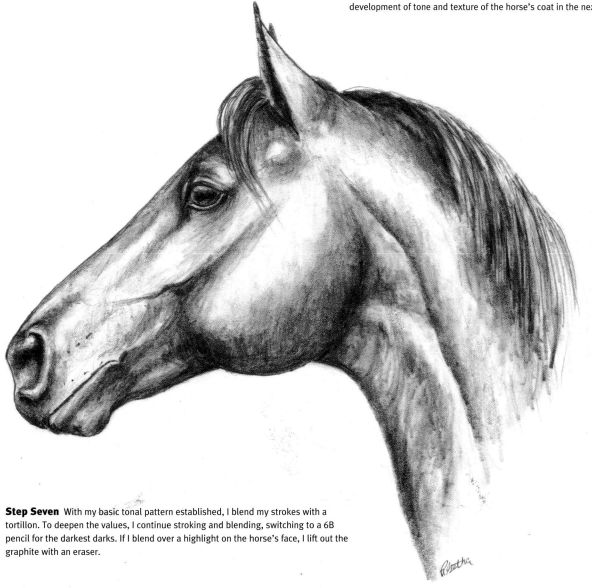

Step Seven With my basic tonal pattern established, I blend my strokes with a tortillon. To deepen the values, I continue stroking and blending, switching to a 6B pencil for the darkest darks. If I blend over a highlight on the horse's face, I lift out the graphite with an eraser.

ADVANCED PROFILES

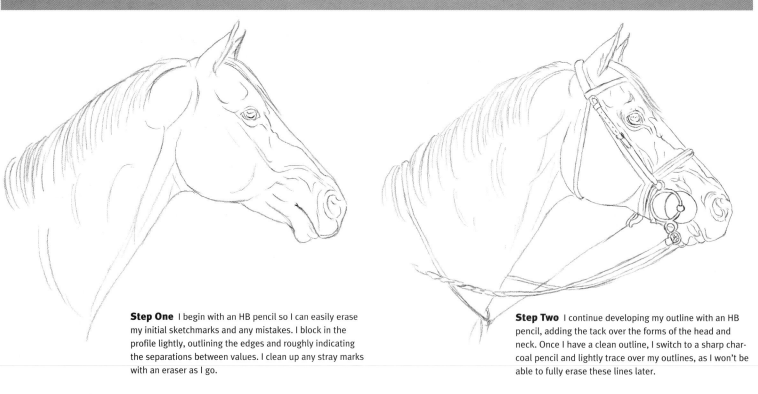

Step One I begin with an HB pencil so I can easily erase my initial sketchmarks and any mistakes. I block in the profile lightly, outlining the edges and roughly indicating the separations between values. I clean up any stray marks with an eraser as I go.

Step Two I continue developing my outline with an HB pencil, adding the tack over the forms of the head and neck. Once I have a clean outline, I switch to a sharp charcoal pencil and lightly trace over my outlines, as I won't be able to fully erase these lines later.

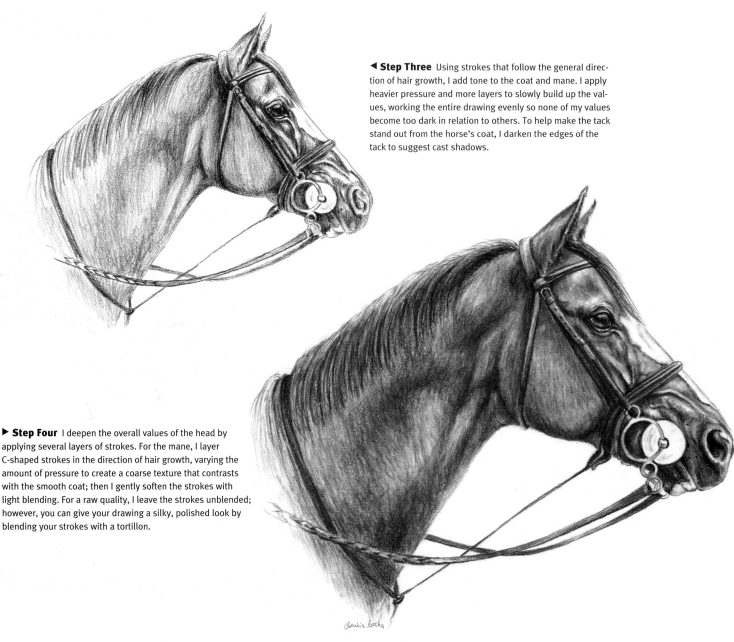

◀ **Step Three** Using strokes that follow the general direction of hair growth, I add tone to the coat and mane. I apply heavier pressure and more layers to slowly build up the values, working the entire drawing evenly so none of my values become too dark in relation to others. To help make the tack stand out from the horse's coat, I darken the edges of the tack to suggest cast shadows.

▶ **Step Four** I deepen the overall values of the head by applying several layers of strokes. For the mane, I layer C-shaped strokes in the direction of hair growth, varying the amount of pressure to create a coarse texture that contrasts with the smooth coat; then I gently soften the strokes with light blending. For a raw quality, I leave the strokes unblended; however, you can give your drawing a silky, polished look by blending your strokes with a tortillon.

Polo Pony

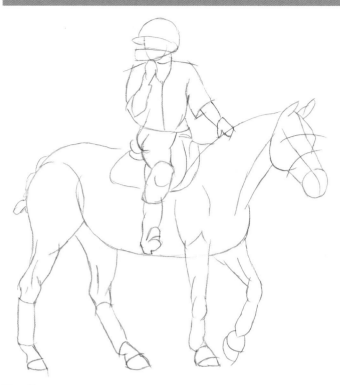

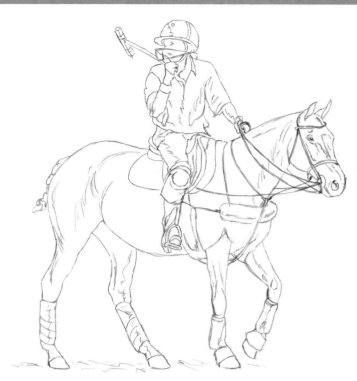

Step One Using an HB pencil, I begin by blocking in the basic shapes of the subject. I keep the lines and pencil pressure light so I can alter and refine them in the following steps. I don't worry about the reins and straps at this point—I just focus on the bulk of the rider and horse.

Step Two Now I add indications of muscles, tack, and shadows. I start refining any harsh angles to reflect the natural curves of the legs, haunches, shoulders, and facial features; then I refine the lines of the rider. I begin erasing any initial lines that I no longer need.

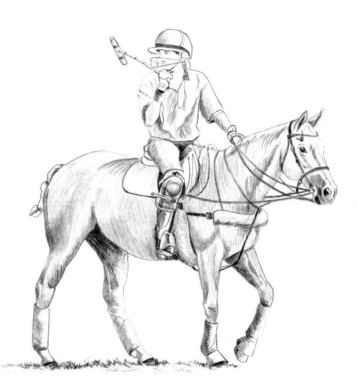

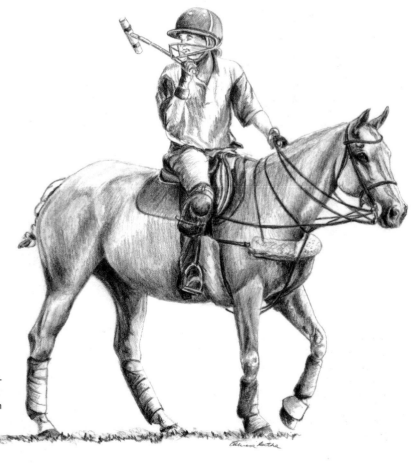

Step Three I begin developing form by adding a light layer of shading with an HB pencil. I focus on the areas of shadow, working from light to dark. As I add tone to the coat, I remember to stroke in the direction of hair growth. Then I sharpen the pencil and begin tightening up the straps.

Step Four In the final phase of my drawing, I use a 2B or 6B pencil to darken the deepest shadows and to develop details. For the middle tones, I lessen the pressure on my pencil while maintaining the sketchy feel of the strokes.

ARABIAN PORTRAIT

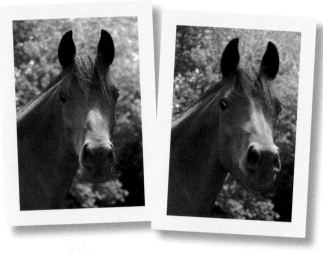

Combining References Two photo references were used for this drawing. I prefer the angle of the head and composition in the photo at left, but the horse is out of focus. I used the reference at right to compensate for this, as the details in this photo appear much sharper.

▶ **Step One** I begin this portrait with ovals for the head and muzzle; then I add several guidelines, as shown, to create reference points for adding the facial features. For example, the uppermost horizontal curve indicates the position of the top of the eyes. Now I add two lines indicating the neck and a curved line for the jaw. Then I carefully place the basic shapes of the ears.

▶ **Step Two** I add one final guideline to the left side of the horse's face to create the "dish" of the muzzle (the scoop from the nostrils to the bottom of the eye, which is characteristic of Arabians). Using the existing lines as references, I outline and add a few details to the facial features. Then I use quick, loose strokes to begin blocking in the mane and forelock, drawing the hair in the direction of growth.

▶ **Step Three** At this point, I erase the lines I no longer need and refresh my outlines. (When you do this, you may find that the guidelines aren't erasing well enough from the paper's surface. If this is the case, you can transfer your outline to a fresh sheet of paper. See "Tracing and Transferring" on page 13.) I continue developing the outline, indicating the subtle changes in form over the face and neck.

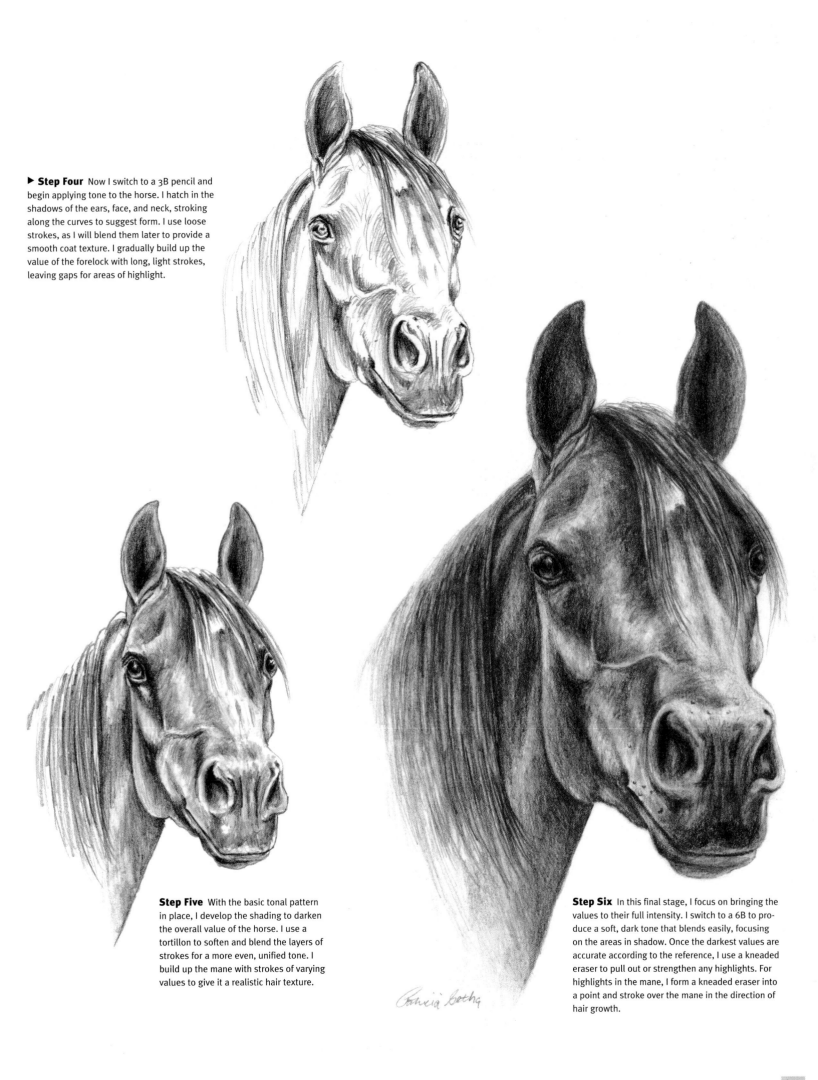

▶ **Step Four** Now I switch to a 3B pencil and begin applying tone to the horse. I hatch in the shadows of the ears, face, and neck, stroking along the curves to suggest form. I use loose strokes, as I will blend them later to provide a smooth coat texture. I gradually build up the value of the forelock with long, light strokes, leaving gaps for areas of highlight.

Step Five With the basic tonal pattern in place, I develop the shading to darken the overall value of the horse. I use a tortillon to soften and blend the layers of strokes for a more even, unified tone. I build up the mane with strokes of varying values to give it a realistic hair texture.

Step Six In this final stage, I focus on bringing the values to their full intensity. I switch to a 6B to produce a soft, dark tone that blends easily, focusing on the areas in shadow. Once the darkest values are accurate according to the reference, I use a kneaded eraser to pull out or strengthen any highlights. For highlights in the mane, I form a kneaded eraser into a point and stroke over the mane in the direction of hair growth.

Appaloosa

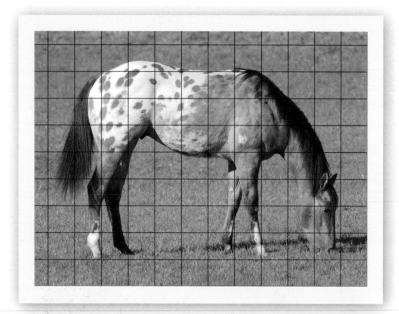

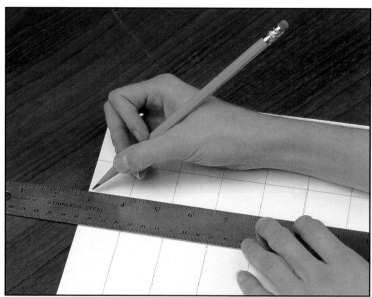

Step One To re-create this photograph, I decide to use the grid method, which uses simple squares as reference points for transferring an image to drawing paper. I begin by placing a grid of one-inch squares over a photocopy of my reference using a pencil and a ruler. I refer to this as I place the outline in my hand-drawn grid in step three.

Step Two Using an HB pencil and very light pressure, I create a grid of squares on my paper that has the same number of rows and columns as the one placed over the reference.(Remember: If you want your final drawing to be larger than the reference, make the squares of the grid larger; if you want your final to be smaller, make the squares smaller.)

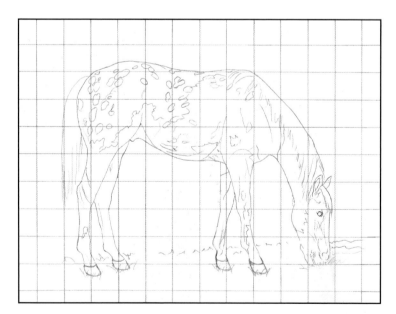

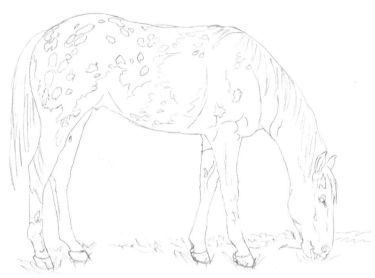

Step Three Now I simply create the outline of the horse by copying what I see in each square of the reference into each square of my drawn grid. (You may choose to keep the outline simple and basic, as you always can refine it after erasing the grid—or you can give yourself a thorough guide by adding the facial features and coat patterns.)

Step Four Using the eraser, I gently rub away the grid lines. I try not to rub too hard, as I don't want to damage the surface of the paper. Then I redraw any areas of the lines that have been accidentally erased, restoring the outline as I go. (If you have trouble fully erasing the grid lines, you may want to transfer your outline to a fresh sheet of paper. See "Tracing and Transferring" on page 13.)

▶ **Step Five** Now I begin working tone into the shadows and across the body using the 3B and 6B pencils. I use layers of graphite to build my drawing slowly—I start out with light pressure, and then I use heavier strokes to develop the muscles and other details. Notice that some of the spots aren't solid—some even contain spots themselves. Noting and capturing these subtleties will add realism to your finished drawing.

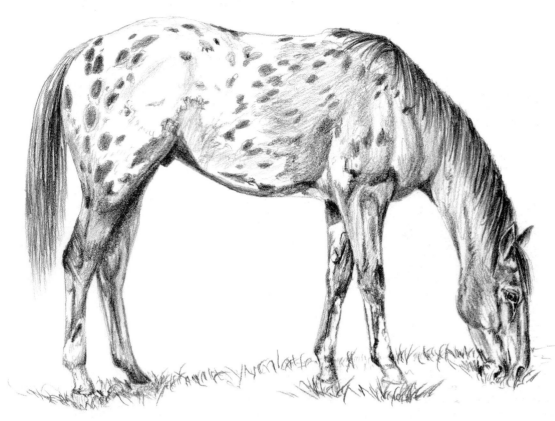

◀ **Step Six** I continue adding value to the horse and grass, working evenly across the drawing. For the light areas of the horse, I use a very light layer of tone to make it stand out from the white of the background. I leave only the brightest highlights free of tone; if I happen to cover them with tone, I simply pull out the graphite with an eraser.

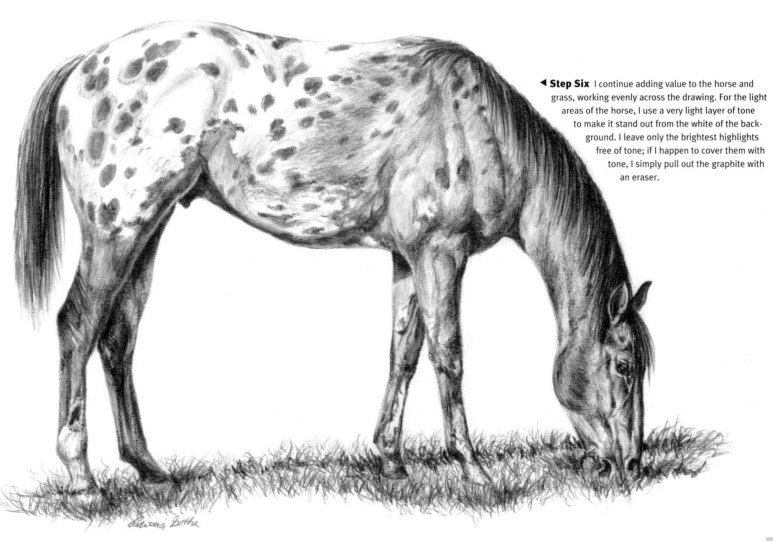

FOAL STANDING

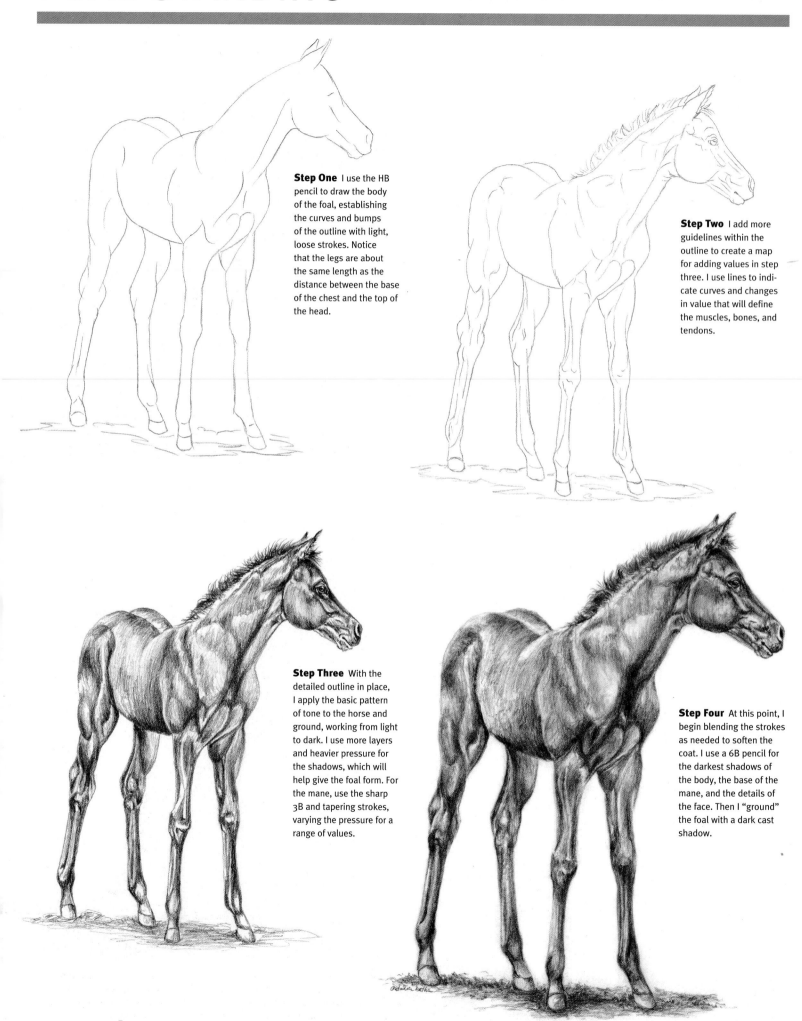

Step One I use the HB pencil to draw the body of the foal, establishing the curves and bumps of the outline with light, loose strokes. Notice that the legs are about the same length as the distance between the base of the chest and the top of the head.

Step Two I add more guidelines within the outline to create a map for adding values in step three. I use lines to indicate curves and changes in value that will define the muscles, bones, and tendons.

Step Three With the detailed outline in place, I apply the basic pattern of tone to the horse and ground, working from light to dark. I use more layers and heavier pressure for the shadows, which will help give the foal form. For the mane, use the sharp 3B and tapering strokes, varying the pressure for a range of values.

Step Four At this point, I begin blending the strokes as needed to soften the coat. I use a 6B pencil for the darkest shadows of the body, the base of the mane, and the details of the face. Then I "ground" the foal with a dark cast shadow.

FOAL CANTERING

Step One This foal in action has three feet off the ground—with this tricky position, I am careful not to tip the horse forward in my sketch. Beginning with the HB pencil, I use light strokes and curving lines to establish the body; then I begin defining the bulges and muscles within the outline. I mark the centerline and browline for feature placement.

Step Two I continue refining the outline, adding details to the neck, face, and legs. I create the distinct curve of the neck, following the contours of the muscles. I add the mane with a series of short, random strokes; then I suggest the tail with a few curved strokes.

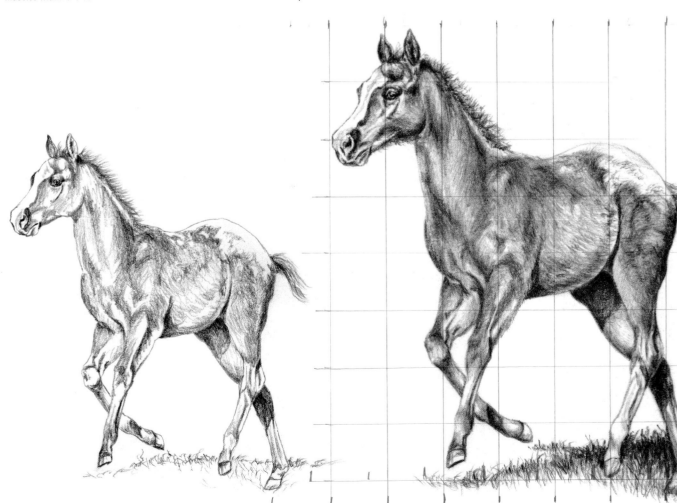

Step Three I use short, rough strokes to suggest this young Appaloosa's fuzzy spring coat. I begin creating the shadows using a 3B; then I work across the body evenly. I block in the two cast shadows on the back right leg with even darker tone. I keep the mane and tail wispy by building up light, tapering strokes.

Step Four Now I switch to the 6B pencil and apply a more polished layer of strokes over the horse's coat, following the direction of hair growth. I avoid stroking over the horse's backside, instead working around the foal's markings. I give the forms and features more contrast by pumping up the darks, and I retrieve highlights with an eraser.

STANDARDBRED TROTTER

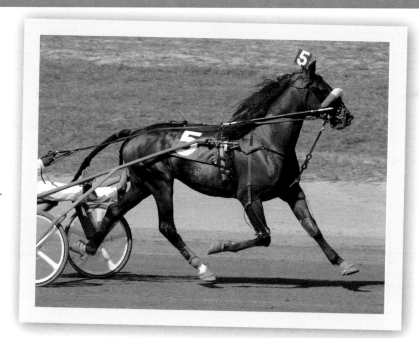

▶ **Defining the Muscles** Because this drawing depicts a competitive horse, it's important to emphasize the fine musculature. I keep the croup flat and the haunches well defined to indicate the propelling power of the hindquarters.

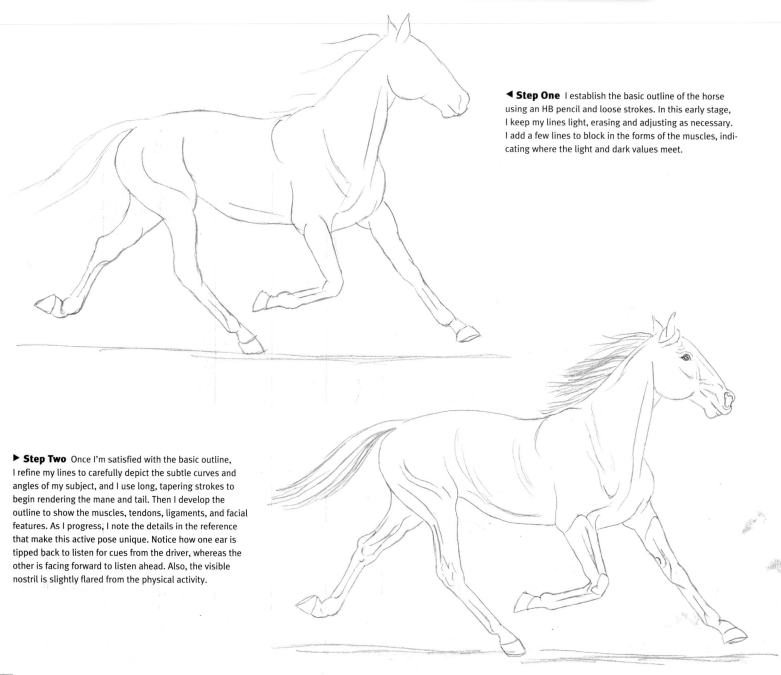

◀ **Step One** I establish the basic outline of the horse using an HB pencil and loose strokes. In this early stage, I keep my lines light, erasing and adjusting as necessary. I add a few lines to block in the forms of the muscles, indicating where the light and dark values meet.

▶ **Step Two** Once I'm satisfied with the basic outline, I refine my lines to carefully depict the subtle curves and angles of my subject, and I use long, tapering strokes to begin rendering the mane and tail. Then I develop the outline to show the muscles, tendons, ligaments, and facial features. As I progress, I note the details in the reference that make this active pose unique. Notice how one ear is tipped back to listen for cues from the driver, whereas the other is facing forward to listen ahead. Also, the visible nostril is slightly flared from the physical activity.

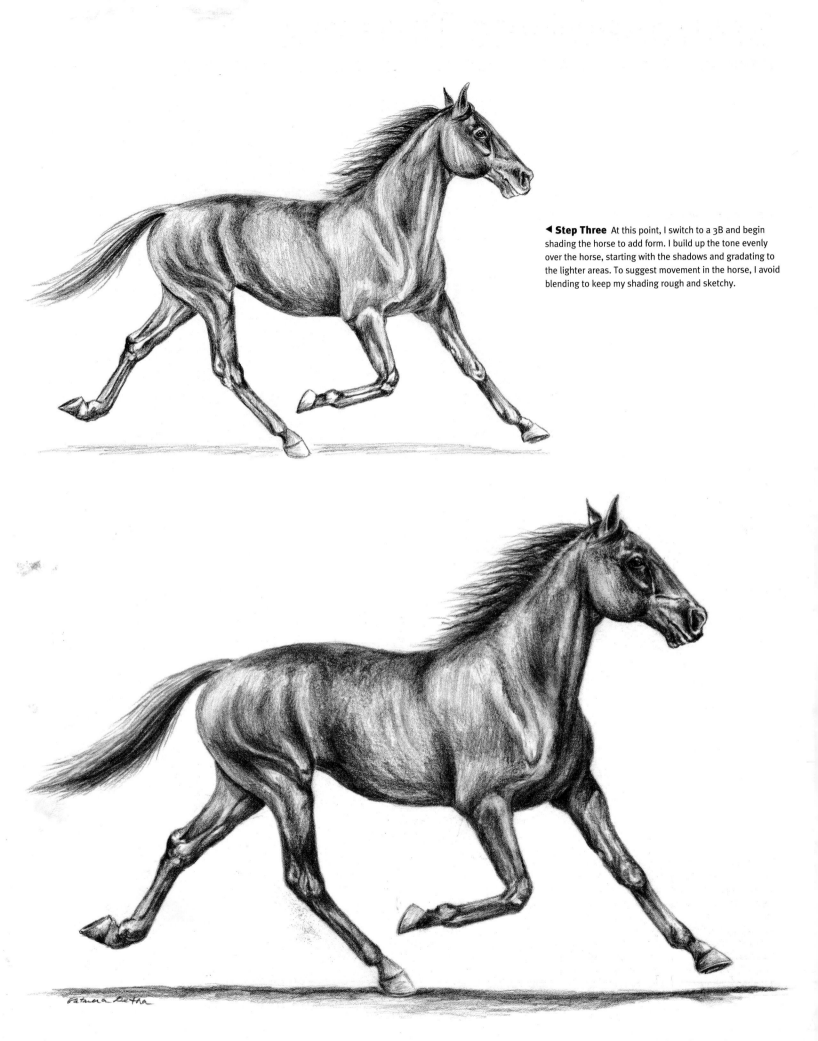

◄ Step Three At this point, I switch to a 3B and begin shading the horse to add form. I build up the tone evenly over the horse, starting with the shadows and gradating to the lighter areas. To suggest movement in the horse, I avoid blending to keep my shading rough and sketchy.

Step Four In this final step, I focus on punching up the values. I stick with the HB and 2B pencils to shade within the lighter areas, but I change to a 6B for darker values. It's important to use the softest pencils for the darkest areas, as harder pencils can burnish the graphite, causing odd reflections or even damage to the paper's surface.

AMERICAN SADDLEBRED & RIDER

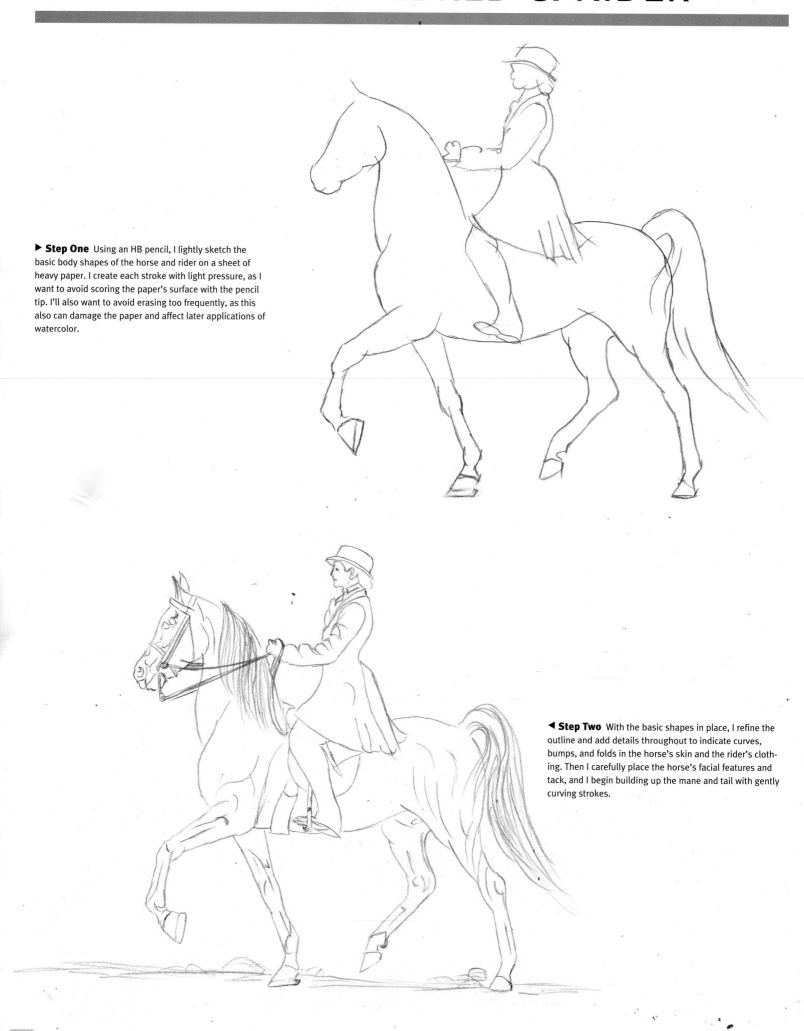

▶ **Step One** Using an HB pencil, I lightly sketch the basic body shapes of the horse and rider on a sheet of heavy paper. I create each stroke with light pressure, as I want to avoid scoring the paper's surface with the pencil tip. I'll also want to avoid erasing too frequently, as this also can damage the paper and affect later applications of watercolor.

◀ **Step Two** With the basic shapes in place, I refine the outline and add details throughout to indicate curves, bumps, and folds in the horse's skin and the rider's clothing. Then I carefully place the horse's facial features and tack, and I begin building up the mane and tail with gently curving strokes.

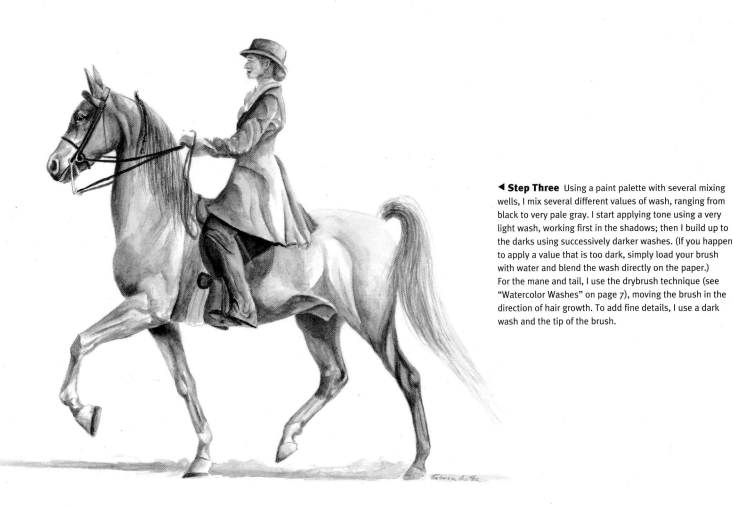

◄ Step Three Using a paint palette with several mixing wells, I mix several different values of wash, ranging from black to very pale gray. I start applying tone using a very light wash, working first in the shadows; then I build up to the darks using successively darker washes. (If you happen to apply a value that is too dark, simply load your brush with water and blend the wash directly on the paper.) For the mane and tail, I use the drybrush technique (see "Watercolor Washes" on page 7), moving the brush in the direction of hair growth. To add fine details, I use a dark wash and the tip of the brush.

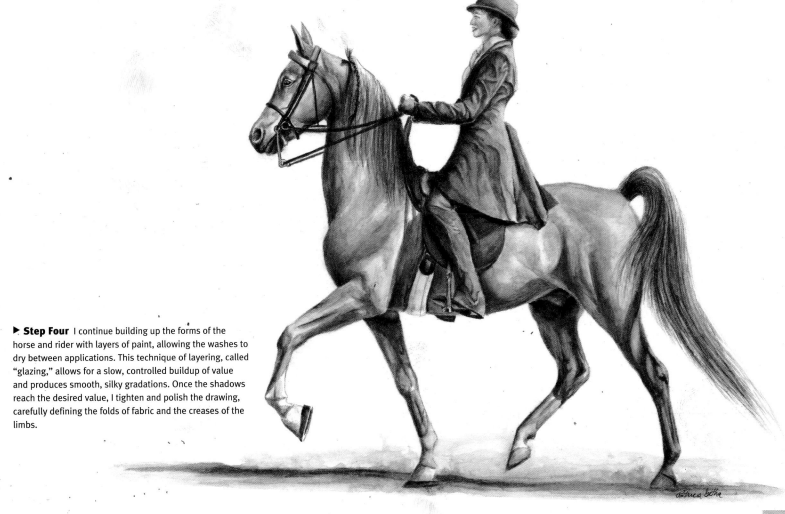

► Step Four I continue building up the forms of the horse and rider with layers of paint, allowing the washes to dry between applications. This technique of layering, called "glazing," allows for a slow, controlled buildup of value and produces smooth, silky gradations. Once the shadows reach the desired value, I tighten and polish the drawing, carefully defining the folds of fabric and the creases of the limbs.

Gypsy Vanner

◀ **Step One** Using an HB pencil, I lightly sketch the outline of the horse to indicate basic anatomy. (If necessary, you can break this step down into even simpler shapes of circles and triangles to block in the body, legs, and feet.)

▶ **Step Two** I add more anatomical elements and refine my outline. I also delineate the large shapes that make up the coat pattern, keeping my lines loose and light so I can erase them later if necessary.

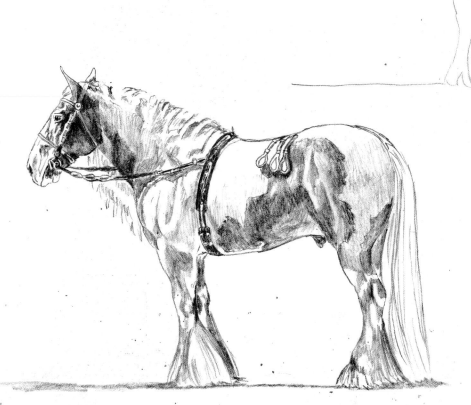

◀ **Step Three** In this stage, I begin to add tone to give my drawing a sense of form. I look at the final drawing and notice the strong light patterns on the horse. This play of light over the horse's back and down his side defines the muscle groups, therefore it should be captured accurately. I continue using an HB pencil and lightly lay in the middle and dark tones across the body, using a bit more pressure in the darker areas.

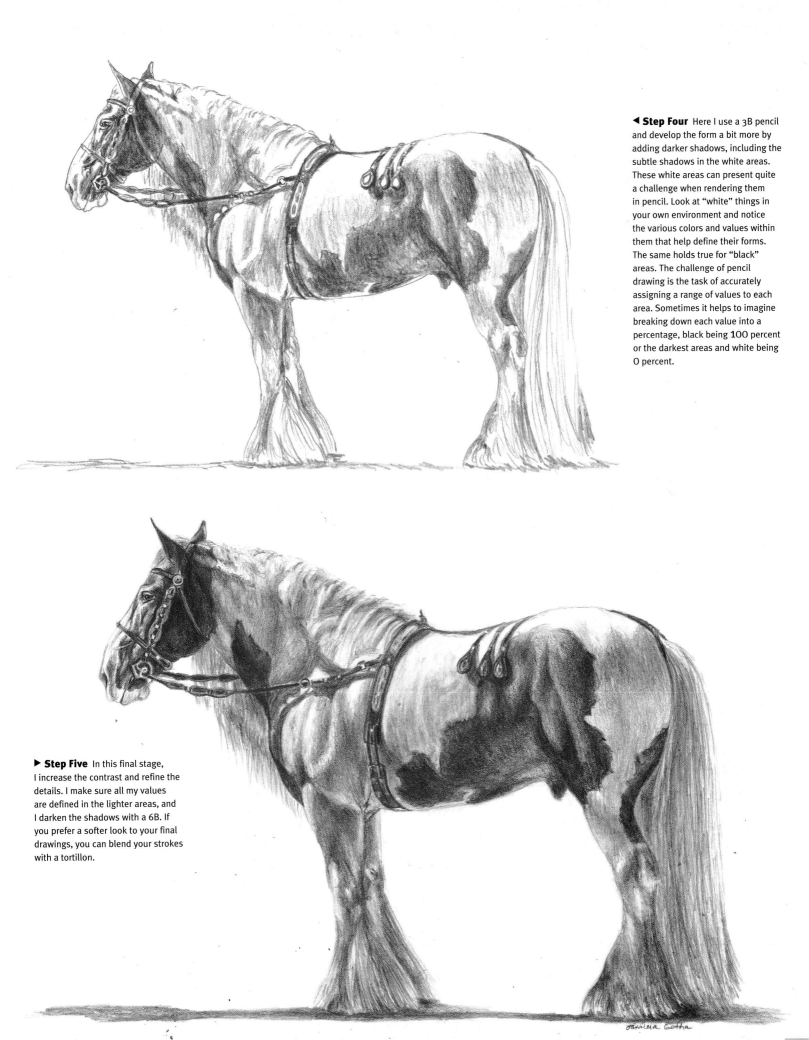

◀ **Step Four** Here I use a 3B pencil and develop the form a bit more by adding darker shadows, including the subtle shadows in the white areas. These white areas can present quite a challenge when rendering them in pencil. Look at "white" things in your own environment and notice the various colors and values within them that help define their forms. The same holds true for "black" areas. The challenge of pencil drawing is the task of accurately assigning a range of values to each area. Sometimes it helps to imagine breaking down each value into a percentage, black being 100 percent or the darkest areas and white being 0 percent.

▶ **Step Five** In this final stage, I increase the contrast and refine the details. I make sure all my values are defined in the lighter areas, and I darken the shadows with a 6B. If you prefer a softer look to your final drawings, you can blend your strokes with a tortillon.

AMERICAN PAINT HORSE

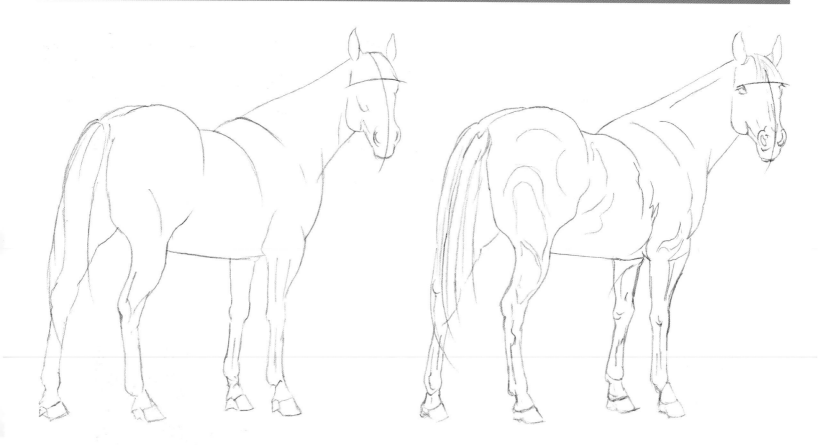

Step One Using an HB pencil, I block in the basic shapes and outline of the horse. Her body is slightly foreshortened through the barrel, so I'm careful to make up for any distortions in my reference. Some camera lenses tend to distort objects taken from this angle—the rump may appear too large in relation to the rest of the body, and the head may appear much smaller and farther away. I retain a sense of the foreshortening in my drawing, but I avoid transferring this exaggerated distortion; these qualities become more obvious in a drawing. Notice that the backs of the pasterns and heels of the feet are visible. I am careful to watch the angles of the feet, making sure they appear accurate.

Step Two In this stage, I refine the drawing and start to note the placement of major muscle groups, tendons, shadows, and highlights. I delineate these areas with light lines as I continue to work with an HB pencil.

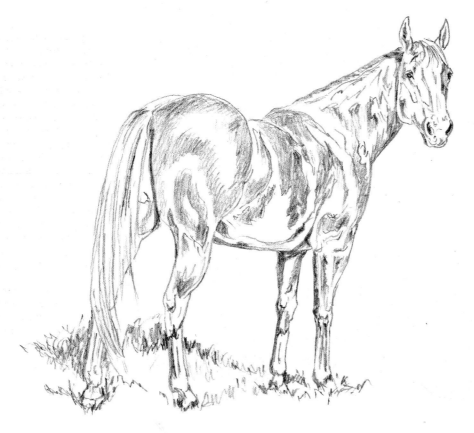

◄ **Step Three** Following the pattern of tone on my reference, I lightly block in the markings of the horse with strokes that follow the direction of coat growth. I continue to note highlights and shadows.

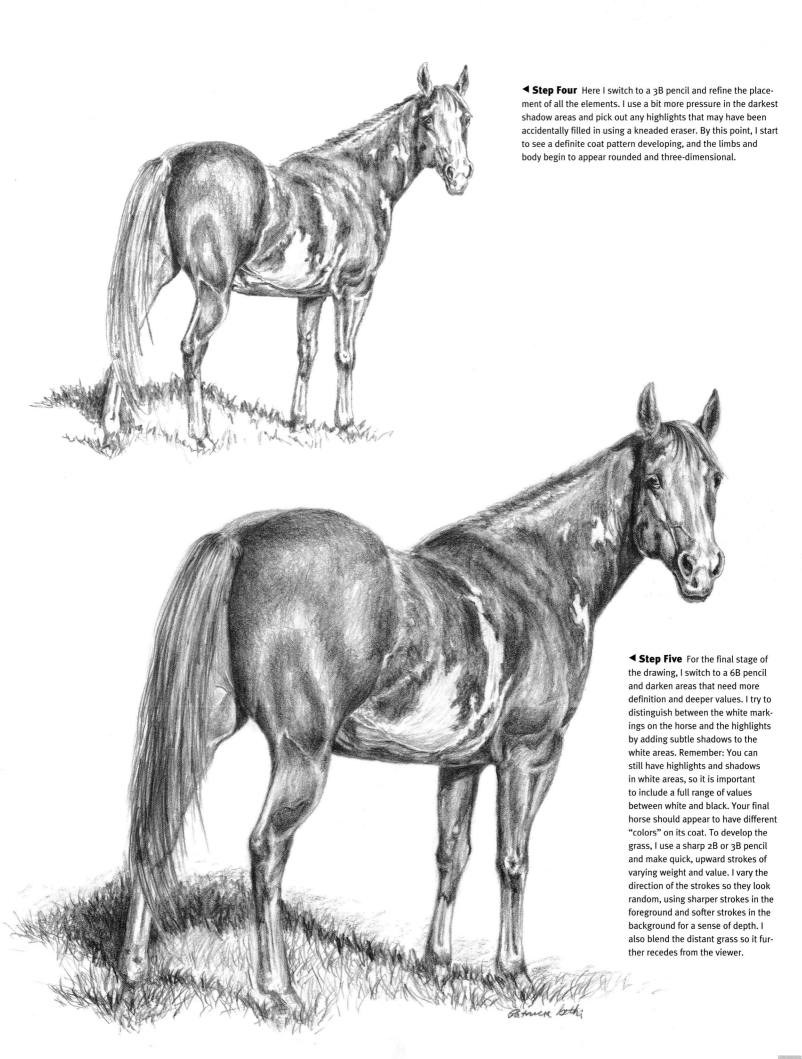

◄ Step Four Here I switch to a 3B pencil and refine the placement of all the elements. I use a bit more pressure in the darkest shadow areas and pick out any highlights that may have been accidentally filled in using a kneaded eraser. By this point, I start to see a definite coat pattern developing, and the limbs and body begin to appear rounded and three-dimensional.

◄ Step Five For the final stage of the drawing, I switch to a 6B pencil and darken areas that need more definition and deeper values. I try to distinguish between the white markings on the horse and the highlights by adding subtle shadows to the white areas. Remember: You can still have highlights and shadows in white areas, so it is important to include a full range of values between white and black. Your final horse should appear to have different "colors" on its coat. To develop the grass, I use a sharp 2B or 3B pencil and make quick, upward strokes of varying weight and value. I vary the direction of the strokes so they look random, using sharper strokes in the foreground and softer strokes in the background for a sense of depth. I also blend the distant grass so it further recedes from the viewer.

PINTO PONY

◄ Step One I start this drawing by lightly blocking in the outline of the body. I indicate the lines in the neck so that when I start shading and adding the mane, I understand how the anatomy would look under all that hair. It is not often that one has the opportunity to sketch a horse in this position, therefore it is important to study the anatomy whenever possible so you can render it accurately. While creating the outline, I notice how various parts of the body line up with one another and compare in size; for example, the withers are the same height as the rump. Picking up on details like this will help you achieve an accurate initial sketch.

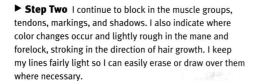

► Step Two I continue to block in the muscle groups, tendons, markings, and shadows. I also indicate where color changes occur and lightly rough in the mane and forelock, stroking in the direction of hair growth. I keep my lines fairly light so I can easily erase or draw over them where necessary.

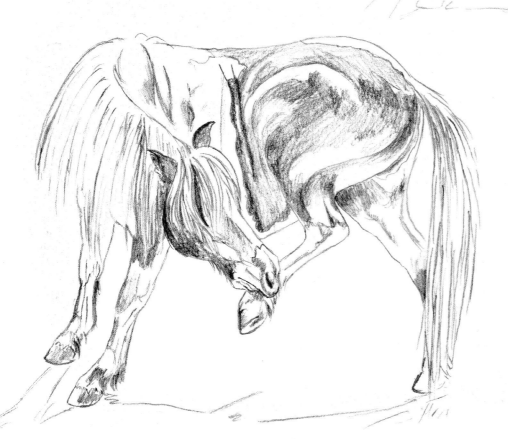

◄ Step Three In this step, I lightly block in the basic values with quick strokes that follow the natural flow of the coat and hair. I pay particular attention to where the direction changes course, such as in the hip area, to keep it as realistic as possible. I keep in mind that there is a very strong light source illuminating the back and top of the withers, creating highlights that will help define the muscles, wrinkles, and anatomy of the pony. Re-creating these effects of backlighting adds contrast and drama to the scene.

▶ Step Four I continue to develop the shadows with a 3B pencil. Because of the strong light on the withers, I don't find a lot of detail in this area, but I still lightly indicate what should be there and suggest the top line of the neck. Using a very sharp 2B pencil, I refine the mane with long, tapering strokes of varying pressure, keeping the lightest areas free of tone. (You may choose to blend this area and soften the strokes with a tortillon.) If the strokes get too dark, I pick them out with a kneaded eraser. I keep on hand a simple, inexpensive barbecue brush (purchased at a grocery store) to brush away any eraser crumbs. Also, I often use a clean sheet of paper to cover areas of the drawing I've worked on to prevent the graphite from smudging, especially in the darker areas.

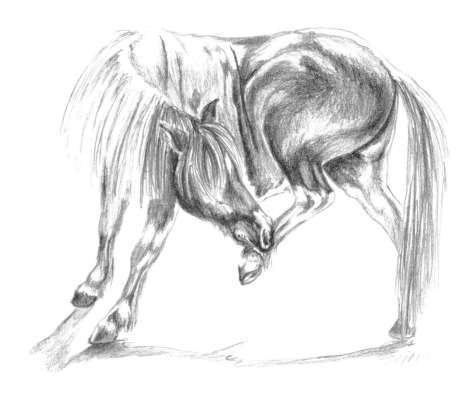

▶ Step Five I finish the drawing by darkening all the shadow areas using a 6B pencil. As I create the cast shadow, I keep in mind that it should always reflect the texture of the surface it appears on. If the surface is rough, the shadow should appear rough as well. If the surface is smooth, blend the shadow to reflect a smooth, uniform texture. As I shade the body, I am especially careful not to lose the nice wrinkles caused by the long stretch of the neck and the body folding in on itself. I often see horses hike up a hind leg and scratch an ear with the hoof like a dog. They must accomplish this while standing, so it is somewhat comical to watch—you would think that a horse would not be able to do this without hurting itself!

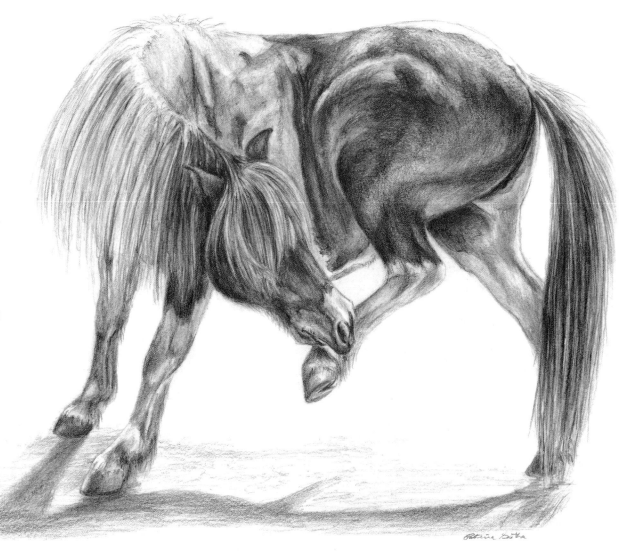

AMERICAN MORGAN HORSE

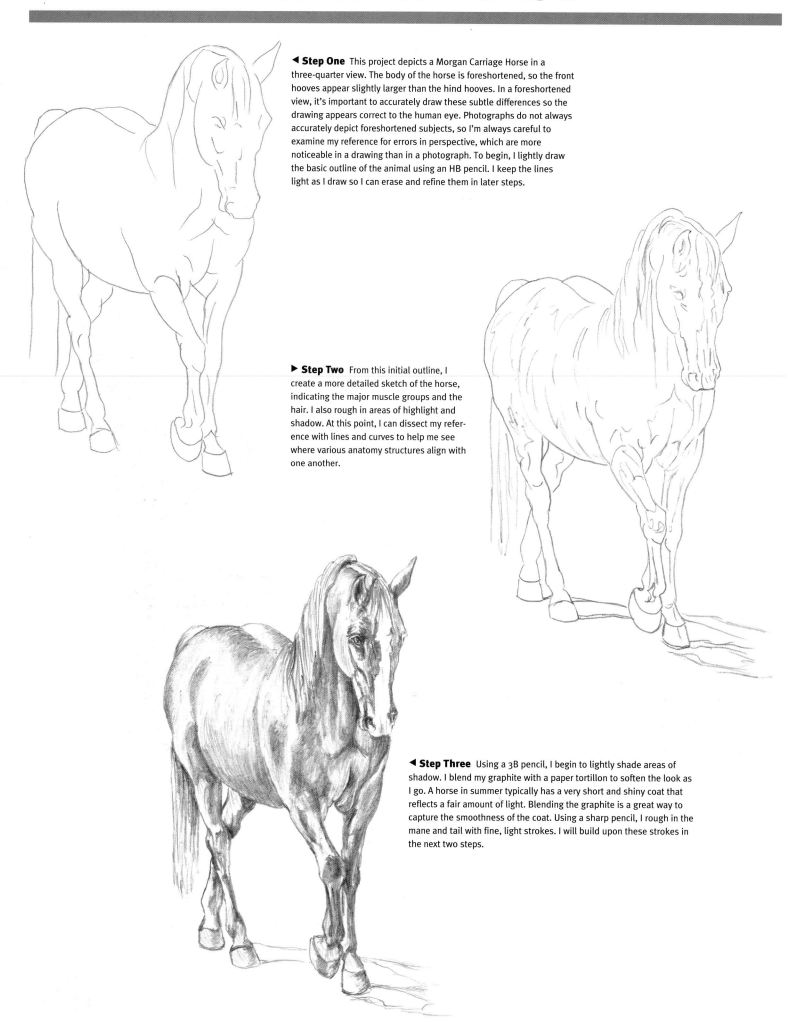

◀ **Step One** This project depicts a Morgan Carriage Horse in a three-quarter view. The body of the horse is foreshortened, so the front hooves appear slightly larger than the hind hooves. In a foreshortened view, it's important to accurately draw these subtle differences so the drawing appears correct to the human eye. Photographs do not always accurately depict foreshortened subjects, so I'm always careful to examine my reference for errors in perspective, which are more noticeable in a drawing than in a photograph. To begin, I lightly draw the basic outline of the animal using an HB pencil. I keep the lines light as I draw so I can erase and refine them in later steps.

▶ **Step Two** From this initial outline, I create a more detailed sketch of the horse, indicating the major muscle groups and the hair. I also rough in areas of highlight and shadow. At this point, I can dissect my reference with lines and curves to help me see where various anatomy structures align with one another.

◀ **Step Three** Using a 3B pencil, I begin to lightly shade areas of shadow. I blend my graphite with a paper tortillon to soften the look as I go. A horse in summer typically has a very short and shiny coat that reflects a fair amount of light. Blending the graphite is a great way to capture the smoothness of the coat. Using a sharp pencil, I rough in the mane and tail with fine, light strokes. I will build upon these strokes in the next two steps.

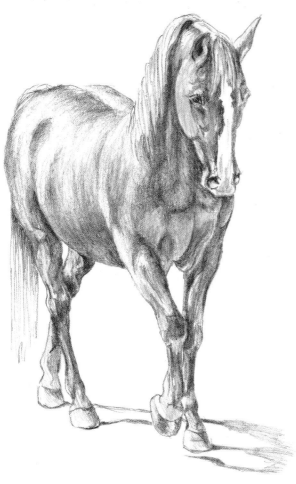

◄ Step Four At this point, I have a good idea of the placement of all the shadows and highlights. I continue to build layers of graphite with a 3B pencil (you can go even softer, if you like), blending with the tortillon as I go. I restore any highlights that have been covered with tone using a kneaded eraser.

► Step Five In the final stage, I switch to a 6B pencil and darken the shadows. I try to indicate the veins and tendons, which are typically visible on a horse at work. This will add realism to your drawings. Sometimes it's difficult to render realistic "white" areas in graphite, as they are not always pure white. I am sure to indicate this in my drawings to give them form and depth. It's also important to distinguish the white areas of the coat in shadow from the non-white areas in the light. To accomplish this, I am careful to use a different range of values within each "color" of the coat.

Dappled Pony

◄ Step One I start by blocking in the main forms of the body, legs, and head. Notice that I draw the arch of the neck even though this area is hidden in the final drawing; it's always important to have a sense of the underlying shapes and alignments. I also rough in the hooves. Hooves are difficult to draw, even for seasoned artists. It is worthwhile to practice drawing them from different angles, even if they don't appear in your final drawing. While it is sometimes a challenge to draw from life, this is the best way to see firsthand how all the parts of the body come together. Photographs tend to flatten forms, making it difficult to determine just how something should look.

► Step Two Building on the sketch from step one, I create a detailed outline of the horse, indicating the position of various anatomical structures, highlights, and shadows. I keep my lines light so I can alter them as I progress. I use an HB pencil for this step, as this lead is neither too hard nor too soft. As a general rule, I use an HB for sketching and reserve hard pencils for light areas and soft pencils for the dark areas. A 3B pencil is great for creating midtones.

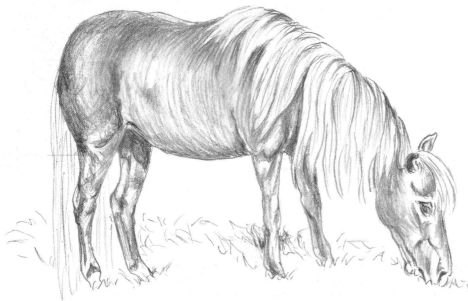

◄ Step Three Step three is a natural progression into step four. I start by laying in the shadows, which help create form and dimension in the drawing. I keep my initial values light and layer the graphite to build the values. I also continue building the mane with long, tapering strokes that curve to suggest the forms of the neck and back.

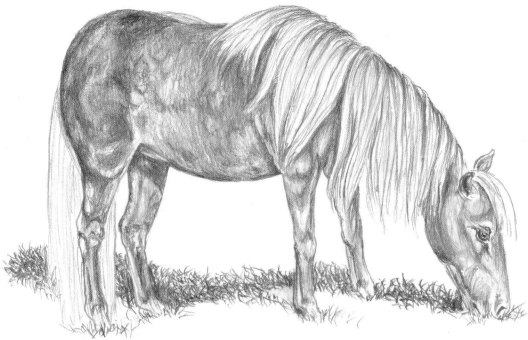

◄ Step Four I don't actually draw individual dapples on the coat. Rather, I blend the values together and then carefully pick out the lighter areas with a kneaded eraser. I am careful to keep the edges soft; hard edges will make the dapples appear unnatural. They should blend into one another and reflect the way the light falls on the body, so the dapples in shadow should appear slightly darker than those in the light. I keep the dapples somewhat random so they look natural, avoiding a patterned look. After picking out the dapples, I lightly shade over the top of them, gradating to a lighter tone toward the bottom of the barrel (torso). For this stage, I switch to a harder lead so I'm not tempted to get too dark.

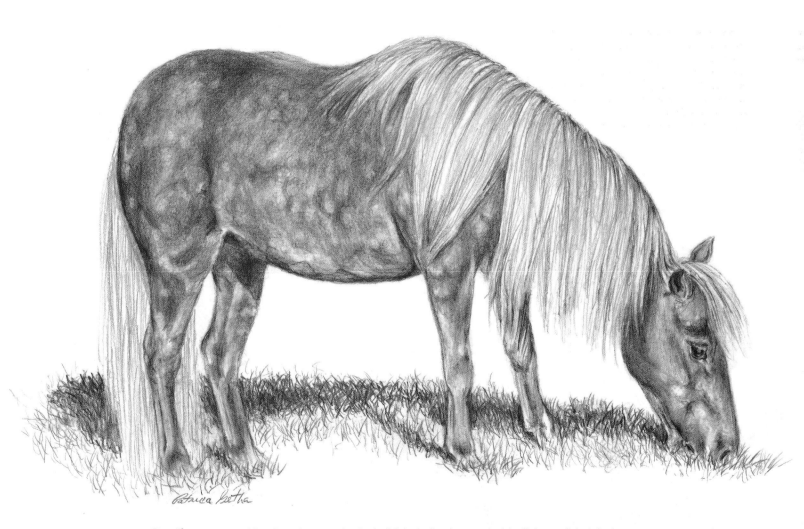

Step Five I continue adding dimension to my drawing by lightly shading the areas receiving little or no light. I clearly indicate the direction of the light by developing the cast shadow on the grass. Using a sharp pencil, I lay in quick, upward strokes of varying values and direction to indicate the texture of the grass. The mane and tail are much lighter than the body, so I am careful to maintain this distinction by leaving areas of lighter strokes intermixed with darker ones. The top of the mane does not have as much light shining on it, so I use slightly darker strokes along this area. Now my drawing is complete.

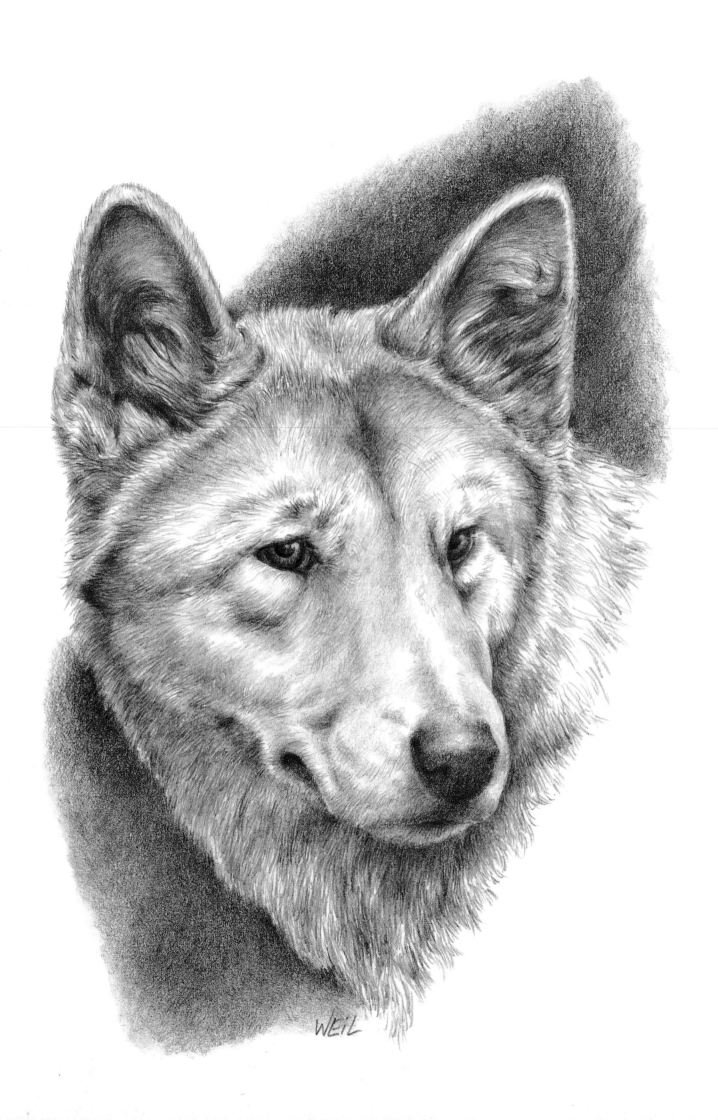

WILD ANIMALS
WITH LINDA WEIL

Linda Weil lives and works in Melbourne, Australia. A graduate of RMIT University, Linda began her career in graphic design, primarily in the print industry. She has been art director and illustrator for a number of Australia's national magazines, and she has specialized in botanical and natural history illustration. A member and past secretary of the Wildlife Artist Society of Australasia, and a member of the Australian Guild of Realist Artists, Linda teaches drawing locally to both beginners and advanced students. Her work has won numerous awards, and she exhibits in galleries and shows throughout Australia. Linda has traveled widely throughout Australia, France, Borneo, the United States, and South Africa, and many of her drawings are a result of the animals and sights she has seen on her travels.

ASIAN ELEPHANT

Large animals such as elephants are great subjects for your first attempts at drawing wildlife. The big, round forms are easy to understand, and the texture of the skin is less daunting than fur. This project features an Asian elephant, which differs slightly from an African elephant in that it has a smaller body and ears, as well as a rounder back. It also has a fourth toenail on its rear feet and only one "finger" at the end of its trunk. The head and body are sparsely covered in wiry hair. Because they are working animals, their tusks often have been cut short to prevent damage to their surroundings. Noting these characteristics will help you accurately portray this type of elephant.

▶ **Rough Sketch** I start with a rough sketch as a plan for the final drawing. Using a soft 2B pencil, I define the general forms of the elephant. I also indicate the lights and darks, keeping in mind that the light is coming from above right. I want the viewer to know that this elephant is Asian, so I decide to add a Malaysian-style house in the background.

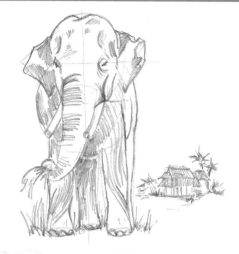

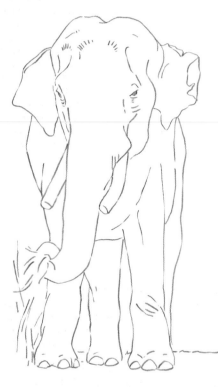

◀ **Step One** Now I transfer only the outline of my sketch to my final art paper. I tape the sketch to a bright window and place a piece of art paper over the sketch. Then I use an HB pencil to carefully trace the outline on the art paper. I do not include any details or the background at this time. For reproduction purposes, the outline you see here is much darker than I would use in my work. I will erase much of the outline by dabbing at it with a kneaded eraser as I work.

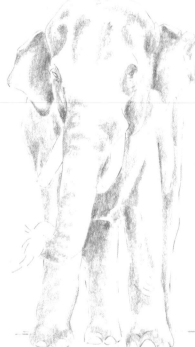

◀ **Step Two** I need to create a very soft, smooth tone to represent the underlayer of skin prior to adding the rough, cracked texture. Using a 2B woodless pencil, I make small circular strokes to fill in the darkest shadow areas. I leave large areas of white, as I will blend the graphite into these areas in the next step. To help protect the white of the paper, I wear a cotton glove with the tips of the fingers cut off. I also rest my hand on a sheet of paper that covers part of the drawing surface.

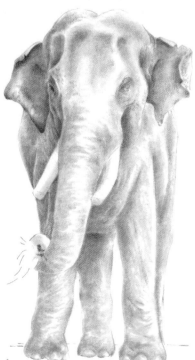

◀ **Step Three** Using a tortillon and light, circular motions, I slowly blend the dark graphite into the white areas of the paper for a smooth, satiny look. I use this residual graphite on the tip of the tortillon to "paint" lighter tones over the white areas of the elephant. Then I use a 2B and circular motions to darken the shadows from step two.

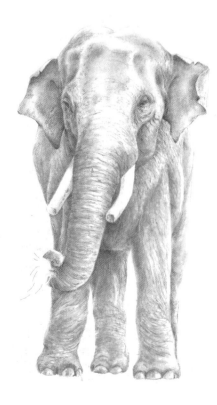

◀ **Step Four** I use the graphite on the tip of the tortillon to "paint" softer tones on the tusks, across the forehead and ears, and on the trunk and chest. Then I add wrinkles to the head, ears, and trunk using a sharp HB mechanical pencil. I sharpen the edges of the curls in the ears and use circular strokes around the eyes. Then I continue down the body, adding wrinkles and creases. I add details to the toes and darken the ends of the tusks. I realize that something is not quite right with the legs, but I keep drawing. Using a sharp 2B mechanical pencil, I darken and enhance the wrinkles, as well as areas around the eyes and inside the ears.

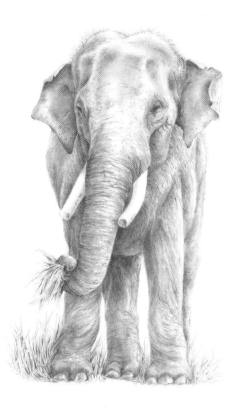

◀ **Step Five** With the 2B pencil, I continue to build up the form of the tough, wrinkled skin. I also deepen the tones in the darkest shadows, and I add some dark hairs on the elephant's head and back. With a very sharp HB pencil, I draw strokes of various lengths to represent the grass on the ground as well as at the end of the elephant's trunk. Then I use a sharp 2B to fill in dark areas between the strokes and give the grass some depth. Next I add further detail in the feet and toes.

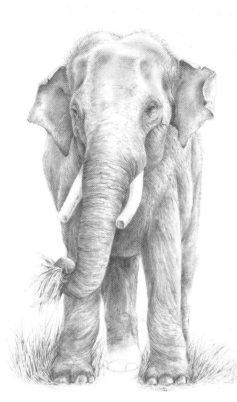

◀ **Step Six** After darkening the grass, I switch to an HB pencil and return to the elephant, emphasizing darks and adding more wrinkles where needed. I still am not happy with the legs; they seem too long and out of proportion. I realize that I was fooled by the photographic distortion of perspective in my reference, which resulted in the elephant's rear right leg appearing too long. I need to raise the elephant's rear right foot and shorten the leg. I carefully erase the bottom portion of the rear right leg with a kneaded eraser. Because I blended the graphite, I cannot remove all the tone. As you can see here, there is a faint "ghost" foot remaining. I will hide this under grass in the next step.

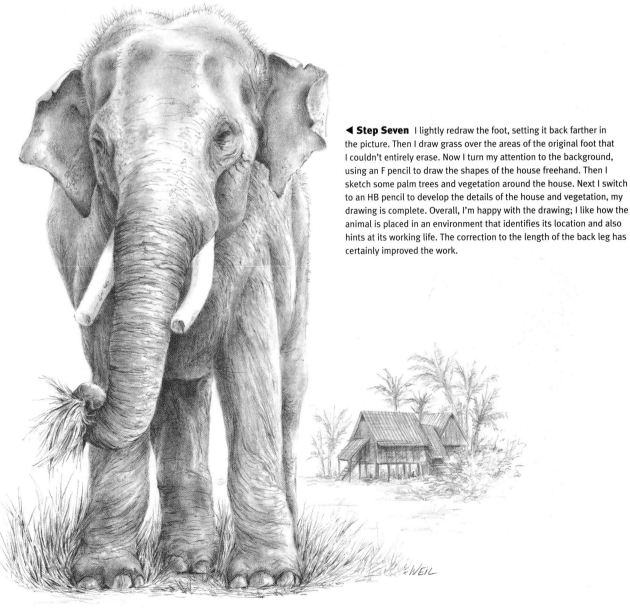

◀ **Step Seven** I lightly redraw the foot, setting it back farther in the picture. Then I draw grass over the areas of the original foot that I couldn't entirely erase. Now I turn my attention to the background, using an F pencil to draw the shapes of the house freehand. Then I sketch some palm trees and vegetation around the house. Next I switch to an HB pencil to develop the details of the house and vegetation, my drawing is complete. Overall, I'm happy with the drawing; I like how the animal is placed in an environment that identifies its location and also hints at its working life. The correction to the length of the back leg has certainly improved the work.

AUSTRALIAN BARKING OWL

The large, slightly crossed eyes and facial "mask" of the Australian Barking Owl are particularly striking. I visited a local wildlife sanctuary and closely observed this subject during a "free flight" demonstration. I was able to take a number of good photos of the bird in flight, as well as when it landed on a nearby fence railing, which is the pose I choose to depict. As I have mentioned, it is always helpful to understand the anatomy of the animal you are drawing. When drawing birds, pay attention to the way the feathers lay. Most birds share the same general feather structure, so refer to diagrams in encyclopedias or other references for help.

▶ **Basic Shapes** I start by drawing a simple circle for the head, dividing it horizontally and vertically along arcs that represent the curvature of the head. My photos show that the owl's body is approximately 2 heads high, the wings extend to about 2¹/₂ heads, and the tail feathers extend to about 3¹/₂ heads. I use these proportions to determine the size of the remaining basic oval shapes that represent the owl's body. Then I find the placement of the eyes and beak and sketch them.

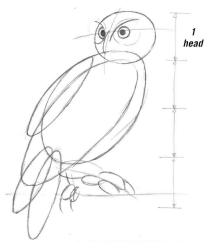

1 head

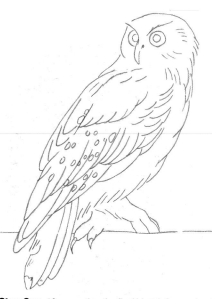

Step One After creating the final sketch for my drawing, I place a piece of tracing paper over the sketch and carefully trace the outline and major features. Then I transfer the final outline onto my art paper with the help of a light box. Notice that the eyes appear slightly distorted. Many artists use a circle template to draw eyes, but I prefer to draw them freehand so they aren't too perfect.

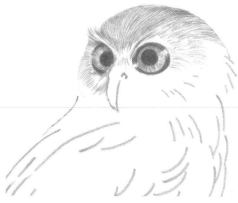

Step Two Starting with the iris, I use an H pencil to lightly draw a series of lines that radiate from the pupil. Then I use a 2B pencil and circular strokes to fill in the pupil. After sharpening my 2B, I darken areas around the eyeball to create this bird's "eyeliner" effect. I am very careful to keep the highlights in the bird's left eye white, as I'd rather work around the white of the paper than lift out tone later. I feel that the pupil is a bit small, so I enlarge it slightly with a sharp 2B pencil. Then I add light tone to the iris using H and HB pencils. With the H pencil I create curved strokes on the head and around the eyes, always drawing in the direction that the feathers lay.

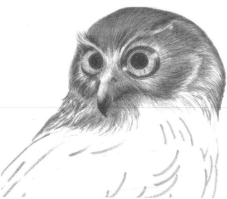

Step Three To achieve the smooth, sleek texture of the feathers, I layer over my H strokes with sharp 2B and HB pencils. I continue layering feathers across the lower area of the face and around the beak with H, HB, and 2B pencils. Where the feathers are lighter, I use an H pencil and less pressure. I layer HB and 2B strokes to create darker tones. Moving to the bottom of the beak, I layer circular strokes with a 2B to create the dark tip. Then I add circular HB strokes along the side of the beak and blend the tone lightly into the white areas of the beak. With the sharp 2B, I darken the nasal holes and the outline of the beak. Then I layer more lines across the cheeks.

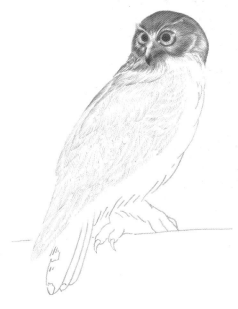

Step Four Now I focus on the body. I start by lightly dabbing at the outline with a kneaded eraser to lighten it. Then I work on the feather shapes with a very sharp HB pencil, making sure that the strokes always reflect the proper direction of the feathers. Working down the wing, I leave the white spots and markings free of tone.

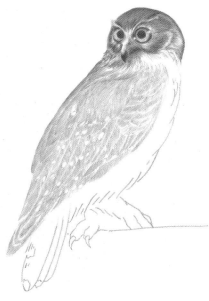

Step Five I use a sharp 2H pencil to layer strokes on top of the previous HB strokes. I make these strokes the same length and use the same amount of pressure as with the HB, but I place the strokes much closer together. Some of the HB strokes show through, giving the impression of a feather texture. I also leave the edge of each feather white.

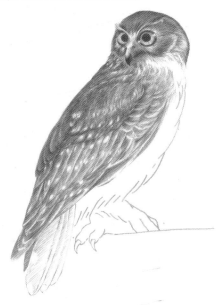

Step Six Now I use the 2B to create darker edges and shadows, and I use the HB to stroke on top of the previous layers to blend the tone. I also draw some of the HB strokes in opposite directions (crosshatching). After lightening the outline of the tail with a kneaded eraser, I create the HB underlayer for the feathers on the tail.

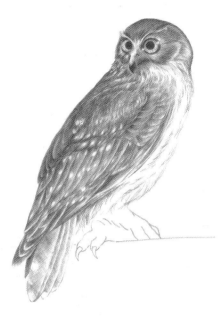

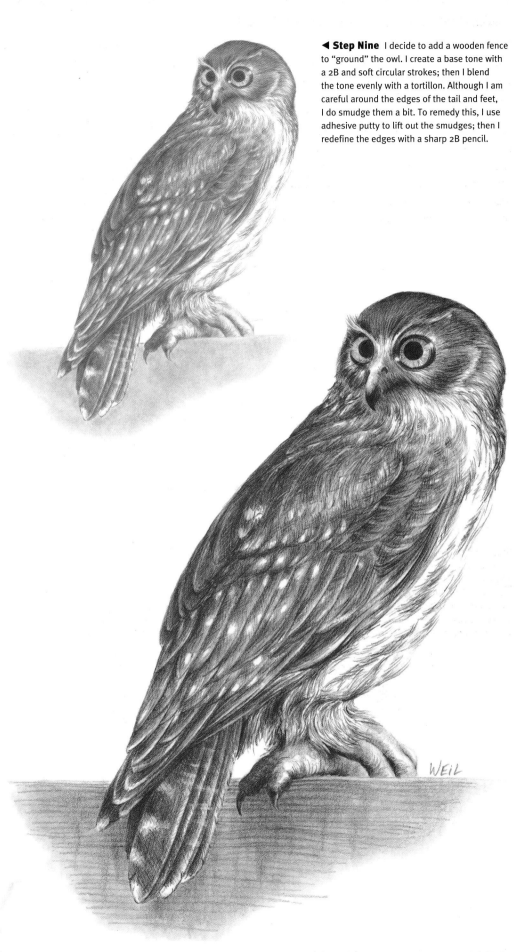

◀ **Step Nine** I decide to add a wooden fence to "ground" the owl. I create a base tone with a 2B and soft circular strokes; then I blend the tone evenly with a tortillon. Although I am careful around the edges of the tail and feet, I do smudge them a bit. To remedy this, I use adhesive putty to lift out the smudges; then I redefine the edges with a sharp 2B pencil.

Step Seven I repeat step six on the tail feathers, adding a bit more crosshatching here than on the body. (If you closely observe a feather, you will see that refracted light shining across the veins gives the appearance of crosshatching.) Returning to the body, I use a slightly blunt F pencil and lightly stroke all over the previous layers of feathers, evening out the tone and darkening the other layers. After erasing the outline of the chest and torso with a kneaded eraser, I lightly stroke in the feathers on the chest. Because the light is directly hitting this side of the bird, I don't need to depict the edge with an outline—the suggestion of feathers will visually fill in the gaps to form the owl's chest and the left side of its body.

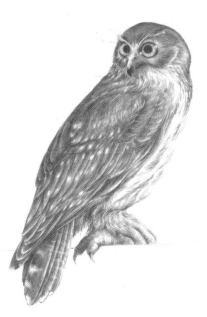

Step Eight I use a 2B pencil to darken the tail feathers, repeating steps five and six. I lift out some tone in the tail with adhesive putty, forming light, horizontal stripes. Still using the sharp 2B, I darken some of the feathers on the chest. Then I use a blunt H pencil and circular strokes to create a light base tone on the feet. To build up form on the feet, I add another layer of circular strokes with an HB pencil, and yet another layer with a 2B pencil. Switching to an F pencil, I add a fourth layer of circular strokes, lightly blending the previous layers. Then I use a very sharp 2B pencil to draw wrinkles on the feet, as well as darken the talons and the areas between the toes. I also add some darker strokes around the neck and under the wing.

▲ **Step Ten** I use an HB pencil to create a series of soft lines down the length of the plank to represent the grain of the wood. I draw these lines very loosely and freely. Then I draw vertical strokes under the bird's feet and tail feathers to suggest cast shadows. These vertical lines contrast with the horizontal lines in the wood and give the plank more dimension. At this point I step back and look critically at the image as a whole. With careful deliberation, I use 2B and HB pencils to add more dark tones and lines all over the body, including the feet, head, chest, and neck. Now my work is complete!

TIGER CUB

Young animals have specific traits that can be very enga- ging—large eyes and ears, fluffy fur, oversized feet, and gangly limbs. To accurately represent a young animal, it's important to observe the proportions of the head to the body when drawing, as these measurements are very different from an adult's. The success of your portrait will depend on the accuracy of the proportions. In this drawing, I employ the technique of negative drawing, or creating the form of an object by drawing the area around it. I also introduce *incising*, which allows you to create fine white lines in a dark area.

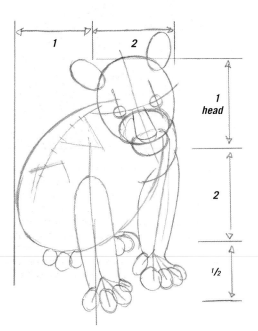

Basic Shapes I start by drawing a circle for the head. After bisecting the circle vertically and horizontally, I block in the eyes on the curved horizontal line. Then I add ovals for the ears, as well as the muzzle. I add the bridge of the nose using a simple cylinder. Looking at my photo refer-ences, I see that the torso is about 2 heads wide. I use a larger oval for the torso. Then I block in the front legs and paws, remembering that the tiger is about $2\frac{1}{2}$ heads tall.

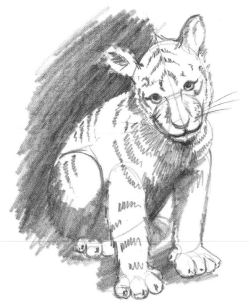

Rough Sketch Using my basic shapes as a guide, I sketch and define the facial features and other details with a 2B pencil. I decide that I want the cub to be lit dramatically, so I quickly add a dark background that also functions as a cast shadow. This background forms the edges of the cub's back and back leg (see step two). Then I roughly place the stripes and shadow areas. Although very rough, this sketch familiarizes me with the subject and the chosen pose.

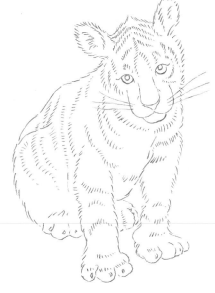

Step One I place a piece of tracing paper over the sketch and carefully trace the outline of the body and major fea-tures. Then I use a light box to transfer the final outline onto my paper. For reproduction purposes, these lines are much darker than I usually draw them. I will carefully erase the outlines with a kneaded eraser as I draw. I include the whiskers in the outline for placement, but I immediately erase them, instead impressing (or incising) them into the paper with a knitting needle. (See "Incising" below.)

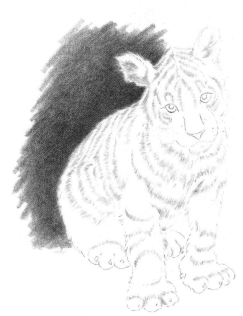

Step Two There are few actual lines in nature; instead, shapes are formed by an object's reaction to light. To show this, I create a dark background to form the edge of the tiger's back (an example of negative drawing). First I lightly erase the outline of the tiger's back from step one. Then I hone the tip of a 2B woodless pencil by rubbing it on scrap paper. I draw broad, flat strokes to build up the background, leaving the edges ragged. Then I add a layer of circular strokes with an HB mechanical pencil. Next I use a sharp HB pencil and short strokes to draw the stripes.

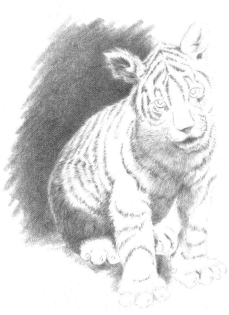

Step Three To even out the tone in the background, I add another layer of circular strokes with a blunt H pencil. This has the same effect as using a tortillon to blend tones. Now I use a very sharp 2B to develop the stripes further, using the same short strokes that follow the direction of fur growth. I also use the 2B to create the shadowed areas on the back leg, inside the ears, under the chin, and the area beneath the animal. I switch to a sharp HB pencil and place short fur strokes all over the cub's body, as well as more fur and shadowed areas in the ears.

INCISING

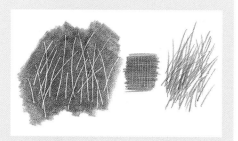

It is very difficult to create fine white lines in areas where you have already added tone. An easy way to create white lines is to indent them into the paper before you draw. This is called "incising." Use a smooth, slightly blunt object such as a knitting needle, but make sure the point is not too sharp. Once you've visualized where your white lines will appear, "draw" the lines with your implement, using a steady pressure that is hard enough to indent the paper but not hard enough to gouge it. Pay attention to where you have already indented, as the lines quickly seem to become invisible. When you draw over the incised area, the graphite will "skip" over the indentations and leave behind clean white lines, as shown in the examples here.

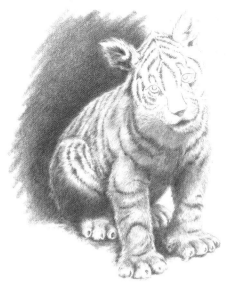

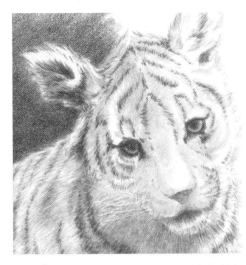

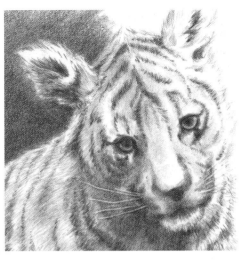

Step Four With a sharp 2H pencil, I add layers of short strokes over the entire body, smoothing and blending the previous layers. I know I need to add several more layers of blended tone to the fur to make it appear soft and fluffy. After studying my reference photo again, I use a slightly blunt F pencil and layer very light, circular strokes on top of the shadowed areas of the coat. Then I use a 2B pencil to deepen the tone of the background, as well as the dark areas on the back leg and paws. I also use the sharp 2B to create darker areas in some of the stripes. I leave areas of the coat free of tone to create the strongest highlights. Then I use a very sharp HB pencil to add more short lines all over the body, enhancing the fur texture.

Step Five Now I use a sharp 2B to draw the dark, thick lines around the eyes, emphasizing the upward curve on the outer edges. I draw the pupil at the top of the eyeball to show an upward gaze. Then I draw lines that radiate from the pupil with a sharp 2H pencil. With an HB pencil, I add more strokes to the dark rings around the eyes. Then I add short, sharp 2H pencil strokes all over the top of the head and around the mouth to create more fur. I use a blunt F pencil to add circular strokes down the left side of the nose and over the muzzle.

Step Six Here I build up the shadow areas on the left side of the face and under the chin to create form. I do this with the 2B pencil and circular strokes. I also use this pencil to darken the tip of the nose, as well as the soft fur around the mouth. Notice how the incised whiskers really start to stand out. After sharpening the 2B, I use it to carefully darken some of the stripes on the head using short strokes. I also add more detail on the ears, using the 2B to "cut" into the white area of the paper, which forms little white hairs.

▶ **Step Seven** After taking a step back and looking at my drawing from a distance, I decide to add more contrast by creating darker fur in places. I don't want to overwork the drawing and lose the detail, though, so I sharpen the HB pencil almost every fifth or sixth stroke to keep my lines crisp. I slowly build up the linework around the mouth, ears, and neck. I also pick out the underside of the incised whiskers, giving them a bit more form and dimension. With a blunt F pencil, I add some circular strokes to the paws, creating a soft tone. Then I use the 2B pencil to add shadows between and underneath the toes, as well as to darken the claws. Now it's time to add final details. Using a woodless 2B pencil, I draw some loose scrumble lines around the tiger's paws. ("Scrumbling" is a technique I use where I cover certain areas with a squiggly line that I make without lifting my pencil. This line sort of wanders about, creating the illusion of a bumpy texture.) I don't try to create any detail here; I just want to give the impression that the tiger is sitting on some loose leaf litter. I hold my pencil loosely and at a slight angle as I scrumble. I am careful to keep the division where the ground meets the paws crisp and sharp. Finally, I return to my sharp HB pencil and work over the entire drawing one last time. I add a bit more detail to the claws; build up some more fur around the neck, both sides of the face, and around the ears; add a bit more tone to the back paw to make it recede more; and refine the fur on the toes and around the mouth. I decide that any more "tweaking" will overwork the drawing, so I declare it finished by signing my name.

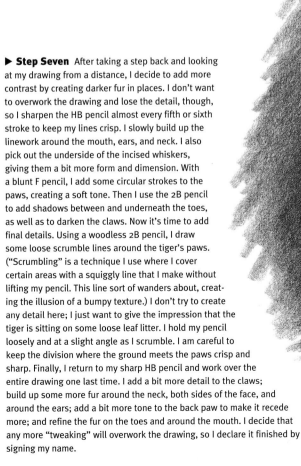

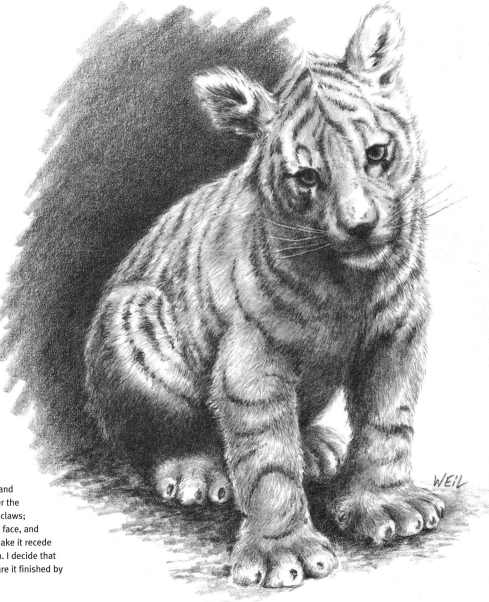

Koala

Koalas are one of my favorite subjects to draw. Their faces have such character, and their simple, round bodies are easy to draw freehand. Koalas don't move about much—in fact, they sleep more than 18 hours a day! So if you see a koala awake, be sure to take a photo because it is a rare opportunity. When drawing a koala, you will need to use a number of pencil techniques to create short and long fur, white and dark fur, and the varied textures of the nose, claws, and eyes.

▶ **Taking Multiple Photos** I spent several days taking photos at a local koala sanctuary, but I couldn't get a "perfect" shot. The best-posed animals were asleep or squinting, and those with their eyes open were in awkward positions. So I took as many photos as I could of koalas both asleep and awake, and I combined multiple references for the final composition.

◀ **Finding the Proportions** To figure out the correct proportions of the koala, I first draw a 6.5" x 9" rectangle on a sheet of tracing paper. I divide this shape horizontally into thirds; then I draw a vertical plumb line that is slightly off-center down the length of the rectangle. Referring to my main reference photo for the scale and size of the head, I center the head circle exactly where the plumb line and the first horizontal line meet. Then I roughly divide the head circle into thirds horizontally and vertically—this will help me correctly position the facial features. I do not need to use a ruler to measure this; I just use my eyes to judge the correct distances. Now I use simple oval shapes to block in the round shapes of the body and ears. Using my reference as a guide, I sketch the arms, fingers, and tree branches.

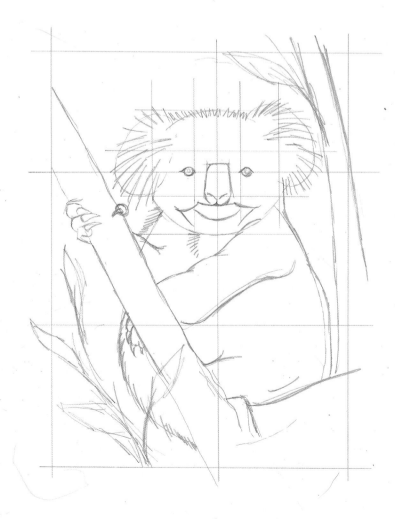

▶ **Blocking in the Features** Now that I have the proportions down, I place another sheet of tracing paper over my drawing and begin refining the shape of the koala. Constantly referring to my main reference shot, I block in the nose, noting where it starts and finishes in relation to the grid. Using my other reference shots as a guide, I position the open eyes almost exactly on the top horizontal line of the grid. Now I place the mouth and cheeks, which are a series of arcs within the bottom third of the head circle. I build up some fur in the ears, on top of the head, and on the chest; then I develop the arms and legs, adding the long claws and noting where the heel of the foot rests against the upright branch. I decide to omit the back foot that awkwardly overlaps the chest area in the main reference photo. I know enough about koalas to know that my drawing will be believable if the foot is tucked out of sight behind the branch. Finally, I add a few more tree branches and leaves.

Step One After transferring the outlines of my sketch to a piece of 300 gsm (140 lb) hot-pressed paper, I start developing the ear on the left, as I plan to work down and across to the right. First I lighten the outline of the ear with a kneaded eraser. Then I use a sharp 2H clutch pencil to draw long, smooth lines for the undercoat, varying their lengths and directions.

Step Two I switch to an HB clutch pencil and draw more long, broken strokes around the 2H strokes, leaving the paper white in areas. As I work in the dark strokes, the white of the paper begins to form the white hairs. (This is a form of negative drawing.)

Step Three Using a sharp 2B clutch pencil, I intensify the shadowed areas of the fur under and on the edge of the ear. This makes the white areas stand out, increasing the impression of long, white fur. I return to the ear again with the 2H clutch pencil, refining the detail. By drawing the ear on the left first, I establish a value range for the rest of the koala; the ear will act as a visual gauge.

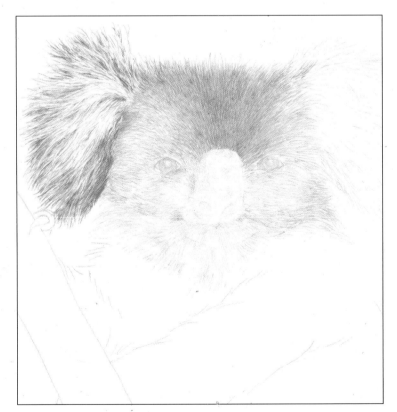

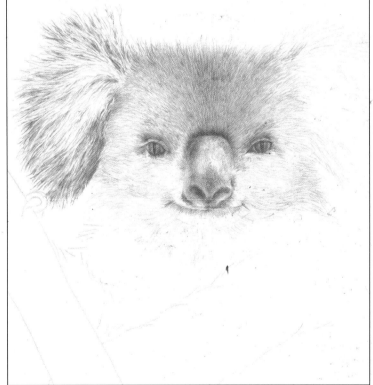

Step Four After lightening the outline of the rest of the head with a kneaded eraser, I use a 2H clutch pencil to create short, quick strokes all over the head, avoiding the eyes and the nose. I draw in the direction of fur growth, placing my strokes very close together. My wrist does not move at all; my fingers do all the work. When I've covered the face, I go back in with an HB pencil and darken the areas across the forehead and above the nose, using the same short strokes as before. Then I use a 2H to add a quick layer of fur to the ear on the right, as well as to build up the fur around the cheeks, chin, and mouth. I form the shape of the iris in the each eye with a light layer of 2H, and I add some tone to the nose.

Step Five After dulling an HB pencil by rubbing it on a piece of scrap paper, I add circular strokes to the nose, leaving some areas white. I switch to a 2B and use short strokes above and below areas of the nose to create more contrast. I also use the 2B to darken the nostrils. Switching back to the HB, I create short lines in the mouth and under the nose. At this point, I realize that the pupils look too human in my sketch—a koala actually has a narrow, vertical slit for a pupil. I sharpen the HB and use it to redraw the pupils and darken them. I also use the HB to form the eyelids and brows with short, directional strokes. I use the 2B to darken the irises and areas around the eyes.

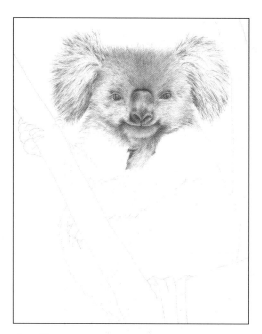

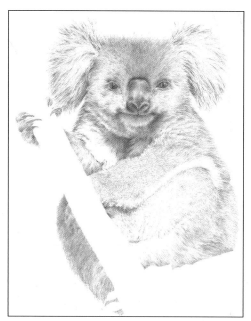

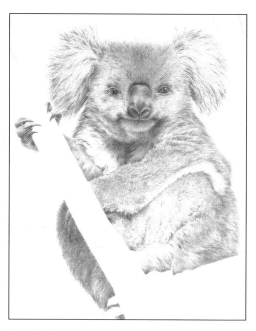

Step Six Alternating between my sharp HB and 2B pencils, I build up the fur all over the face and chin. I use the 2B to create dark shadows around the mouth, nose, chin, and cheeks; then I use the HB like a tortillon to blend the tone. Using both pencils and circular strokes, I further develop the tone on the nose, creating a dark, leathery texture. Turning to the eyes, I define the darks with the 2B and accentuate the shape and form with the HB. I also slightly widen the eyes by darkening the lower lids. Then I carefully lift out a highlight in each eye with adhesive putty. Now I concentrate on the ear on the right, repeating steps two and three. I don't finish the ear completely.

Step Seven After lightening the outline of the body with a kneaded eraser, I use short, light strokes with a 2H pencil to create the undercoat for the entire body. Again, I always draw in the direction of the fur growth and avoid creating patterns. I leave the chest and underarms white, but cover the rest of the body with a light network of inter-lacing 2H strokes. The fur on the arms is the shortest and most random in direction, so I make my lines reflect this. I notice that I've made the fur on the koala's leg (near the main branch) too patterned and regular; I will remedy this by adding some overlapping strokes as I darken this area in the next step. Now I add tone to both paws with the HB pencil, and I draw the long claws.

Step Eight I work over the entire body at once with very sharp HB and 2B pencils. I use the 2B to create the black-est areas near the white fur—the 2B "cuts" into the white areas, forming white "hairs"—I refer to my reference photo to see how the fur curls and swirls over areas of the body. I add some overlapping strokes on the left side of the body to avoid creating a pattern.

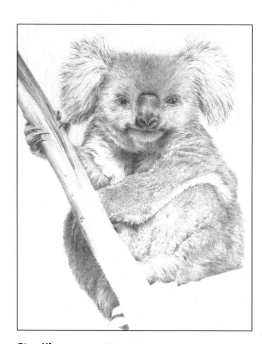

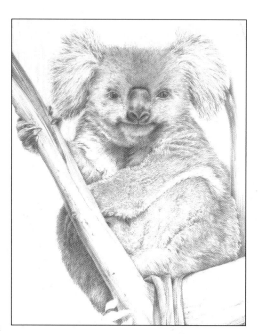

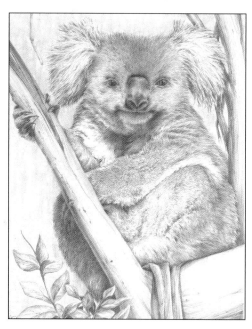

Step Nine I create a light background at the top of the image with a dull F wood-cased pencil. Then I begin adding tone to the main tree branch with 2H and HB pencils, using my entire hand and wrist to create long, smooth strokes. I build up the tone of the branch as a series of long lines of different values, creating the lined texture of a eucalyptus tree. I also add some spots and nicks with the HB to add more texture.

Step Ten Now I use an HB pencil to add the slightly curved shadows cast on the branch by the koala's fingers and claws. Then I use the 2B to deepen the tone of the shadows, as well as darken and intensify the hand and claws to create more form. I continue working down the branch, alternating between the 2H and 2B pencils. I add tone to the fattest part of the branch, where the koala rests, and create the three strips of bark hanging over this wide section. The tree branches in this drawing frame the work nicely; they also keep the viewer's eye from straying out of the picture by forming a visual "wall" that leads the eye back into the center of the work.

Step Eleven Now I need to complete the background and foreground leaves. I draw the leaves with an HB pen-cil and loose, soft lines. Now I add tone to the branches behind the koala, using the technique from step nine. I make the branches behind the ear on the right fairly dark, as this makes the white fur of the ear advance forward. Then I add a bit more detail to the ear, allowing the hairs to overlap the branch. I switch to an F pencil to add more tone in the background. Instead of creating defined shapes, I use circular strokes and let my hand wander about the area. I add a short, hanging branch in the upper-left corner, which adds to the framing effect of the composition.

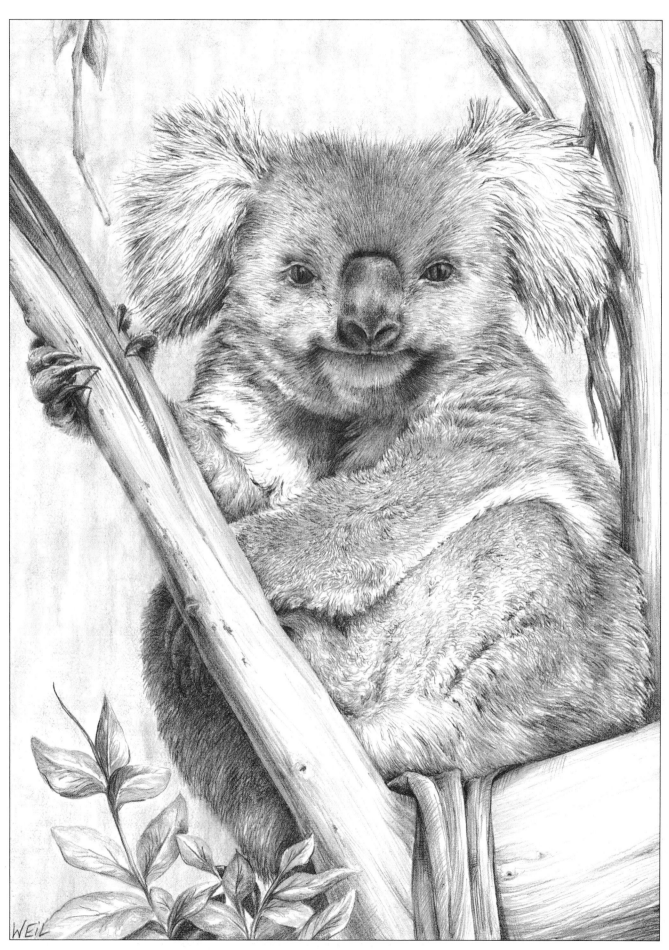

Step Twelve To finish, I add final touches with an HB pencil—I deepen some tones for more contrast, add detail lines in the eyes and nose, and build up just a bit more fur texture all over the body. I am very pleased with this drawing and the "framed" composition.

DINGO

A portrait is a drawing of the head of a human or animal that shows the subject's face and expression. A good portrait will reveal something of the subject's character or personality. In human portraiture, the subject often is drawn from a straight-on view. This viewpoint can be very difficult when drawing animals due to the amount of foreshortening that would be required in rendering the nose, muzzle, or beak. I prefer to use a three-quarter view, where the head of the animal is turned slightly, as I find it easier to correctly portray the length and proportions of the nose from this angle. This portrait is of a dingo, which is an Australian wild dog. These beautiful animals share many features with domestic dogs, but I find that their eyes look slightly feral and untrusting. It is this wild, undomesticated look that I want to portray in my drawing.

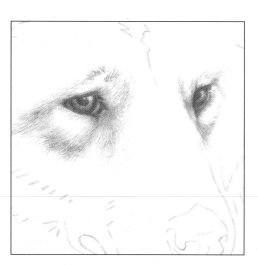

Step One After carefully tracing the shape of the head and the major features from my reference photo, I transfer the outline to my art paper. Then I establish the eyes (see "Drawing the Eyes" on page 109). Now I start developing the surrounding fur. I lay down light, short strokes with a sharp 2H pencil, drawing in the direction of fur growth. Then I build a layer of HB pencil on top of this lighter layer, keeping the point very sharp. Next I softly blend the 2H and HB strokes using linear strokes with an F pencil.

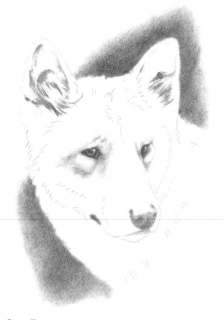

Step Two Using a 2B woodless pencil and circular strokes, I create the dark area behind the dingo's head (similar to the background for the tiger cub on page 102). I use the same pencil and technique for the nose and mouth, adding layers upon layers until I achieve a soft, dense black. I also use the 2B woodless pencil to lay down dark, thick linear strokes in the ears.

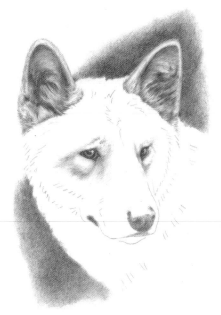

Step Three I secure a sheet of clean paper over the eyes. Then I use a sharp HB pencil to layer linear strokes over the entire ear area, varying the lengths of the strokes and leaving areas of the paper white. When finished, I use a sharp 2B to deepen these shadow areas. Then I use an F pencil and soft, circular strokes to blend the tones along the edges and within the inner "cups" of the ears.

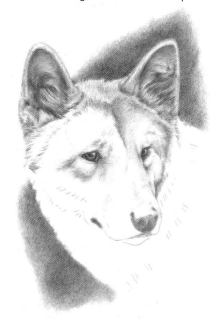

Step Four Now I move the clean sheet of paper down to protect the lower half of my drawing. Then, using a sharp 2H mechanical pencil, I apply quick, short strokes over the top of the head and around the forehead and eyes. I leave large areas of the paper white to depict the dingo's straw-colored fur. Next I use a well-sharpened HB mechanical pencil to layer strokes on top of the 2H undercoat, creating a sense of texture. Where the fur flips up around the ears and for the crease down the center of the forehead, I use a blunt F pencil to softly blend and deepen the tones.

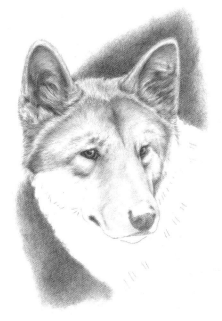

Step Five I continue the same technique on the left side of the face. When finished, I add sharp 2B strokes around the forehead crease, eyebrows, and temple ridges for added contrast and texture. Then, using a slightly blunt F pencil, I add soft circular strokes across the forehead and down the muzzle, creating a soft tone that blends into linework.

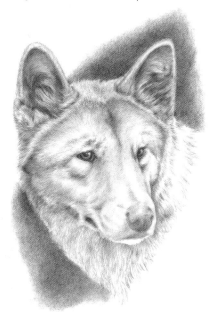

Step Six I repeat step five over the bottom half of the face and on the muzzle, slowly building up the tones. Using circular strokes and an F pencil, I blend the tones over the muzzle and nose. Then I use a 2B pencil to fill in the corner of the mouth; I also create some linear strokes around the jaw. I switch to an HB and create denser, thicker, longer lines for the undercoat of the neck, adding darker strokes over the shadowed part of the neck. I leave quite a bit of white paper exposed to suggest the fur on the upper right side of the neck.

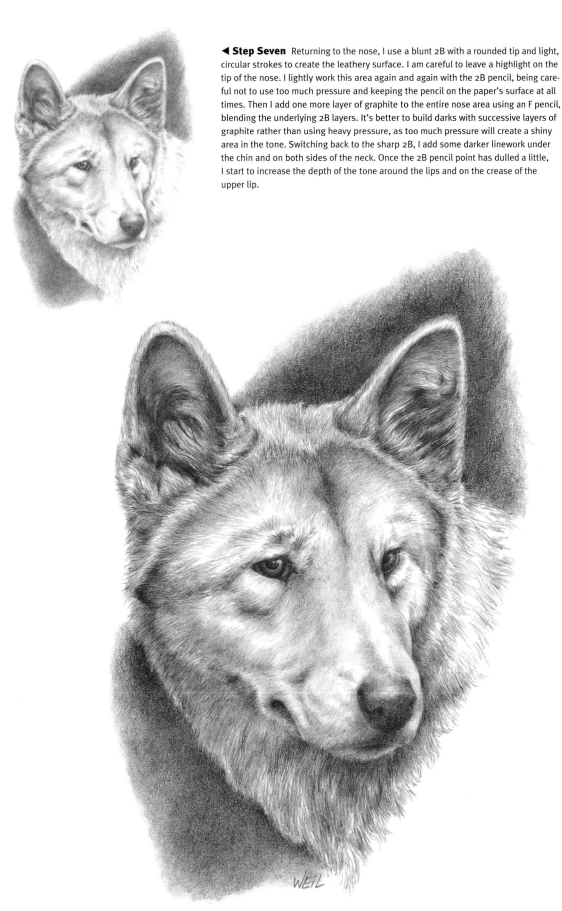

◄ Step Seven Returning to the nose, I use a blunt 2B with a rounded tip and light, circular strokes to create the leathery surface. I am careful to leave a highlight on the tip of the nose. I lightly work this area again and again with the 2B pencil, being careful not to use too much pressure and keeping the pencil on the paper's surface at all times. Then I add one more layer of graphite to the entire nose area using an F pencil, blending the underlying 2B layers. It's better to build darks with successive layers of graphite rather than using heavy pressure, as too much pressure will create a shiny area in the tone. Switching back to the sharp 2B, I add some darker linework under the chin and on both sides of the neck. Once the 2B pencil point has dulled a little, I start to increase the depth of the tone around the lips and on the crease of the upper lip.

Step Eight Using the 2H and HB pencils, I work over the face, refining and building up the texture of the fur with additional linework. I do the same with the HB and 2B on the neck and around the nose. Note how the darker fur of the neck in the lower right area defines the shape of the muzzle. Although I do not add much detail to the fur on the right side, the eye perceives the impression of fur. Now I use the 2B to add several more layers of circular strokes to the left side of the background near the neck. After sharpening the 2B, I intensify the dark edges all over the face: the corner and front of the mouth, under the mouth, the nasal openings, the "eyeliner" and pupils, the dark fur on the forehead, and the darkest fur in the ears. When you've reached the final stages of a drawing like this, it is always difficult to know where to stop. If you overwork the drawing, you'll create unsightly shiny spots, and if you add too little shading, it will appear unfinished. It helps to walk away from your work for an hour or two and return to it later with a fresh eye. After doing so, I decide that I'm happy with the dingo at this stage. He has a certain air of suspicion about him that I like, so I declare the drawing finished.

DRAWING THE EYES

Step One I start by making very light, circular strokes with a blunt H pencil over areas of the eyeball in shadow. This is done very lightly; I just want a faint base to start with.

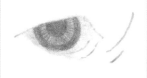

Step Two Now I use a sharp (but not fine-pointed) HB to create radiating lines in the iris. I use the same pencil to create the outer dark ring of the iris, as well as a solid tone that fills the pupil. I am not too worried about highlights at this stage.

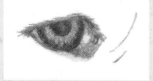

Step Three With a 2B pencil, I deepen the dark areas of the pupil and the ring around the iris. I use an HB pencil to deepen the tones of the whites of the eyeball with soft, circular strokes. I also use the HB to define the "eyeliner" around the eye, as well as create the round area in the corner of the eye.

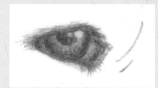

Step Four I use a 2B to darken the "eyeliner," pupil, and the ring around the iris. With a blunt F pencil, I add a light tone over the entire surface of the eyeball, blending the softer 2B back into the irises. Then I use the HB to go over the lines in the iris and the hair surrounding the eye. I also hint at eyelashes. I knead a bit of adhesive putty into a sharp point and lift out the highlight.

Kangaroo

Australia's iconic marsupial is an ideal subject to photograph, as it often is found in a stationary pose, either grazing or watching. This particular kangaroo, with its head gazing directly at the viewer and its large tail resting on the ground, is a good reference to use for portraying the quiet nature of these graceful animals.

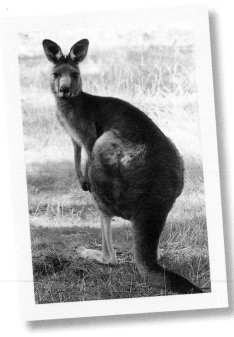

Experimenting with Texture A kangaroo's coat is thick and dense, with an even color and texture. I always enjoy exploring the swirls and flow of the fur texture in my kangaroo drawings.

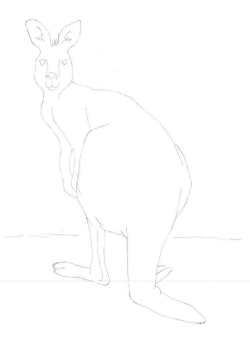

Step One Using an enlarged photocopy of the reference photo, I trace the outline of the kangaroo on a piece of sketch paper. I also trace the eyes, muzzle, nose, mouth, a few small fur details, and the horizon line, which I'll use later to "ground" the animal with grass. Then, using a 2 mm clutch pencil with an HB lead, I transfer my sketch to a sheet of hot-pressed paper.

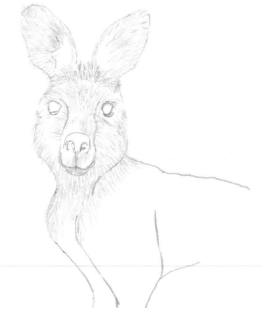

Step Two I carefully lighten the outline of the head by dabbing at it with a kneaded eraser, leaving only a faint guideline. Starting with the ears and working down the head, I use a sharp 2H clutch lead to draw quick, short strokes for the undercoat, which will act as a directional guide for the rest of the fur. I leave the eyes and highlights of the cheeks, muzzle, and ears white.

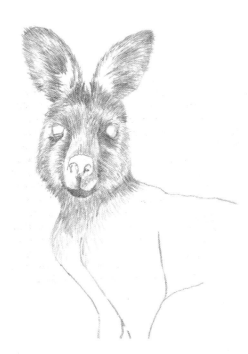

Step Three With a well-sharpened HB clutch lead, I begin to build up the second layer of fur. Still using swift, short strokes and following the direction of fur growth, I concentrate on building deeper tones and form. Sharpening my pencil often, I keep the stroke length and starting points fairly random to avoid unattractive edges or ridges. I take care to avoid the white highlight areas.

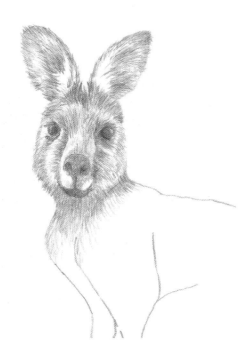

Step Four With a slightly blunt HB clutch lead, I use a circular motion to build up a dark, even tone for the eyes and leathery nose. I gradually build up layers of tone as I draw over these areas again and again, taking care to not press too hard. To create the highlight in each eye, I form a kneaded eraser to a point and lift out some tone. With a very sharp 2B clutch lead, I delicately accentuate the edges of the eyes and nostrils, deepening the darkest areas.

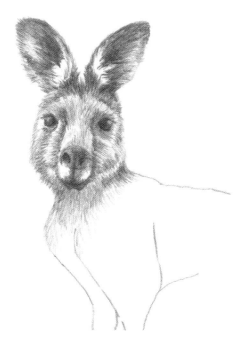

Step Five Still using the sharp 2B lead, I build up the darkest areas of the fur on the head with short strokes, always following the direction of the fur. I pay particular attention to creating dark tones in the ears, as these areas provide the negative space that creates the white areas (see page 11). The deep tone in the inner ear helps create the appearance of white fur tufts on the outer ear. I add a few 2B strokes into this white area to create an even greater sense of depth and make the white fur stand out.

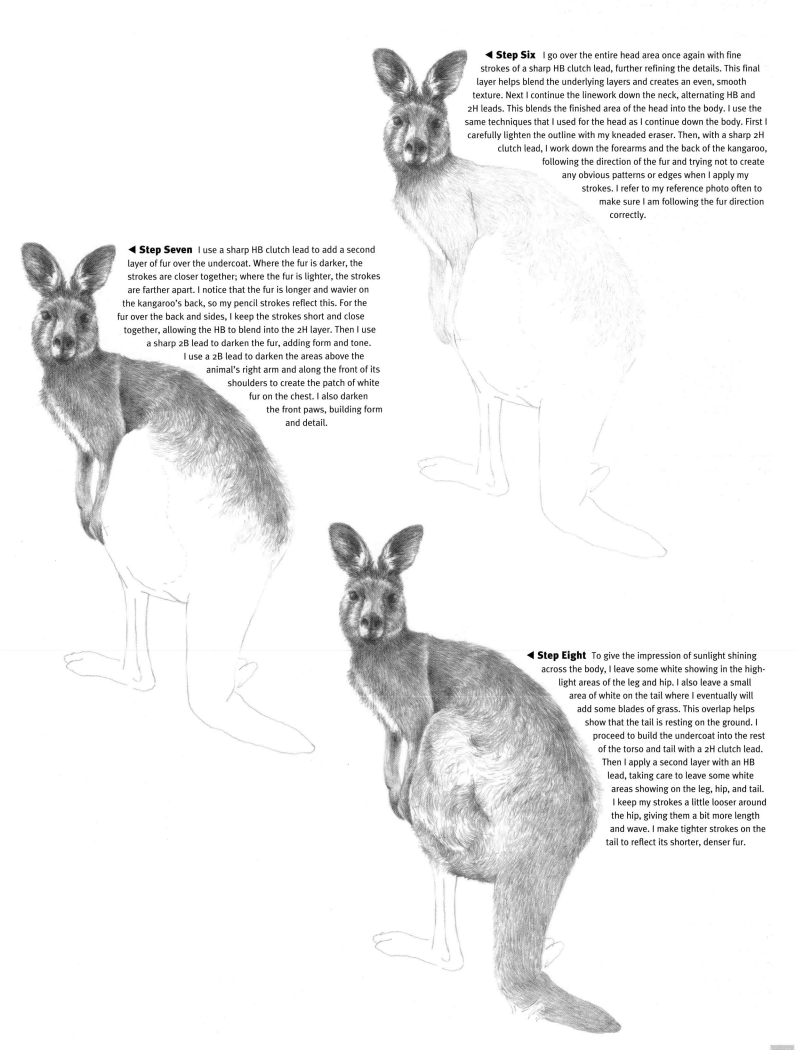

◄ Step Six I go over the entire head area once again with fine strokes of a sharp HB clutch lead, further refining the details. This final layer helps blend the underlying layers and creates an even, smooth texture. Next I continue the linework down the neck, alternating HB and 2H leads. This blends the finished area of the head into the body. I use the same techniques that I used for the head as I continue down the body. First I carefully lighten the outline with my kneaded eraser. Then, with a sharp 2H clutch lead, I work down the forearms and the back of the kangaroo, following the direction of the fur and trying not to create any obvious patterns or edges when I apply my strokes. I refer to my reference photo often to make sure I am following the fur direction correctly.

◄ Step Seven I use a sharp HB clutch lead to add a second layer of fur over the undercoat. Where the fur is darker, the strokes are closer together; where the fur is lighter, the strokes are farther apart. I notice that the fur is longer and wavier on the kangaroo's back, so my pencil strokes reflect this. For the fur over the back and sides, I keep the strokes short and close together, allowing the HB to blend into the 2H layer. Then I use a sharp 2B lead to darken the fur, adding form and tone. I use a 2B lead to darken the areas above the animal's right arm and along the front of its shoulders to create the patch of white fur on the chest. I also darken the front paws, building form and detail.

◄ Step Eight To give the impression of sunlight shining across the body, I leave some white showing in the highlight areas of the leg and hip. I also leave a small area of white on the tail where I eventually will add some blades of grass. This overlap helps show that the tail is resting on the ground. I proceed to build the undercoat into the rest of the torso and tail with a 2H clutch lead. Then I apply a second layer with an HB lead, taking care to leave some white areas showing on the leg, hip, and tail. I keep my strokes a little looser around the hip, giving them a bit more length and wave. I make tighter strokes on the tail to reflect its shorter, denser fur.

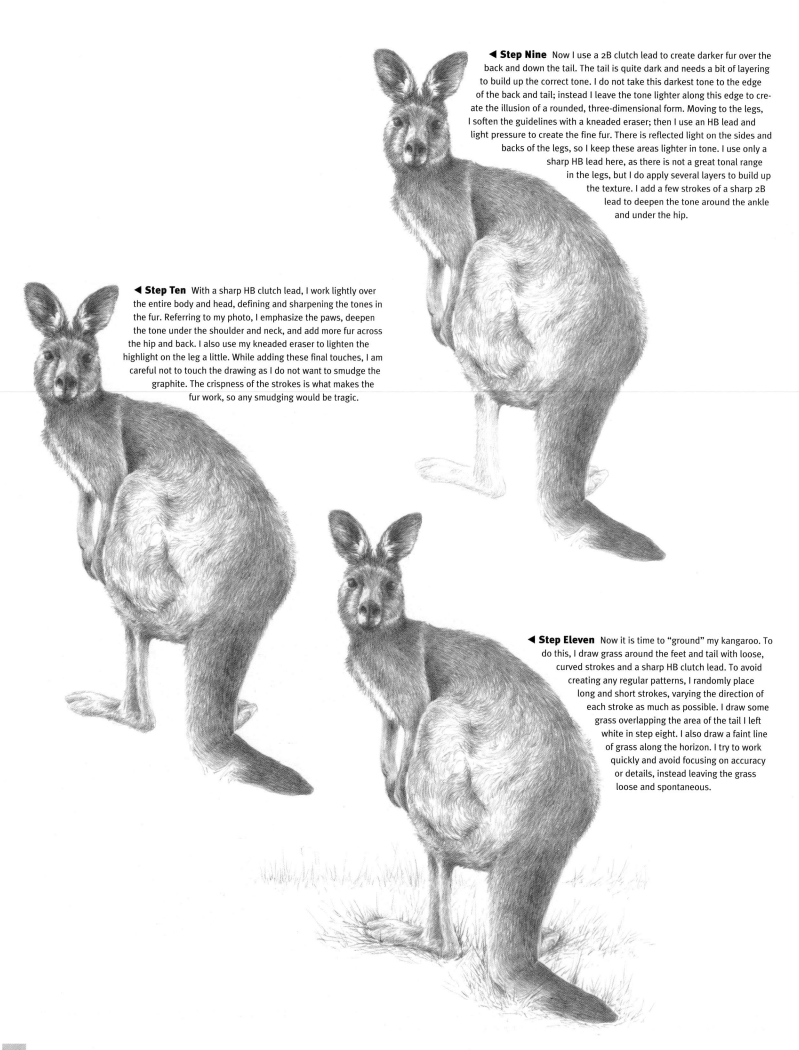

◄ Step Nine Now I use a 2B clutch lead to create darker fur over the back and down the tail. The tail is quite dark and needs a bit of layering to build up the correct tone. I do not take this darkest tone to the edge of the back and tail; instead I leave the tone lighter along this edge to create the illusion of a rounded, three-dimensional form. Moving to the legs, I soften the guidelines with a kneaded eraser; then I use an HB lead and light pressure to create the fine fur. There is reflected light on the sides and backs of the legs, so I keep these areas lighter in tone. I use only a sharp HB lead here, as there is not a great tonal range in the legs, but I do apply several layers to build up the texture. I add a few strokes of a sharp 2B lead to deepen the tone around the ankle and under the hip.

◄ Step Ten With a sharp HB clutch lead, I work lightly over the entire body and head, defining and sharpening the tones in the fur. Referring to my photo, I emphasize the paws, deepen the tone under the shoulder and neck, and add more fur across the hip and back. I also use my kneaded eraser to lighten the highlight on the leg a little. While adding these final touches, I am careful not to touch the drawing as I do not want to smudge the graphite. The crispness of the strokes is what makes the fur work, so any smudging would be tragic.

◄ Step Eleven Now it is time to "ground" my kangaroo. To do this, I draw grass around the feet and tail with loose, curved strokes and a sharp HB clutch lead. To avoid creating any regular patterns, I randomly place long and short strokes, varying the direction of each stroke as much as possible. I draw some grass overlapping the area of the tail I left white in step eight. I also draw a faint line of grass along the horizon. I try to work quickly and avoid focusing on accuracy or details, instead leaving the grass loose and spontaneous.

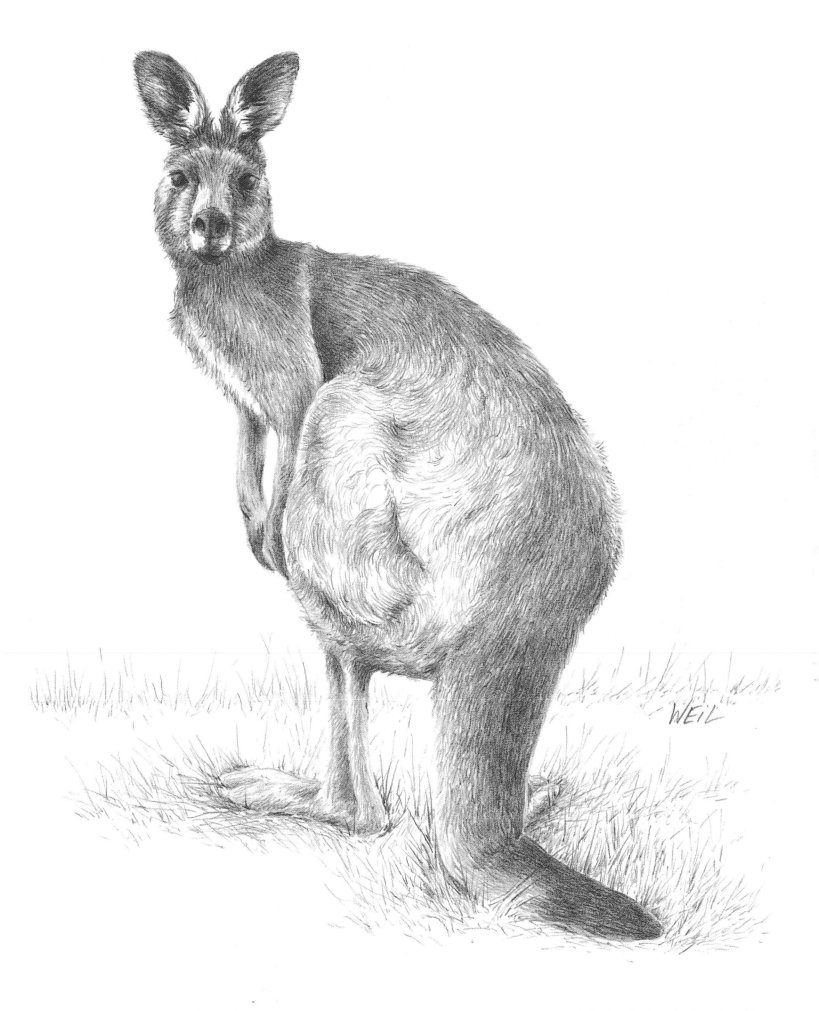

Step Twelve I continue to develop the grass, darkening the tone under the kangaroo's feet to further ground the animal. When I'm satisfied with my drawing, I sign the work and lightly spray the entire drawing with workable fixative to help prevent smudging.

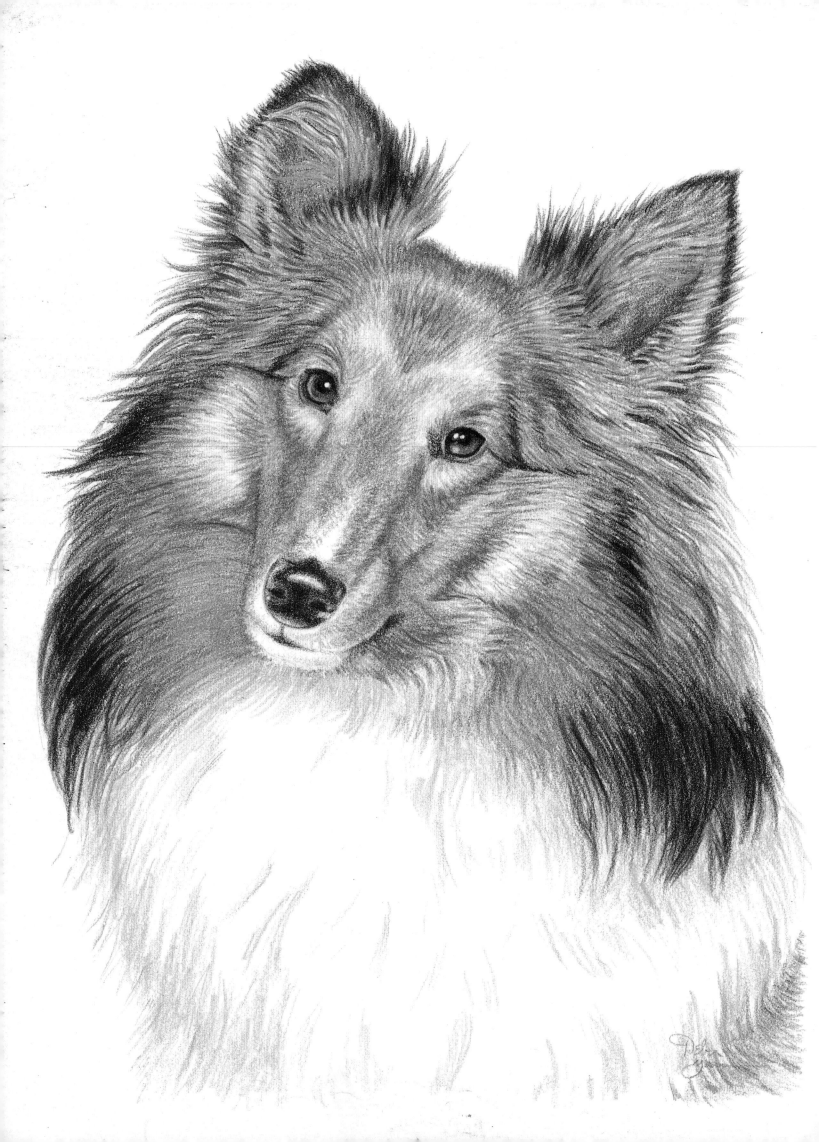

ANIMALS IN COLORED PENCIL
WITH DEBRA KAUFFMAN YAUN

Debra Kauffman Yaun discovered that she had a knack for drawing when she was a young girl growing up in Tampa, Florida. After graduating from the Ringling School of Art and Design in Sarasota, Florida, Debra worked as a fashion illustrator. She has drawn and painted many commissioned portraits, and she enjoys teaching classes and workshops in portraits and colored pencil. Debra's artwork has been published in several art magazines and books, and she has won numerous awards, including an international award. She is a signature member of the Colored Pencil Society of America, having served as president of the Atlanta chapter, and she is a juried member of the Portrait Society of Atlanta. Debra's work is currently featured in five Walter Foster Publishing titles. Debra and her artist-husband have two grown sons and currently reside on 11 acres of countryside in Georgia.

COLORED PENCIL TOOLS & TECHNIQUES

You don't need many supplies to get started in colored pencil, so you won't need to invest a lot of money. All you need to start out are a few basic colors, an eraser, a sharpener, and some paper. (See page 117 for the colors used in this chapter.) Below are a few recommended tools that are good for beginners. You'll also find information on using colored pencils—remember that the way you sharpen your pencil, the way you hold the pencil, and the amount of pressure you apply all affect the strokes you create. You can create everything from soft blends to brilliant highlights to realistic animal textures with colored pencil. Once you become familiar with the basics, you'll be able to decide which tools and techniques will capture your subject's unique qualities.

PENCILS

The price of a pencil indicates its quality; better pencils have truer color. Many brands offer sets of pencils that provide a basic array of colors. Some art stores also sell colored pencils individually—this way you can choose which hues you like best among several different brands. Once you've chosen your palette, make sure to store your pencils safely in a container—and try not to drop them. The lead in a colored pencil is very brittle, and it's likely to break in the shaft if the pencil is dropped. This may not be immediately apparent, but it will eventually render the pencil useless.

▶ **Choosing Pencils** There are many different types of colored pencils available— harder, thinner leads are ideal for rendering fine lines and detail, whereas softer, thicker leads are great for filling in large areas. Experiment to find which you prefer.

ERASERS

Ordinary erasers can't be used to remove colored pencil; the friction between a rubber or vinyl eraser and the paper will actually melt the wax pigment and flatten the *tooth* (or grain) of the paper. Instead, many artists use a small battery-powered eraser to remove the pigment without crushing the paper underneath. A kneaded eraser is also useful for removing small amounts of color; twist or pinch it into any shape you like and then press it lightly on the paper to pick up the pigment. When it gets "dirty" and is not as effective, you can knead it (like dough) thoroughly to reveal a clean surface. You can also press clear tape on an area to remove unwanted pigment.

PAPER

Slightly textured, thicker paper is best for colored pencil work because the rough grain "catches" the color so it accepts more pigment than a very smooth paper would. Art and craft stores carry a variety of textured watercolor papers and illustration boards that offer a good tooth for colored-pencil art; look for a paper with a medium grain to start. For practice or doing quick studies on site, you'll want to have a sketch pad or sketchbook.

▶ **Experimenting with Paper** You might also consider experimenting with different colored papers. Be sure to use the less-textured side of the paper. If you choose a colored paper that shares a dominant hue in your drawing, you can create color harmony in your drawing. Using black paper with light colors creates a sense of drama and contrast.

SHARPENERS

You can achieve various effects depending on how sharp or dull your pencil is, but generally you'll want to make sure your pencils are sharp at all times; a sharp point will ultimately provide a smoother layer of color. Although a small hand-held sharpener will do, an electric or battery-powered sharpener is better suited for fine art purposes. You can also use a sandpaper block to sharpen your pencils; the sandpaper will quickly hone the lead into any shape you wish. It will also sand down some of the wood. The finer the grit of the paper, the more controllable the resulting point. Roll the pencil in your fingers when sharpening to keep the shape even.

EXTRAS

You'll need a brush to gently remove the pencil residue from your paper (a camera lens brush, as shown on page 6, will work well), a spray fixative to preserve your finished drawing (see page 7), and a blending stump to create soft blends (see page 6). A pencil extender is handy when the pencil gets too short to hold onto comfortably, and you may want a triangle for making straight lines and some artist's tape for masking off edges. It's also nice to have white gouache (similar to watercolor paint but more opaque) and a small brush on hand for adding tiny highlights.

Hand-held sharpener

Triangle

Kneaded eraser

Pencil extender

Sandpaper block

Blending stump

STROKES

Each line you make in a colored pencil drawing is important—and the direction, width, and texture of the line you draw will all contribute to the effects you create. Practice making different strokes, as shown in the examples below. Apply light, medium, and heavy pressure; use the side and then the point of your pencil; and experiment with long, sweeping strokes as well as short, precise ones.

Pressure With light pressure, the color is almost transparent. Medium pressure creates a good foundation for layering, and heavy pressure flattens the paper texture, making the color appear almost solid.

Strokes and Texture You can indicate a number of different textures by creating patterns of dots and dashes on the paper. To create even, dense dots, try twisting the point of your pencil on the paper.

LAYERING AND BLENDING

Because colored pencils are translucent, artists use a transparent layering process to either build up color or create new hues. This layering process is wonderful because it creates a much richer hue than you could ever achieve if you were using just one pure color. To deepen a color, layer more of the same over it. If you want to blend your strokes together, you can use a stiff bristle brush (see page 131).

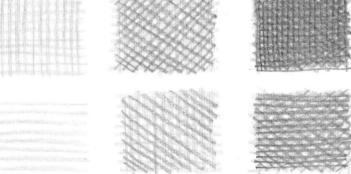

Layering with Hatch Strokes Here yellow, orange, red, and blue were layered on top of one another with crosshatching (laying one set of hatched lines over another but stroking in a different direction) to demonstrate one way of creating a new color. Work from light to dark to avoid getting a muddy mix.

COLOR PALETTE

Below are the main colors used for the projects in this chapter. Keep in mind that the names of the colors may vary among brands; also, sometimes two pencils that have the same name are different hues.

Black *Black cherry* *Burnt ochre* *Burnt sienna*

Burnt yellow ochre *Canary yellow* *Cedar green* *Cerulean blue*

Chartreuse *Cloud blue* *Cool gray 30%* *Cool gray 50%*

Cool gray 70% *Cool gray 90%* *Crimson* *Dark brown*

Dark indigo *Dark purple* *Dark umber* *French gray*

French gray 30% *French gray 70%* *Geranium lake* *Green bice*

Henna *Indigo blue* *Jasmine* *Kelp green*

Light cerulean blue *Peach beige* *Peacock blue* *Poppy red*

Prussian green *Pumpkin orange* *Raw sienna* *Sap green*

Sepia *Sienna brown* *Slate gray* *Sunburst yellow*

Thio violet *True blue* *Tuscan red* *Ultramarine*

Venetian red *Warm gray 50%* *White* *Yellow ochre*

Rooster

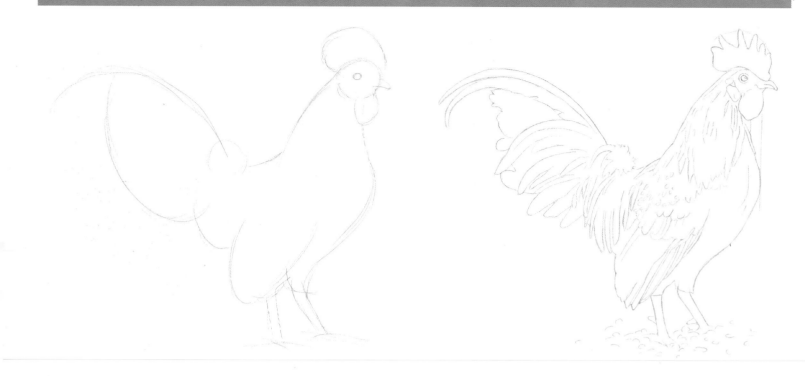

Step One I begin by loosely sketching the rooster's body, using a circle for the head and an oval for the tail. Then I add the remaining details, using my photo reference as a guide. Notice how the top tail feathers extend over the rest of the tail.

Step Two I refine and detail the face and head, keeping a guideline along the top of the comb to help line up the edges properly. I also draw a line from the wattle to the chest to line them up accurately; then I erase these guidelines. When drawing the feathers, I don't draw individual feathers but instead show how they are grouped. Next I draw some rocks around the rooster's feet.

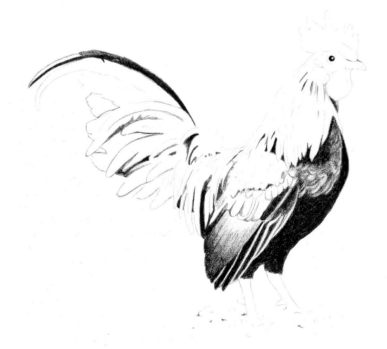

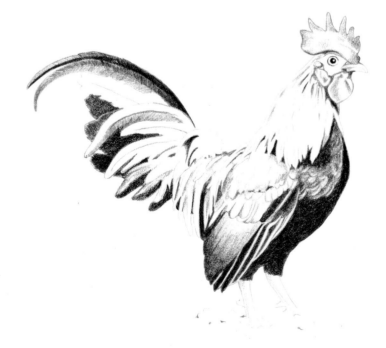

Step Three I begin establishing the dark areas with cool gray 90%. I fill in the eye (leaving the highlight white), outline some feathers, and shade a few of the dark areas between the tail feathers. Then I fill in most of the chest and the top tail feather. I also shade some of the dark wing feathers, leaving some white stripes, and establish a few small, dark feathers and some dark spots on the ground, using medium to hard pressure.

Step Four Switching to dark purple, I lightly shade a few areas on the body and head, as shown. Using Tuscan red with light to medium pressure, I outline and darken some areas of the face, comb, and wattle. Then I use indigo blue to draw shafts (centerlines) in some of the feathers and shade up to the centerline with medium pressure. Using cool gray 90%, I shade the bottom halves of the three lowest tail feathers and darken some of the back tail feathers.

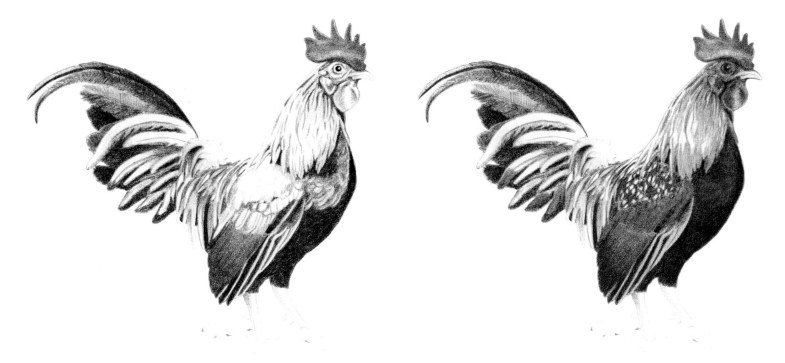

Step Five I add more cool gray 90% to the tail. Then I lightly add dark brown to the backs of the legs. Using medium to hard pressure with the same color, I fill in some of the feathers on the back and neck. Then I use cool gray 30% to shade the fluffy white feathers at the base of the tail. I blend the edges of these feathers into the surrounding areas using cool gray 90%, making them appear soft and fluffy. I also fill in the lower wing with sienna brown, using strokes that follow the direction of the feathers. Next I apply more Tuscan red to the face, leaving some areas white. Then, using small, circular strokes, I apply a layer of Thio violet to the comb.

Step Six I apply Thio violet to the face and wattle; then I shade around the pupil with a very sharp cool gray 90%. Using burnt ochre, I fill in most of the neck feathers, leaving the paper white for the lightest areas. With firm pressure, I add a layer of ultramarine to the chest, overlapping the cool gray 90% from step five. I lightly outline the beak with cool gray 90%, and then I fill it in with a light layer of burnt yellow, leaving the tip white. I apply black cherry to the top part of the wing, leaving several white spots. Next I fill in the stripes on the wing with yellow ochre. Then I use ultramarine to finish the wing and add color to the tips of some of the tail feathers.

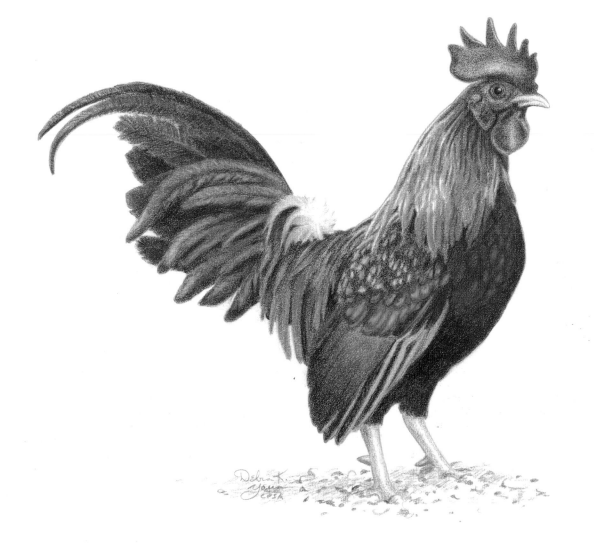

◀ **Step Seven** I add burnt ochre to the top of the rooster's right leg and to some of the long feathers on the rooster's back. Then I shade the spurs on the legs with French gray 50%. Using firm pressure and cool gray 90%, I draw the feather shapes on the chest. I add more Thio violet to the comb and face, deepening the color and leaving some white showing. I also add indigo blue to the middle tail feathers with firm pressure. Then I work on the top part of the wing: I add small touches of Thio violet to the spots that were previously white, applying small strokes of light cerulean blue to the left sides of the spots; then I lightly blend the colors with white. Next I apply some yellow ochre to the white areas on the neck; I also darken some lines on the neck with black cherry. I use a small amount of Tuscan red to darken the brown feathers on the back; then I use firm pressure and indigo blue to darken areas around these back feathers as well as some tail feathers. I also use peacock green to blend some of the blues in the tail feathers. To "ground" the rooster, I add spots of color around the feet with burnt ochre, dark brown, and raw sienna. Then I add some slate gray to indicate the rooster's shadow. As a final touch, I use heavy pressure and white to add shine to some of the tail feathers.

Shetland Sheepdog

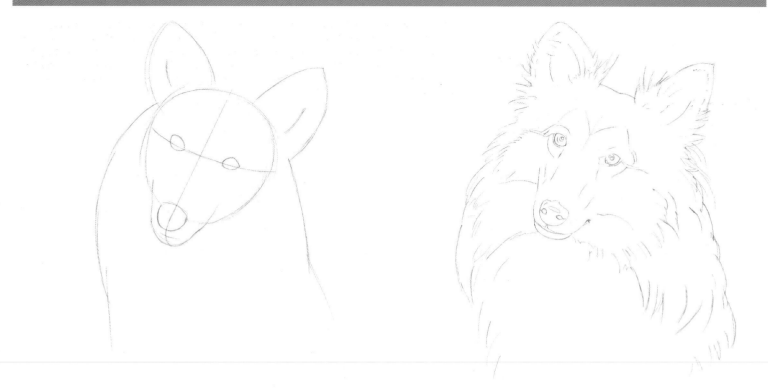

Step One With an HB pencil, I sketch a circle for the dog's head and a rounded triangle for the muzzle. Then I draw the vertical centerline so it reflects the angled position of the dog's head. Next I add the slightly curved horizontal centerline. I use these guidelines to position the eyes and nose; then I draw the large ears and the basic shape of the body.

Step Two I refine the eyes, nose, and mouth, adding details and erasing unneeded lines as I go. I draw some jagged lines for the fur, making sure they reflect the curves of the dog's body. Then I establish the light and dark areas of the fur on the face, which will help me when applying color.

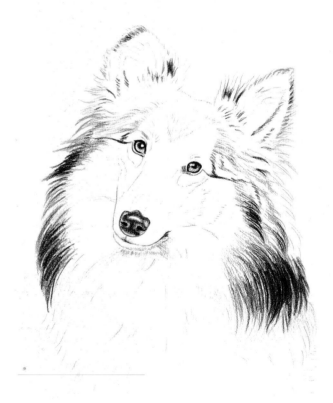

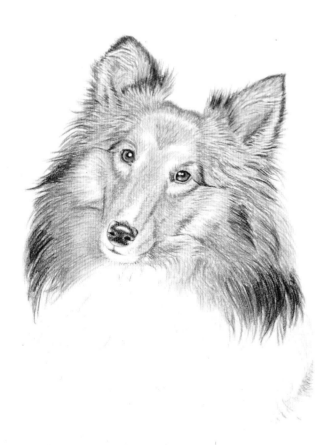

Step Three Still using the HB pencil, I add longer, softer lines to indicate the fur. Then I begin applying color by establishing the darkest areas with cool gray 90%, using strokes that follow the direction of the fur growth. I use the same pencil to fill in the eyes and nose, leaving the highlights white. Next I use medium pressure to add a few long strokes of cool gray 30% to the chest and under the chin.

Step Four I lightly fill in the inner ears with henna and use long strokes of dark umber for the fur on the edges of the ears. For the fur on the face, I use the same pencil and short strokes, following my sketch and leaving some areas white. Then I apply Venetian red to the irises. I use cool gray 90% to refine the nose and pupils, as well as to darken the long fur on the sides of the head and neck. Then, using medium pressure and sienna brown, I create long strokes on the ears and neck and short strokes on the face, pressing harder for darker areas. I also apply a light layer of sienna brown over the henna in the ears.

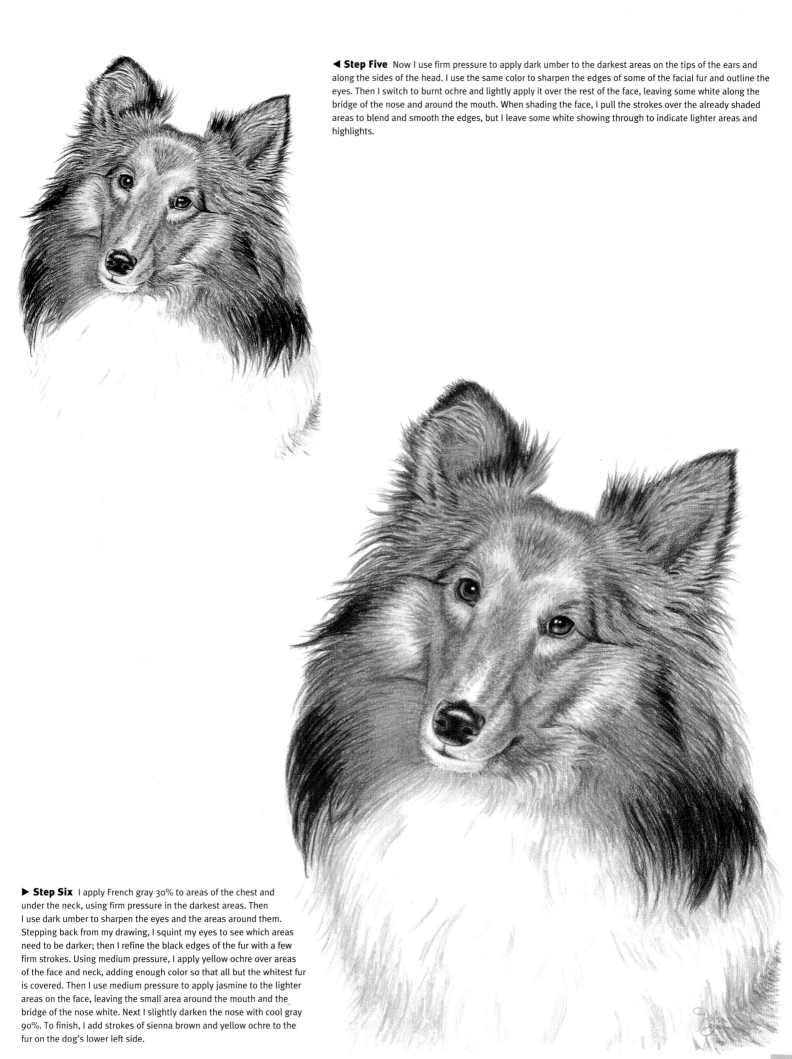

◄ Step Five Now I use firm pressure to apply dark umber to the darkest areas on the tips of the ears and along the sides of the head. I use the same color to sharpen the edges of some of the facial fur and outline the eyes. Then I switch to burnt ochre and lightly apply it over the rest of the face, leaving some white along the bridge of the nose and around the mouth. When shading the face, I pull the strokes over the already shaded areas to blend and smooth the edges, but I leave some white showing through to indicate lighter areas and highlights.

▶ Step Six I apply French gray 30% to areas of the chest and under the neck, using firm pressure in the darkest areas. Then I use dark umber to sharpen the eyes and the areas around them. Stepping back from my drawing, I squint my eyes to see which areas need to be darker; then I refine the black edges of the fur with a few firm strokes. Using medium pressure, I apply yellow ochre over areas of the face and neck, adding enough color so that all but the whitest fur is covered. Then I use medium pressure to apply jasmine to the lighter areas on the face, leaving the small area around the mouth and the bridge of the nose white. Next I slightly darken the nose with cool gray 90%. To finish, I add strokes of sienna brown and yellow ochre to the fur on the dog's lower left side.

GRAY SQUIRREL

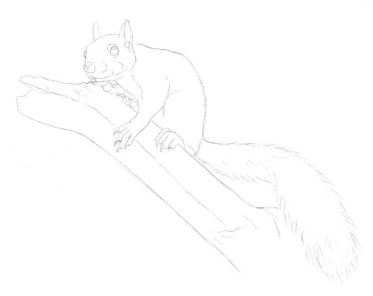

Step One First I use an HB pencil to sketch the basic shapes of the squirrel's body, head, and tail. Then I add the legs and ears. I draw the vertical centerline on the face to help place the facial features, and I add curved lines to indicate the tree branch.

Step Two I refine the shapes and add details, including the individual toes and claws. Then I add some short, quick lines to the tail to show the direction of fur growth. I also add details to the branch.

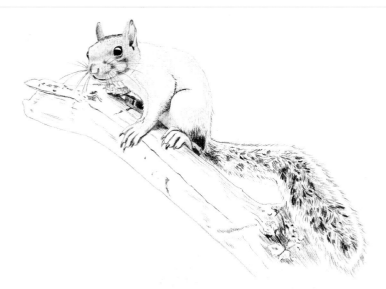

Step Three I add the whiskers with the HB pencil; then I switch to a very sharp cool gray 90% and begin establishing the dark areas. First I darken the whiskers with medium pressure; then I use short strokes for the shadowed areas on the legs. I also darken the toes and claws. I use a light touch to shade around the nose and under the eye, and I use short strokes for the fur on top of the head. Using firm pressure, I fill in the eyes, leaving the highlights and a line under the squirrel's left eye white. Next I add short strokes to the tail, varying the pressure and the direction of the lines to indicate the changes in the fur. Then I lightly apply a small amount of henna to the insides of the ears and add sienna brown to the edges of the ears and in a few places in the tail. I apply a light layer of burnt yellow ochre to most of the head, using short strokes for the body. Then I use long and short strokes to add details to the branch with cool gray 90%. Next I use indigo blue to add shadows where the paws touch the branch. Then, with medium to hard pressure, I apply cool gray 30% to the chin, chest, parts of the legs, and the stomach.

DRAWING THE TAIL

The squirrel featured in this project is a young squirrel; notice that his feet look too big for his body and that his tail isn't as full and fluffy as an adult's. The drawing above is a side view of a mature gray squirrel. Despite the name, most squirrels aren't just gray—their fur tends to be made up of many different colors. Also, some squirrels are more gray whereas this one is more brown. The fur in a squirrel's tail is usually very colorful—each strand of fur changes color from where it attaches to the body to the tip of the tail. This squirrel's tail starts out brown, goes to black, and is tipped with white; this gives the appearance of bands of color. The strands fan out in several directions, with some coming straight toward the viewer, which makes the tail a little confusing to draw. Just make sure you draw the strokes in the proper direction. When drawing this tail, I leave some areas completely white for extra contrast; I also add a dark background around the tail so the light fur is easier to see. Because the fur of the tail is very thin, I allow the background color to show through in a few places along the edges of the tail. I also carefully blend along the edges of the fur so they are not too sharp against the background—this also helps keep the fur from looking too thick.

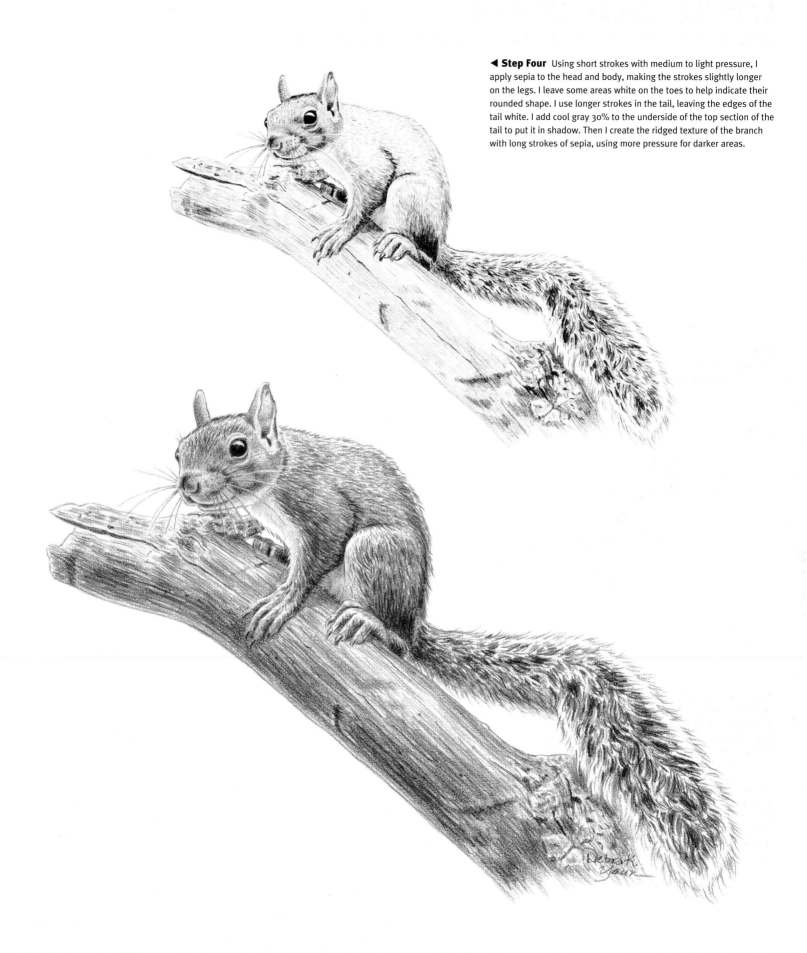

◄ Step Four Using short strokes with medium to light pressure, I apply sepia to the head and body, making the strokes slightly longer on the legs. I leave some areas white on the toes to help indicate their rounded shape. I use longer strokes in the tail, leaving the edges of the tail white. I add cool gray 30% to the underside of the top section of the tail to put it in shadow. Then I create the ridged texture of the branch with long strokes of sepia, using more pressure for darker areas.

Step Five I soften the highlight in the squirrel's left eye by applying indigo blue along the edge; I also use this color to draw a few eyebrow hairs over the eyes. Next I apply cool gray 30% to the tips of the paws to show how they curve around the branch. I add more strokes of cool gray 90% to the branch, using more pressure on the lower shadowed side to make it darker. I draw a few small, circular spots on the branch with the cool gray 90%; then I use the same color to add more short strokes to the squirrel's body and long strokes to the tail. I still leave a few white areas on the body and in the tail, especially along the edges of the tail to show the white-tipped fur. Next I apply a very light layer of cerulean blue to the gray chin, chest, and tummy; I also apply some spots of this color to the squirrel's tail. I add a tiny spot of cerulean blue to the eye highlight and then I use a small amount of indigo blue on the underside and along the top edge of the branch. These touches of blue add some color to the mostly brown and gray composition. Now I use a very sharp cool gray 90% along all of the edges to sharpen the drawing. Using firm pressure, I deepen some of the darkest areas with black for more contrast. Now my drawing is complete.

HORSE

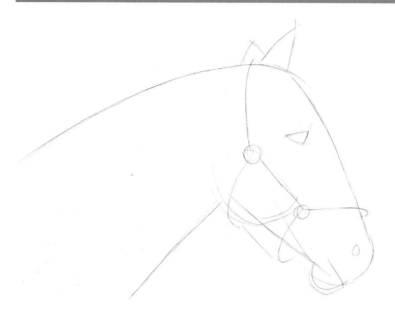

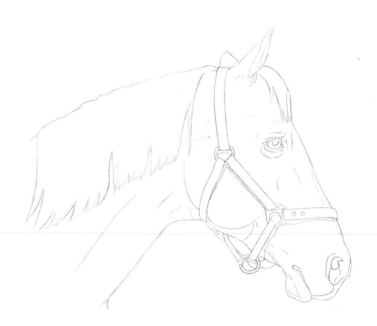

Step One With an HB pencil, I use basic shapes to sketch the head, neck, ears, and eye. Then I draw the bridle, curving it to follow the shape of the horse's head. Next I indicate the nostril and mouth.

Step Two Using the basic sketch as a guide, I develop the facial features, ears, and bridle. Then I draw the mane and indicate some of the folds of the skin and shadowed areas.

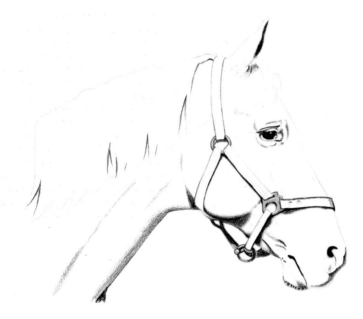

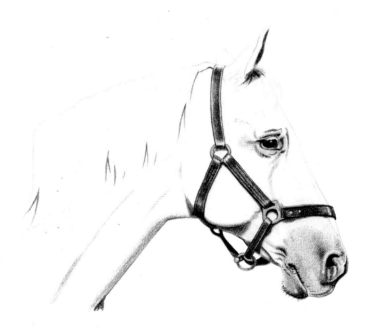

Step Three I fill in some of the shadowed areas using cool gray 90%; then I layer indigo blue over some of the shadow edges. Next I color the iris with sienna brown. Using medium pressure, I apply yellow ochre to the metal areas of the bridle, leaving small areas white for highlights.

Step Four I lightly apply dark umber to the bridle, leaving small areas white to suggest the shine of the leather. I leave larger white areas near the metal rings to show that the leather is worn there. I also use short strokes and medium pressure to indicate some stitching on the bridle where it stretches over the cheek. Then, using cool gray 90%, I outline and shade the nostril and the line of the mouth. For the lighter areas around the muzzle, I use cool gray 50%. Next I create a few whiskers on the chin with cool gray 90%; I use the same color to create more shadows under the ear. Moving down the face, I apply henna to the corner of the eye. Then I add some color to the shadows under the cheek and on the neck with indigo blue.

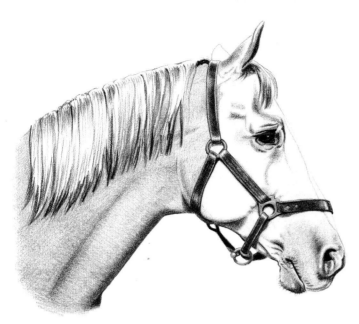

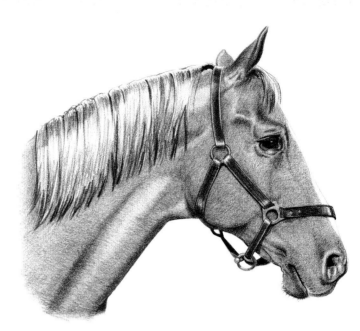

Step Five Now I add more color to the leather of the bridle by lightly applying burnt sienna over the dark umber, using more pressure to create darker areas. I give the metal rings a bit more form by adding some burnt sienna on the edges of the metal. Using cool gray 90%, I outline the eyelashes and shade around the eyes. Next I add dark umber to the shadows on the head and neck. I develop the hair of the mane and forelock using cool gray 90%, leaving areas of the paper white for shine and pressing harder for the darker areas at the bottom of the mane. Then I lightly fill in the neck with an even layer of burnt ochre. I also use burnt ochre to outline the edges of the ears and the blaze that extends from the forehead to the top of the nose.

Step Six I fill in the entire face, layering over the shadowed areas and leaving the blaze white. Then I very lightly apply burnt ochre to the gray on the nose and muzzle. I create the darker folds and areas on the face and neck by adding more burnt ochre. Next I lightly apply ultramarine for the dark areas of the mane, leaving areas white for shine. Then I apply a little cool gray 70% around the eye, nose, and mouth.

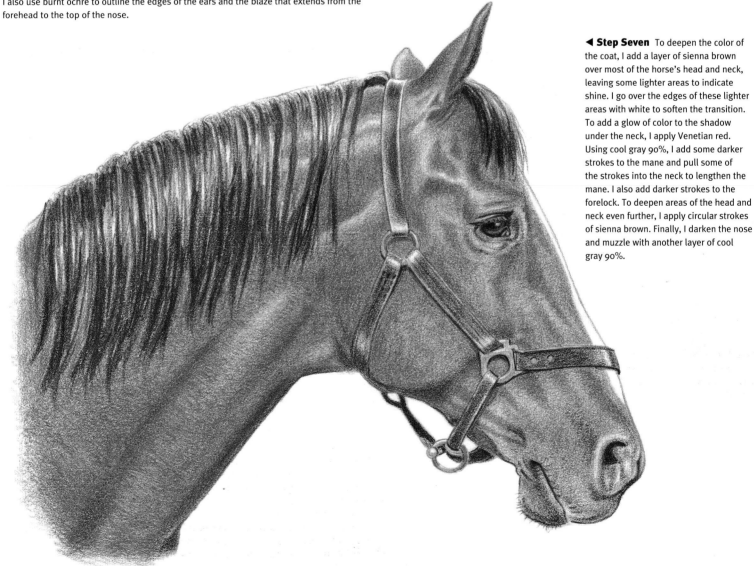

◀ **Step Seven** To deepen the color of the coat, I add a layer of sienna brown over most of the horse's head and neck, leaving some lighter areas to indicate shine. I go over the edges of these lighter areas with white to soften the transition. To add a glow of color to the shadow under the neck, I apply Venetian red. Using cool gray 90%, I add some darker strokes to the mane and pull some of the strokes into the neck to lengthen the mane. I also add darker strokes to the forelock. To deepen areas of the head and neck even further, I apply circular strokes of sienna brown. Finally, I darken the nose and muzzle with another layer of cool gray 90%.

LORY

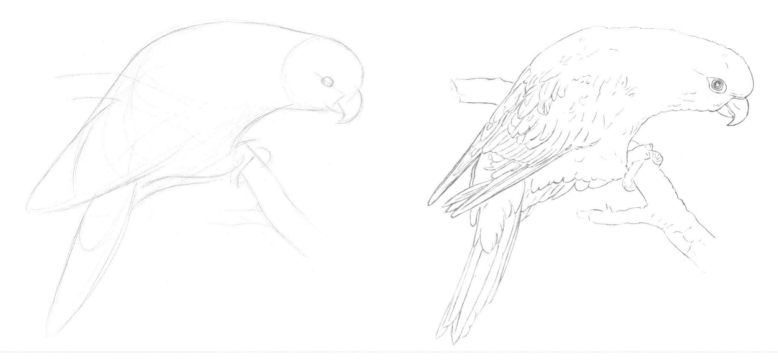

Step One I begin by sketching the basic shapes of the lory with an HB pencil, careful to accurately block in the bird's proportions and position. This lory is lowering his head as he bends forward. When placing the eye, I keep in mind that the forehead is very large.

Step Two Next I refine the shape of the bird and draw the large feathers, indicating a few of the smaller feathers. I detail the eye, which features several rings. The pupil has a circle around it, then a teardrop surrounded by another teardrop shape. I also refine the shape of the branch and add a few lines to the talons.

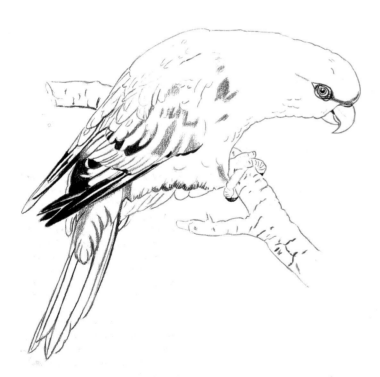

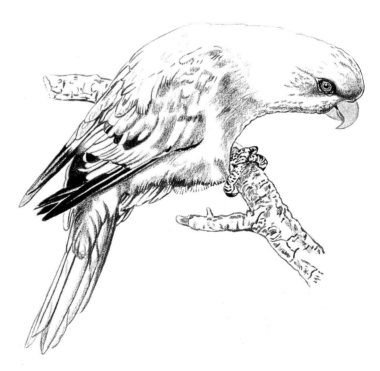

Step Three With a very sharp Tuscan red, I draw over the inner teardrop shape of the eye, color in the dark area between the top and bottom beak, and make a small line at the top of the beak. I fill in the pupil with a very sharp black, then outline the outer teardrop shape. I add a few black lines inside this area and then use the black on the toenails and within the feathers, as shown. I add black cherry to some feather edges and apply a light layer of the black cherry to some of the darkest areas of the red feathers. I also color the curved line from the eye along the upper beak with black cherry; then I use sepia to add some lines to the branch.

Step Four I apply burnt ochre to the branch in a few small areas. Then I use warm gray 50% for the branch, pressing hard for the lines and using medium pressure for the shaded areas. I add cool gray 50% around the pupil and the inside of the beak for shadows. I add canary yellow evenly over the beak with medium pressure. To achieve more realism, I indicate smaller feathers with Tuscan red, although it is not necessary to render every feather. Using light pressure, I add Tuscan red to the shadowed areas of the feathers. With the same color, I go over some feather edges and outline the bird's head using medium pressure. I add ultramarine to the feather edges on the lory's back and near its foot with firm pressure, pulling the color into the Tuscan red.

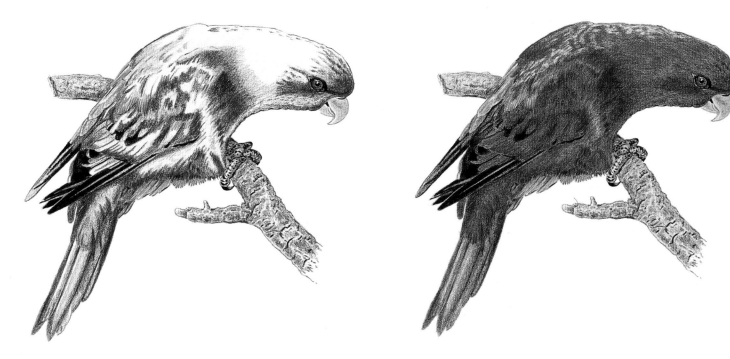

Step Five I apply cool gray 50% to the outermost eye shape and the foot, carefully leaving the highlighted areas white. I color some of the medium dark areas of the lory's body with crimson red, using medium pressure and pulling the color over the Tuscan red. Next I use true blue on the feathers over the ultramarine with firm strokes to define the shape of the feathers. I also add a light hint of true blue over the foot. Then I apply a light layer of black to a few feathers for greater contrast. I use warm gray 50% over the branch with medium strokes, following the contours of the bark. I also add a light layer of cadmium orange hue to the beak, leaving yellow showing at the inner edge.

Step Six Next I apply poppy red to the remainder of the bird using strokes in the direction of feather growth, but I leave a few areas on the back and wings white to indicate the lustrous feather texture. I pull poppy red over the edges of the existing reds to blend the colors more evenly. The tail feathers are a lighter red, so I use cadmium orange hue over the reds, leaving a few light areas for highlights. I add a little more black to the long wing feathers.

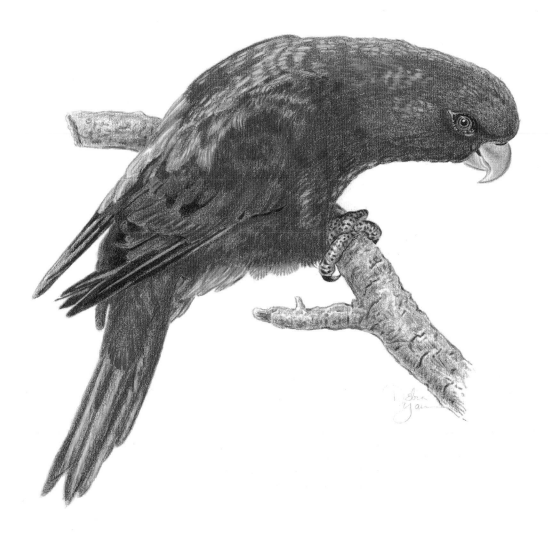

◄ **Step Seven** Now I make the shapes of the feathers crisp using crimson red and a few strokes of Tuscan red. I blend the highlights of the feathers on the back with white, using firm pressure to pull the white over the edges of the red. I also apply a little ultramarine to the blue feathers and blend with white using firm strokes. I apply a few short strokes of white to the side of the head to refine the round form. I add a very light layer of ultramarine to the lower part of the branch, indicating a shadow and giving the branch more depth. Finally, I enhance the detail around the eye using a very sharp black.

LEOPARD

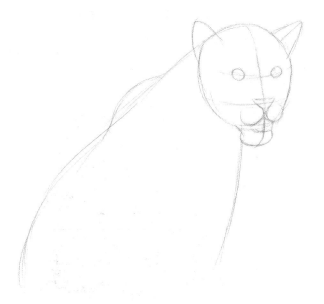

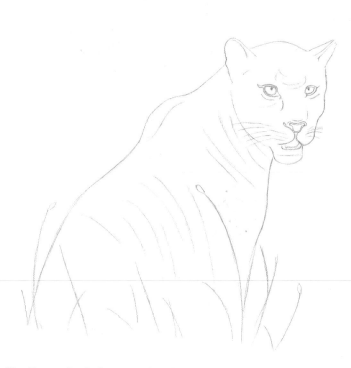

Step One I sketch the basic shape of the head with an HB pencil. The head is turned at a three-quarter angle, so I shift the vertical centerline to the right and curve it to follow the form of the face. Note that the guidelines for the eyes, nose, and mouth are also curved. I indicate the ears and nose with triangle shapes, and I depict the cheeks with two half-circles. Next I draw the body, adding a small hump for the shoulders.

Step Two I refine the features, making the eye on the right smaller to show that it is farther away. I also adjust the leopard's left ear so less of the inside shows, indicating the turned angle of the head. Next I draw the whiskers and some curved lines on the body to help me line up the spots in the next step. I also add some long blades of grass.

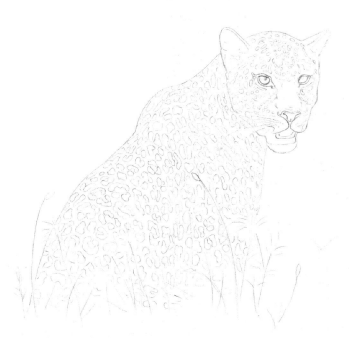

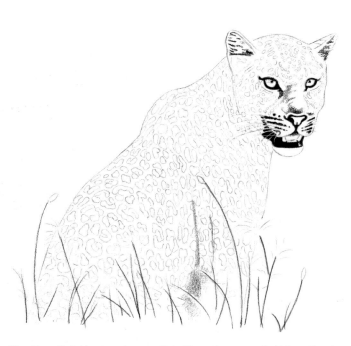

Step Three Now I draw the leopard's spots, using the curved lines as guides and erasing them as I go. A pattern like this can be confusing, so it's helpful to find areas where the spots line up. (You may want to try covering up some of the leopard so you can concentrate on small areas at a time.) Then I detail some of the blades of grass and draw a few more.

Step Four Switching to cool gray 20%, I add more long, curved whiskers. Then I use a very sharp black pencil to outline the eyes and fill in the pupils, nostrils, mouth, and areas on the cheeks and in the ears, as shown. Next I color the blades of grass with dark brown. Using cool gray 90%, I lightly shade around the leopard's right eye and along the bridge of the nose. I use the same color to lightly shade along the creases on the legs.

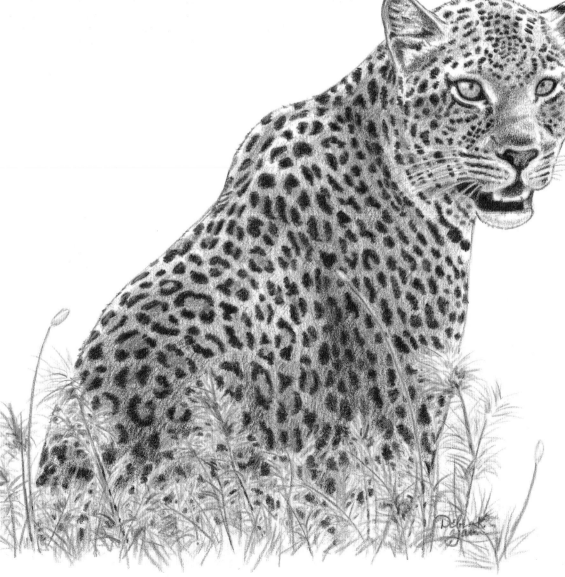

LEOPARD SPOTS

Here you can see the kinds of strokes that make up this leopard's fur. It is important to make sure your strokes follow the form of the body. Also make sure to leave the edges somewhat ragged and rough; smooth edges will make the spots look "stuck on" and unnatural.

Step Five Now I fill in the irises with yellow ochre, leaving a white highlight in the leopard's right eye. (Going over the highlight with a white colored pencil helps protect it from being covered by other colors.) Using medium pressure, I apply burnt ochre to the ears and some areas of the head; I use the same color to lightly fill in the centers of most of the spots and other areas of the body. With firm strokes, I add burnt sienna to the existing grass and draw a few more blades. Then I use firm pressure to apply henna to the nose and tongue. Switching to black, I finish the spots using very short strokes that follow the direction of fur growth. Then I add even more grass with raw sienna.

◄ **Step Six** I apply a light layer of sepia over most of the body and lower face. Then I add cool gray 90% to the ears and middle of the body to emphasize the crease behind the front leg. Next I add cool gray 20% to the chin, leaving the center white. Using firm, short strokes, I add some dark areas to the grass with sepia and burnt ochre. Now I apply dark umber to most of the body, adding a few strokes of burnt ochre to the spots and some cool gray 90% to the leopard's rump. To finish, I use a very sharp cool gray 90% to darken a few areas on the body and go over the outlines of the edges of the body and head, varying the pressure so the lines aren't solid and look more realistic.

MAINE COON

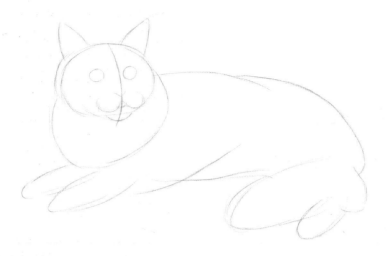

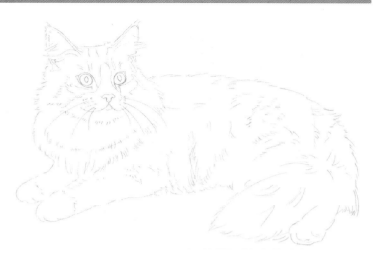

Step One I start by using an HB pencil to sketch the basic shapes on a piece of scrap paper. I block in the cat's head and body, using ovals for the paws and tail and triangle shapes for the ears. I also indicate the rounded chest and the centerline of the cat's face. Then I indicate the facial features. Now I check the proportions, making sure the turned head is positioned correctly.

Step Two Now I develop the details, erasing unneeded lines as I go. I create a few short strokes on the face to indicate the direction of the fur. Then I add the lines around the eyes that extend down along the nose. I also draw the pupils, which are shaped like footballs. I indicate a few whiskers, as well as the white areas on the front paws and some of the fur patterns on the body. Next I transfer this drawing to a sheet of sanded pastel paper.

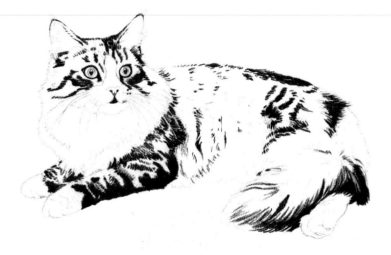

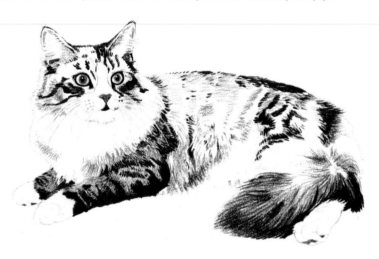

Step Three Using cool gray 90%, I shade the "whites" of the eyes and the pupils. Then, with short strokes and medium-to-hard pressure, I create the darkest areas of fur on the head and body, following the direction of fur growth. The fur on the tail is longer than elsewhere, so my strokes reflect this.

Step Four Now I apply geranium lake to the nose and pads on the paws. Then I add a light layer of dark brown to areas of the head and body. Next I color the irises with cedar green. I fill in the pupils with black, being sure to leave a highlight in each pupil.

DRAWING CATS' EYES

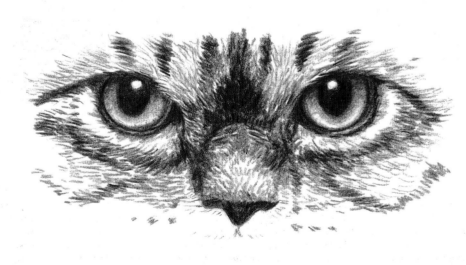

The shape of a cat's pupils changes with the amount of light it receives. For example, in low lighting the pupils appear larger and more circular (as shown here), whereas in strong lighting the pupils can appear like tiny vertical slits. When drawing a cat from a straight-on view, make sure the pupils are facing straight ahead (instead of angled as they are in the featured three-quarter view). Also keep in mind that a cat's sclera, or "white" of the eye, is much less visible than a human's, as cats' irises cover a much larger area than humans' do.

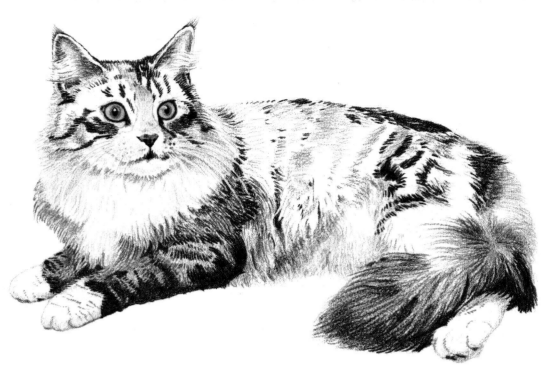

◀ **Step Five** Referring to my reference photo, I continue to add color to the cat. I apply a bit of jasmine to a few patches on the body, as well as on the ears, nose, and around the mouth. Then I apply French gray 70% to areas of the face and body, using short strokes that follow the direction of fur growth. Using medium pressure, I add a layer of chartreuse to the irises; then I apply black to the side of the nose and the mouth. Next I apply henna to the pads on the paws and use short strokes of cool gray 90% on the paws, indicating the fur. Then I use medium pressure to apply cool gray 90% to the undersides of the chin, stomach, and paws to suggest shadows; I use heavier pressure under the paws. I layer short strokes of burnt umber over the jasmine areas of the head and body to deepen the color. I also apply long strokes of burnt ochre and French gray to the tail. Next I add some long strokes of French gray 70% for the fur inside the ears.

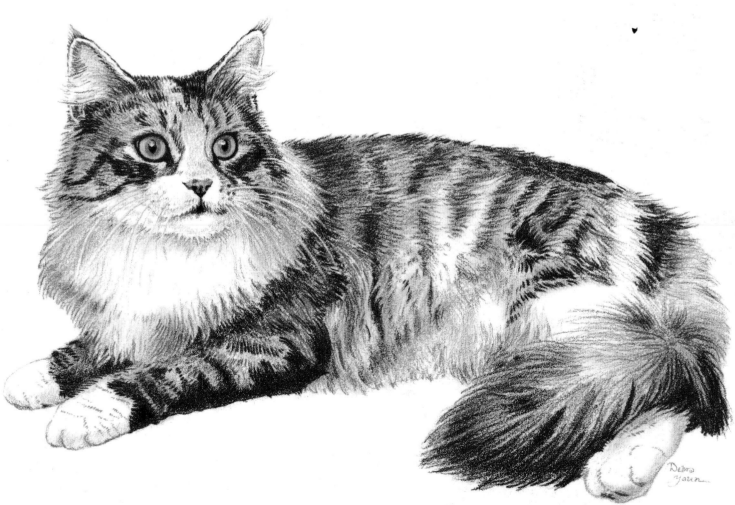

Step Six I apply cool gray 90% on the sides of the neck, making sure to avoid the overlapping whiskers; then I apply the same color all over the body to darken the fur. I add a small spot of true blue to the highlights of the pupils, then blend it with white. Next I layer canary yellow over the chartreuse in the irises, making the color of the eyes more intense. Next I shade areas on the chest and neck to help define the whiskers with cool gray 50%. I also add a bit of cool gray 30% to the lower part of the stomach. Now I stand back to determine whether any area needs more color. For extra contrast, I add a little more burnt ochre to the areas where I've already applied it, and I add black to the darkest areas of the fur. Then I gently pull a stiff bristle brush over the fur to help blend and soften the color. I do this very carefully, though, as too much blending can smudge the drawing. I avoid blending the eyes, as I want them to be clear and shiny. I stand back from the drawing again, make any necessary adjustments, and sign my name.

ALPACA

Step One Using an HB pencil, I sketch the basic shape of the body and then add the legs, long neck, and oval-shaped head. Next I place the eye and mouth, adding a modified oval for the tail. The body, legs, and tail are thick due to the fur, but they would be even thicker if this alpaca wasn't shorn.

Step Two Now I refine the outline and features, and I add a few lines to indicate the changes in the fur.

Step Three I apply cool gray 90% to the mouth, nose, eye, ear, and feet, using firm pressure for the darkest areas. I am careful to leave a white highlight in the eye. I also add light shading under the tail.

Step Four Now I apply a light layer of cool gray 50% to the alpaca's front right leg to make it recede and appear more distant. With light pressure, I add more shading under the tail and on the alpaca's back left leg. Using cool gray 50% and medium pressure, I shade the face and ears. With varying pressure, I add small marks to indicate the dark areas between sections of fur. In some areas, including the tail, I draw soft lines around small sections of fur. Then I layer burnt ochre with firm to medium pressure over most of the existing fur. I also apply a small amount of burnt ochre to the nose and ears. With firm strokes, I draw grass around the feet with Prussian green. Then, using cool gray 90%, I create rocks on the ground.

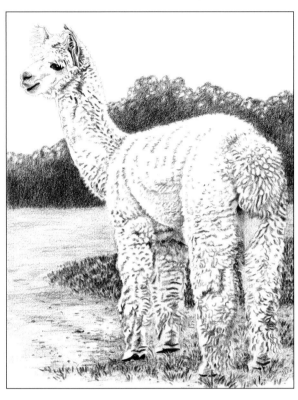

◄ Step Five I add several firm strokes of chartreuse to the clumps of grass in the foreground. Then I shade the ground with dark brown, varying the strokes with medium to light pressure. Using short strokes with firm pressure, I add kelp green to the area behind the legs. I use the same color and longer strokes for the grass under the feet. Now I use indigo blue and circular strokes to start the distant trees, leaving some white showing through in small spots at the top. I also add some dark brown to the backs of the feet.

► Step Six I add short strokes of peacock blue to the grass behind the legs. Next I apply an even layer of Prussian green to the distant trees, leaving some of the white spots free from color. Using firm pressure and long, vertical strokes, I fill in the sky with light cerulean blue. I pull this color into the trees, filling in the white spots and blending the colors. This also pushes the trees back into the distance. Using horizontal strokes, I apply a light layer of cloud blue to the ground beneath the trees and over the center patch of grass. Returning to the alpaca, I define the edges of the face and fur with a very sharp sienna brown. Then I add a small amount of cool gray 30% to the face, ears, and face, leaving some areas white. Next I use firm pressure to apply burnt yellow ochre to most of the fur; I use some circular strokes and some short, straight strokes to portray the woolly appearance. To finish, I add some firm strokes of burnt ochre to the fur and a bit more grass around the feet with Prussian green.

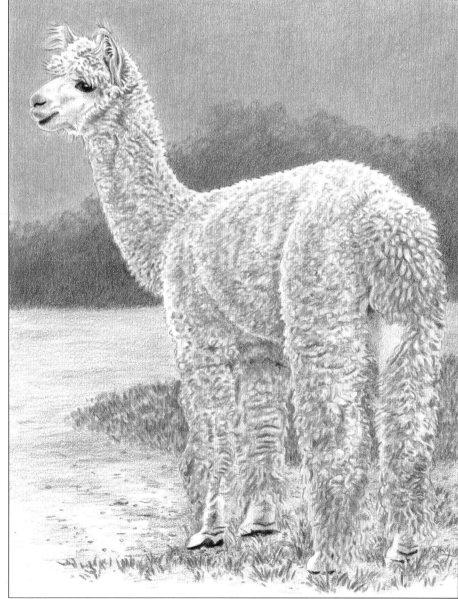

Box Turtle

Step One First I sketch the basic shapes of the turtle's head and shell using an HB pencil. Then I add the eye and draw a few lines on the shell to indicate the patterns. The back legs are hidden by the shell so I don't draw them.

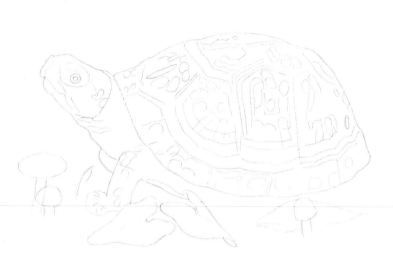

Step Two I add more lines to the pattern on the shell; then I draw some spots and folds on the skin, as well as a line for the mouth. Next I sketch some mushrooms and leaves around the turtle.

Step Three I continue adding lines to the shell and markings on the turtle's skin; then I draw more leaves and moss underneath the turtle.

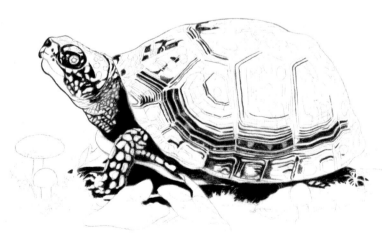

Step Four Now I use dark indigo to establish the dark areas on the shell and body, avoiding the spots on the skin. Then I use the same color and firm pressure to create the dark shadow beneath the turtle, drawing around the moss and leaves.

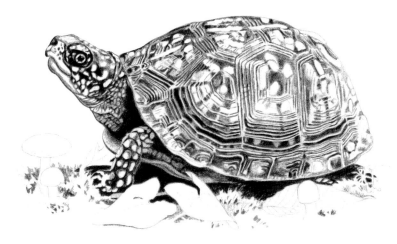

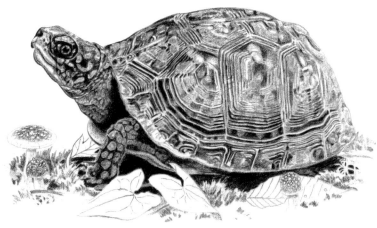

Step Five Using cool gray 90% and medium pressure, I apply color to the bottom of the shell, gradually lightening the pressure to show a change in value. I also use this color to lightly shade the chin and mouth. I add more details to the shell and body with indigo blue, using light pressure for lighter areas and going over the dark indigo on some areas of the shell. I also use this lighter blue on top of the head and on some of the spots on the leg and shell. Now I apply black to the pupil, leaving a small area of white around it. Then I apply dark indigo with short strokes to create some dark areas of moss. I also use this color on some of the spots on the body to indicate a shadow.

Step Six I lightly apply pumpkin orange to spots on the head, body, and shell, pressing harder where I want the color to be more intense. Then I fill in a few more areas on the body and shell with dark indigo. I switch to kelp green and lightly fill in the iris, leaving a small white highlight. I also use this color and short, firm strokes to shade the moss. I lightly apply Tuscan red to the tops of the mushrooms, leaving white spots in the centers; then I shade the mushroom stems with cool gray 90%. Using dark brown, I outline the leaves and draw the veins; I also use this color to shade some sticks on the ground. Now I use Tuscan red to go over the veins and shade the undersides of the two leaves by the turtle's foot.

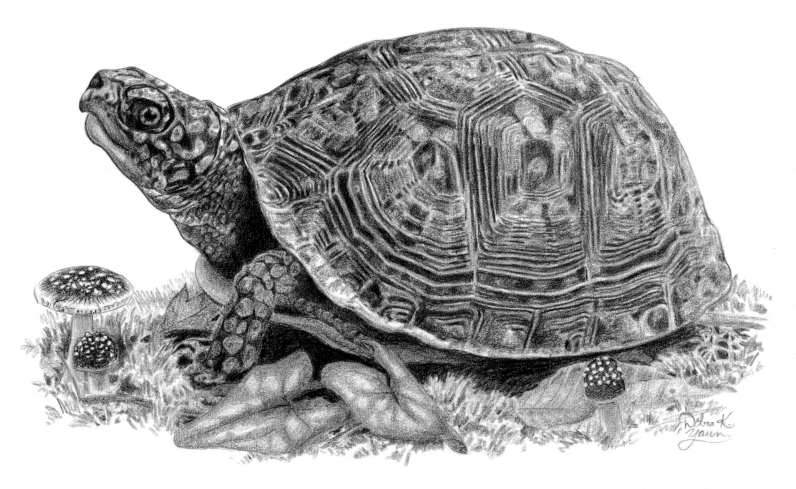

Step Seven Now I apply sepia to the leaf to the right of the turtle; I color the other two leaves with Prussian green, going over the Tuscan red veins and leaving some lighter spots by using less pressure. Using poppy red, I shade around the white spots on the tops of the mushrooms and draw a few lines along the edges of the largest mushroom. I also use this color to brighten up some of the spots on the shell. Next I apply a layer of jasmine to the stems of the mushrooms, going over the cool gray 90%. I use beige and circular strokes to shade the bottom part of the shell, blending the existing colors. Then I add more kelp green to the moss and darken some areas of the foreground with dark brown and dark indigo; I also darken a few areas of the shell with dark indigo. Finally, I apply sunburst yellow to some spots on the shell.

Red Fox

Step One Using an HB pencil, I sketch the basic shapes of the fox's head. The nose is long and extends from the head because the fox is at a three-quarter angle; the vertical centerline curves with the head and extends out along the nose. Next I add triangle shapes for the ears, a line for the mouth, and ovals for the eyes. Note that the eye on the right is hardly visible.

Step Two I refine the drawing, adding more of the neck and body and the outlines of the inner ears. I also indicate the areas of fur on the chin and neck. Then I draw the whisker markings and the whiskers themselves. I refine the eyes and nose, drawing the iris and pupil as half-circles for the eye on the right.

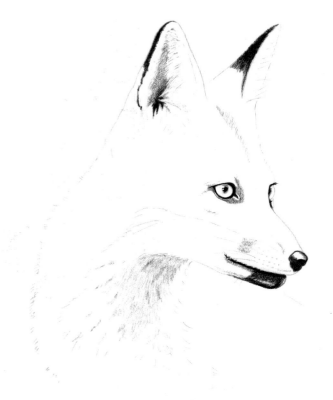

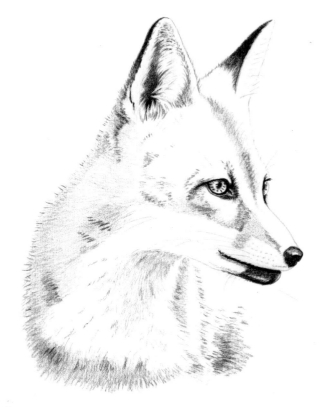

Step Three I add a few more details to the drawing, including a few strokes to indicate the direction of the fur growth. Now I switch to a black colored pencil to shade the tips of the ears, the pupils, and the outlines around the eyes. I shade most of the nose with firm pressure, leaving the top white; I also shade the mouth area. Next I fill in the ear on the left with cool gray 90%, using firmer pressure as I go down. With the same color and medium pressure, I shade around the eye, forehead, neck, and mouth, and I add a patch on the side of the muzzle. Then I make short, firm strokes inside the ear with a white pencil; I add a few darker strokes between the white strokes with cool gray 90% .

Step Four Now I apply short strokes of dark brown to areas of the head, neck, face, and body. With firmer strokes I apply dark brown to the area below the black in the inner ear, pulling the strokes over the white fur. I also add a layer of henna to the left side of the inner ear. Then I add some firm stokes of white to the head, body, and areas around the eye. Next I apply cool gray 90% to the nose, leaving the highlight white. Using medium pressure and dark brown, I add strokes to the iris that radiate out from the pupil. Now I use the HB pencil to sketch the hairs above the eyes; I will darken them later.

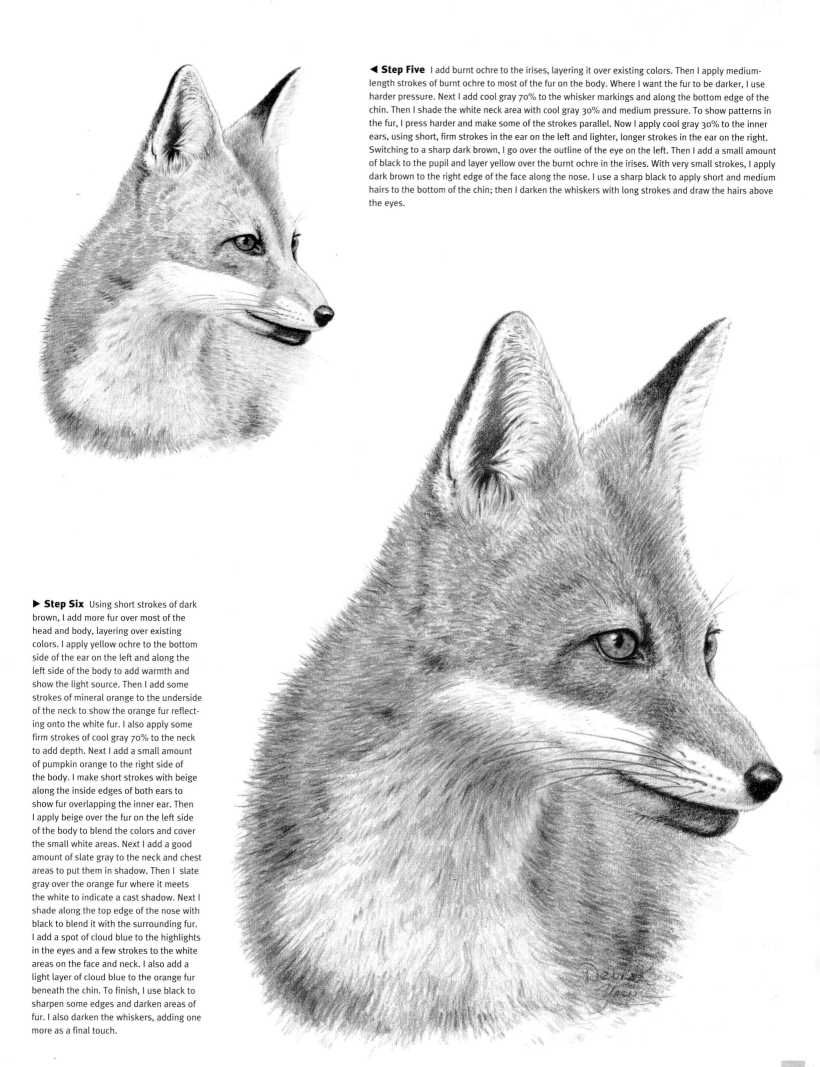

◄ Step Five I add burnt ochre to the irises, layering it over existing colors. Then I apply medium-length strokes of burnt ochre to most of the fur on the body. Where I want the fur to be darker, I use harder pressure. Next I add cool gray 70% to the whisker markings and along the bottom edge of the chin. Then I shade the white neck area with cool gray 30% and medium pressure. To show patterns in the fur, I press harder and make some of the strokes parallel. Now I apply cool gray 30% to the inner ears, using short, firm strokes in the ear on the left and lighter, longer strokes in the ear on the right. Switching to a sharp dark brown, I go over the outline of the eye on the left. Then I add a small amount of black to the pupil and layer yellow over the burnt ochre in the irises. With very small strokes, I apply dark brown to the right edge of the face along the nose. I use a sharp black to apply short and medium hairs to the bottom of the chin; then I darken the whiskers with long strokes and draw the hairs above the eyes.

► Step Six Using short strokes of dark brown, I add more fur over most of the head and body, layering over existing colors. I apply yellow ochre to the bottom side of the ear on the left and along the left side of the body to add warmth and show the light source. Then I add some strokes of mineral orange to the underside of the neck to show the orange fur reflecting onto the white fur. I also apply some firm strokes of cool gray 70% to the neck to add depth. Next I add a small amount of pumpkin orange to the right side of the body. I make short strokes with beige along the inside edges of both ears to show fur overlapping the inner ear. Then I apply beige over the fur on the left side of the body to blend the colors and cover the small white areas. Next I add a good amount of slate gray to the neck and chest areas to put them in shadow. Then I slate gray over the orange fur where it meets the white to indicate a cast shadow. Next I shade along the top edge of the nose with black to blend it with the surrounding fur. I add a spot of cloud blue to the highlights in the eyes and a few strokes to the white areas on the face and neck. I also add a light layer of cloud blue to the orange fur beneath the chin. To finish, I use black to sharpen some edges and darken areas of fur. I also darken the whiskers, adding one more as a final touch.

BUSH BABY

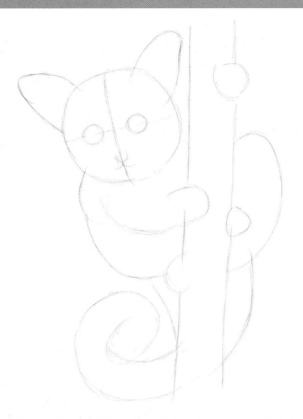

Step One Using an HB pencil, I lightly draw a circle for the head; then I add the body, limbs, and tail, making the body wrap around a tree. Now I draw the facial guidelines and place the features, making sure the nose is low on the face. Then I add the triangular ears.

Step Two I refine the drawing, adding soft lines to indicate some of the fur. Then I draw the individual fingers and toes, noting that the second finger is shorter than the others. Next I add branches and leaves to the tree. I also add a few lines to the tail to indicate how the fur changes as the tail curves. Now I work on the eyes: Starting with the original circles, I draw several more circles that get larger as they go outward; then I add the pupils and highlights. I also refine the ears, nose, and mouth.

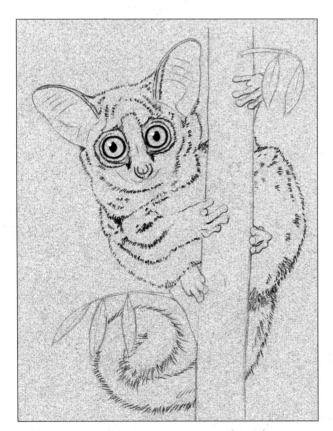

Step Three Now I transfer the drawing to the smooth side of a gray-toned paper (see "Tracing and Transferring" on page 13). This paper will provide much of the gray fur for me. After the lines are transferred, I indicate fur on the head and body with short, firm strokes of cool gray 90%. I use the same color to lightly outline the nose, fingers, and toes; then I create the light ridges inside the ears. After covering the highlights in the eyes with white, I fill in the pupils and outline the eyes and the fur around the eyes with black.

Step Four I adjust the ear on the left, turning it so more of the outer part of the ear shows. Then, using dark indigo, I lightly shade areas on the ears and paws, as well as under the chin and along the underside of the tail. I use the same color to shade the undersides of the branches and both sides of the tree, making the right side darker to suggest the direction of light. Switching to black, I add more fur, indicate the mouth, and lightly shade the irises. I also use black to fill in the fur around the eyes with firm pressure and short strokes.

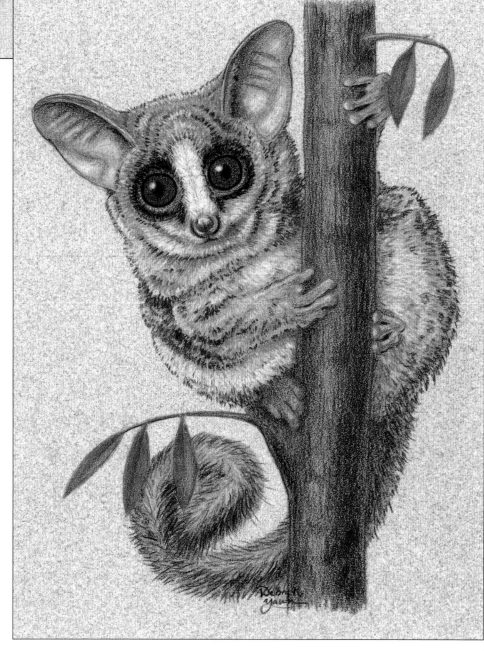

◀ Step Five I lightly apply kelp green to the leaves; then I apply a light layer of henna to the nose, tips of the digits, and inner ears. I add color to the tree with dark brown, using vertical strokes for the trunk and horizontal strokes for the branches. Next I firmly apply short strokes of French gray all over the body and head, changing the direction of the strokes as the fur curves with the body and tail. Then I apply cool gray 70% to the fur on the body, creating darker areas with cool gray 90%. I also apply cool gray 90% to the tops of the ears. Next I go over the henna on the nose, digits, and inner ears with peach. I lift out some color along the highlight of the tree trunk with a kneaded eraser to give it a rounded look. Next I apply chartreuse to the lighter sides of the leaves, as well as to the left side of the bush baby's body and right forearm. Then I fill in the irises with Tuscan red, using medium pressure and strokes that radiate out from the pupil. As usual, I leave white highlights in each eye.

▶ Step Six I add a little more henna to the nose and around the eyes; then I brighten the irises with a small amount of poppy red. Using a white pencil with firm pressure and short strokes, I create white fur on the face and body, leaving some gray paper showing through. Then I use the white pencil to blend the colors inside the ears, as well as on the paws. Next I add slate gray to some shadowed areas under the forearm and chin, as well as areas behind the tree. Then I add black to the tail, toes, and shadowed areas of the tree. To finish, I brighten some light areas with firm strokes of white.

Cow

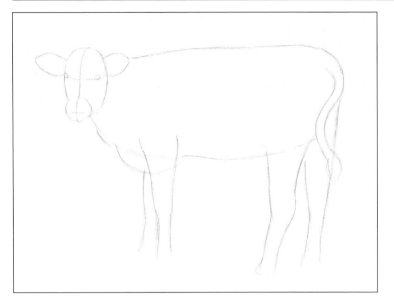

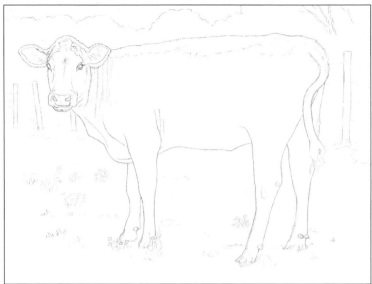

Step One Using an HB pencil, I sketch an oval shape for the head and a smaller circle for the nose. Then I add the facial guidelines: a slightly curved vertical centerline and horizontal lines for the eyes and nostrils. Next I draw the ears, making the ear on the left slightly larger because the ear on the right is turned forward. Now I add the body, making it about 6 heads long; I also draw the legs and curved tail.

Step Two I refine and detail the shapes, adding the nostrils, mouth, and hooves. Then I indicate folds in the skin and add some short strokes to the edges of the body to suggest its coat. Now I draw a background of trees and a fence, adding clumps of grass and wildflowers on the ground and around the cow's hooves.

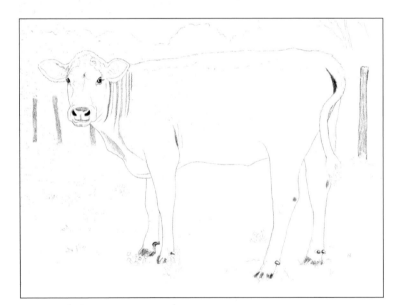

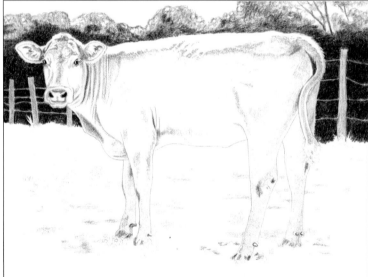

Step Three Switching to cool gray 90%, I use medium pressure to shade the darkest areas on the cow's body, including the hooves, neck wrinkles, top of the nose, and chest; I also shade the fence posts. Then I use firm pressure to fill in the eyes and nostrils.

Step Four After applying henna to the insides of the ears, I use light to medium pressure to shade the face and some areas of the body with slate gray, going over some of the dark areas from step three. I also lightly apply burnt sienna to areas of the ground. Then, using indigo blue and firm pressure, I shade most of the area directly behind the cow, avoiding the ground and the fence. I use medium to light pressure to shade the foliage above the cow, leaving small areas of white showing through.

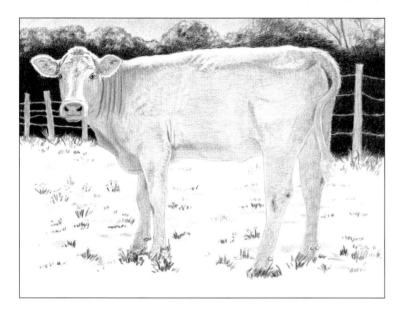

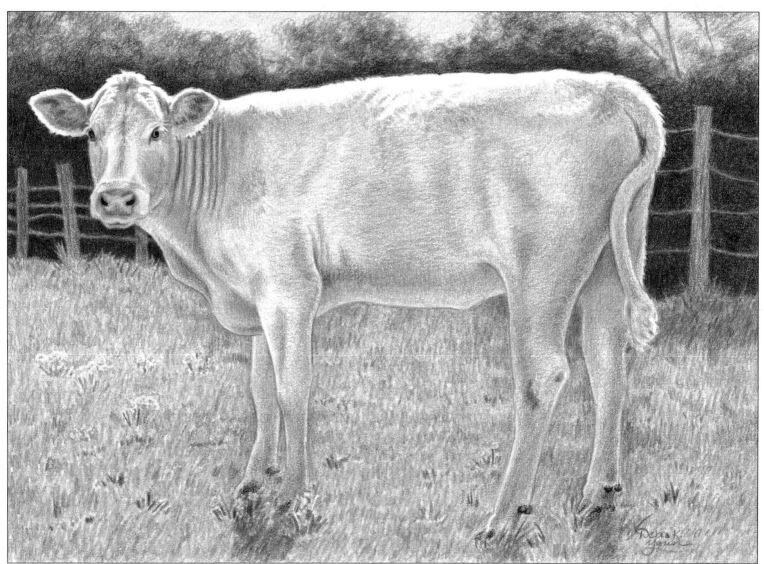

◄ Step Five Now I start the grass with Prussian green, using more pressure for the grass in the foreground to help suggest depth. (The lighter grass in the background looks farther away.) I add a few strokes of pumpkin orange to the grass; then I use canary yellow and circular strokes for the flowers, adding burnt ochre for the flower centers. Returning to the cow, I cover most of the body with peach beige, leaving the top edges of the cow's back white to show the sunlight coming from above. I also leave a great deal of white on the bridge and sides of the nose. Then I use medium pressure to apply blue slate to the sky, still leaving some white showing through.

Step Six I go over the fence with slate gray and then add long, vertical lines of cool gray 90% to the posts. I also use cool gray 90% on the cow's hooves. Now I add interest to the drawing by applying several subtle colors to the cow. I apply yellow ochre to the cow's underside and the hair on the tail, putty beige around the eyes, beige sienna inside the ears, more peach beige on the face, and cloud blue on the white areas on the nose and forehead. I also add poppy red to areas of the ears and a light layer of beige sienna over some of the peach beige on the face. Then I apply light cerulean blue to the shadows on the closest legs, the upper part of the tail, the top of the back and nose, and the upper part of the foliage. To finish the cow, I add a light layer of dark brown to the body and use French gray 50% and short, firm strokes to blend the colors on the coat. Now I refine the background. To darken the lower part of the background, I add a layer of black; then I apply a layer of Prussian green over the black and up over most of the foliage. Next I use short, vertical strokes to complete the grass, using sap green for the background and green bice for the middle- and foreground. To help the grass in the background recede, I apply some strokes of light cerulean blue. I create the cast shadows on the grass from the legs with firm pressure using indigo blue; I also apply this color over the grass near the fence posts to suggest the shadows of the trees. To finish, I add more indigo to the trees and brighten the grass with a few more firm strokes of green bice.

INDEX